BRANDED PROTEST

INGEBORG BLOEM AND
KLAUS KEMPENAARS

EDITORS
Ingeborg Bloem and Klaus Kempenaars

CONTRIBUTORS
Shehab Awad
Steven Heller
John Loughlin
Terrie Ng
Rudy Reed
Rob Walker
Kacey Wong

EDITORIAL TEAM
Laura Brown
Joe Mejía
Sarah Payton
Rudy Reed
Jane Szita

DESIGN
Ingeborg Bloem and Klaus Kempenaars
xSITE (AMS & NYC)
xsite.guru

PUBLISHER
BIS Publishers
Building Het Sieraad
Postjesweg 1
1057 DT Amsterdam
The Netherlands
T +31 (0)20 515 02 30
bis@bispublishers.com
bispublishers.com

BISPUBLISHERS

ISBN 978 90 6369 541 5

Front pages (1-2)
Amazon Defense Act.
São Paulo, August 23, 2019
Photo by Romerito Pontes, CC BY 2.0
Back pages (207-208)
Photo courtesy Extinction Rebellion

Contents

"Although, for ideas to get traction, protest movements need to show they are brand-conscious to be recognized and taken seriously, the key is not to be so focused on branding that they forfeit authenticity."

STEVEN HELLER, Co-Chair,
MFA Design Department, School of Visual Arts

Cause Branding:
The Right Balance

By STEVEN HELLER

To mobilize and proselytize, activist organizers must employ whatever means are possible to reach their respective masses – demonstrations, marches, sit-ins, civil disobedience, ephemera, bills, posters, mailers, multimedia, video, podcasts and social media, among them. These methods will range from impromptu to deliberate strategies that either mimic their opponents' tactics or initiate original attention-grabbing feats of their own. Activism is, after all, a campaign, and a campaign demands a concerted level of combativeness through efforts fortified with the most effective tools possible. Over time, the commercialized practice called *branding* has been weaponized for political causes. As such, it is a proverbial double-edged sword.

Branding is a charged practice and overused buzzword, an umbrella for marketing, advertising and public relations aimed at manipulating target audiences to embrace a person, thing or idea. Branding can be both benign and nefarious. Branding is responsible for the yogurt we buy, the gasoline we pump, the airline we fly, the soda we drink, as opposed to all of the other yogurts, gasolines, airlines and sodas on the market that – as a result of effective branding – are not our preferred choices. Branding is also a propaganda tool used toward the build-ups of the wars we fight, the rhetoric we consume, the political party we belong to, the religion we practice and the ideology we believe in. Branding is the manufacture of public opinion and from that derives brand loyalty.

At the root of branding is the branding iron that was originally used to identify and register property, protect ownership and thwart thievery. The accepted custom of ineradicably searing livestock with a fiery iron dates back a thousands of years, and in the United States is an ownership law (akin to a license plate, another form of brand). Animal branding, also known as *stigmatizing*, relates in this way to the violent practice of branding the flesh of human slaves with marks of ownership and punishment.

It is sobering to realize that from branding property came the branding of commercial products, which in turn became the means to distinguish between competing consumer goods, services and businesses. After

the industrial revolution, distinguishable trade names, trademarks and logos became standard sales tools for manufacturers in producing and marketing packaged products.

The idea of branding as a practice and profession developed over time. Competition fostered the need for brands that could attract customers through real or fictional qualities and narratives about the product's heritage and legacy. In the 1950s and '60s, fusing the design of advertising campaigns, packaging and corporate identity (which might include registered trade characters) emerged as the main ingredients of what is now called branding. Add psychological market testing to this equation, and the field of brand strategy and strategists emerged. Today, branding is a lucrative profession as every new and old product, service, ideology and campaign must appeal to a market segment or constituency and fulfill a particular "gap." The language of brand-speak is growing to accommodate an ever-expanding universe of need in all areas, including protest, dissent and advocacy.

Cause branding is a logical offshoot of commercial branding. Today political parties "stay on brand" to appeal to their desired base. Likewise, protest or dissent movements have turned to brand strategies to reach their followers. The Internet has made branding evermore essential yet complex. There are so many communication platforms today that pushing a brand message to the right audiences requires skill and expertise. Almost anyone who uses digital media – virtually all of us – thinks they know how to optimize its power. This is a fallacy. The Internet is an expanding black hole. Sometimes getting a meme to go viral is the secret ingredient. But this is not as easy as it sounds.

The Internet is like a wave. It can reach tsunami proportions and carry millions of people with it or break calmly on an empty shore with nobody the wiser. The old method of posting or distributing analog notices had its limitations, but – despite the power of new technologies to circulate messages faster – the public continues to develop filters. As with the annoyance of telephone marketers, people have a low tolerance for interruption in their lives. Unless a compelling issue is phrased or visualized in an equally persuasive way, no amount of online visibility will raise an eyebrow. For cause branding to have a chance at success it must use many commercial branding tropes. The severe danger is in developing seemingly disingenuous messages that are excessively strategized to sway public opinion, as in the case of Cambridge Analytica's involvement in political campaigns across the world.

Is it possible to over-brand? To have too much exposure? Did the phenomenon of the "pussy hats" from the 2016 Women's Marches, for instance, help the movement? Does it still? Or do some ideas have legs while others run their course? Impromptu actions benefit from grassroots energy, but that can be quickly exhausted by a lack of organization and resources. Therefore, cause branding requires coordination but should avoid appearing to be too calculated or overly brand-handled.

Younger organizers and activists are very familiar with branding. Being digital natives, they tend to instinctively know which aspects of the practice to use to meet their specific needs. Cause branding should not simply copy commercial branding techniques. Although, for ideas to get traction, protest movements need to show they are brand-conscious to be recognized and taken seriously, the key is not to be so focused on branding that they forfeit authenticity. This book offers examples and options in the ever-changing endeavor of cause branding, yet these are not necessarily templates for action, for every cause demands unique strategies in order to address unique issues.

"Ours is a time of renewed and accelerated bigotry regarding race, sexuality, gender identity, and religion, of pending ecological disasters, of shifts and rifts among international powers, of nationalism, neo-fascism, globalism, jingoism, xenophobia, international and domestic terrorism, national militancy and the forming of amateur militias, of corporatism, corruption and cronyism, of twittering leaders, voter suppression, election interference, post-truth media, suppression of free press and civil liberties, demagoguery, authoritarianism, dogmatism, uncompromising political parties, cyber and drone warfare, growing economic disparity and technological developments most of us cannot comprehend or counter, to name a few. There seems to be much to voice concern about and oppose."

Introduction

By INGEBORG BLOEM and KLAUS KEMPENAARS

We are all exposed to branding: from a torn sheet of cardboard duct-taped to a scrap of wood and scrawled with whatever writing utensil someone was able to find at home to slick corporate advertising campaigns in the press, targeted through streaming portals, social media, and television. Many of us recognize branding and its intent to influence our actions. And those who recognize it might like to imagine themselves immune to its effects. The Nike logo – officially referred to as the "swoosh" – is presented to us wherever the company can hope to claim our attention. We might like to think we recognize such ubiquity for the inducement it is. We are wise to such sloganeering and trademarked icons; we make our own decisions. And yet some of us are loyal to Nike, and some of us are Adidas people. So, how does branding work?

Commercial interests certainly earn the highest marks in using and innovating branding. Branding is several millennia old and reflects the interest of ownership. Cattle were burned with a mark so that people would know which head belonged to whom. "Brand" as a marketing term derives from company names stenciled or burned (branded) onto wooden packing crates a few hundred years ago to render them identifiable for distribution. "Brand new," instead of meaning recently purchased, once meant that the purchaser pridefully claimed personal ownership of an item directly in its producer-branded packaging – meaning that there have been no previous owners. Some companies recognized that they could out-compete other commercial interests by defining and distinguishing themselves through their burn mark and gain what we now call "brand

loyalty." Almost as soon as the fields of sociology and psychology were born, companies hired experts in human nature to shape their sway. Academics and artists were put to service. Departments were formed to design a specific company identity and a corresponding public facade. A commercial advertising industry evolved to develop and disseminate *the idea* of a company. Freelance designers positioned themselves in a burgeoning marketplace to satisfy the less-than-corporate enterprises. Jingle melodies, the perfect color, the perfect font, the perfect wording, all studied, debated, rejected, and approved to promote the economic interests of a company.

Although they may be the greatest investors in, and highest achievers of, insinuating a proprietary identity into the public conscience, businesses are not alone in branding, nor were they the first. Political slogans appear scrawled on the walls of affluent houses excavated in Pompeii. Emperors printed the few words that could fit onto coins minted during their reign to remind subjects of their personal mottos. Flags have

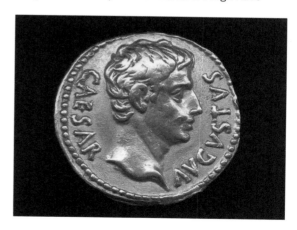

identified nations for as long as there have been nations – and clan groups for much, much longer. And people rally to them still. Throughout history, a slogan, icon, flag, or rallying cry – branding, that is – works because it has a way of niggling its way into the very identity of the participant: I like this, I agree with this, I stand for this, I am this. I tattoo the "swoosh" on my chest.

In recent decades, political campaigns have matched commercial savvy in branding, with carefully crafted slogans and lapel buttons, rally chants and super PAC-funded advertising campaigns. A media campaign, whether political or commercial, has become a coordinated front set upon populations. Those in positions of power, and those hoping to be, leverage the resources they can to design brand campaigns to reach and influence more people. By tapping into identity, they hope to seduce loyalty and secure ubiquity.

But what about protest movements? Can they seduce? Often spontaneous and lacking funds, leadership, power, unity, research groups, and centralized missions, how do they deliver a message of purpose that can unify participants and rally those yet to participate? Instead of promising the gratification of consumption, they often ask participants to risk much: scorn, ostracism, violence, media mis-representation, police countermeasures, job security in order to strike, lost wages in order to march, and potential ineffectiveness.

Yet people protest, and we witness and remember certain images and messages of protest as surely as we can hum along to a McDonald's jingle. We are familiar with the images of a lone figure blocking a column of tanks approaching Tiananmen Square, Pride parades around the world, the peace sign (both the hand gesture and

the Nuclear Disarmament circle), the crowding of the National Mall in Washington D.C. by hundreds of thousands, a black-gloved fist raised on the Olympic podium. These images of protest spread in their time and still persist because they too find their way into a person's sense of self. They indicate that discontent is relatable.

If protest is the voicing of relatable discontent, how does it operate in the social media age and against a backdrop of overwhelming media noise? How do protest movements spread their message farther, deeper and faster than with graffiti or word-of-mouth? Do they brand? If so, how? Can branding be used to give a voice to the voiceless? Does branding provide the means to expand the societal power of ordinary people?

We are two graphic designers concerned with how the power of our work is applied. Coming from a generation when the only functional term in our profession was *corporate identity*, we felt restricted to commercial goals and were happy when the term *branding* finally arose. The word *branding* has a much broader application than *corporate identity* does. It is more generic and provides the opportunity to describe a wide range of design solutions, tools, and assets. This inclusivity allows us to focus our efforts on any number of messages, how they work, and what they serve. We want to examine how the broader branding concept can be applied to protest movements.

Ours is a time of renewed and accelerated bigotry regarding race, sexuality, gender identity, and religion, of pending ecological disasters, of shifts and rifts among international powers, of nationalism, neo-fascism, globalism, jingoism, xenophobia, international and domestic terrorism, national militancy and the forming of amateur militias, of corporatism, corruption and cronyism, of twittering leaders, voter suppression, election interference, post-truth media, suppression of free press and civil liberties, demagoguery, authoritarianism, dogmatism, uncompromising political parties, cyber and drone warfare, growing economic disparity and technological developments most of us cannot comprehend or counter, to name a few. There seems to be much to voice concern about and oppose. And so, we have researched protest movements and interviewed key participants within them for how the movements communicate to, and are taken seriously by, different audiences with varied interests, whether they be organizers, volunteers, donors, corporations, lobbyists, politicians, or everyday people.

In our research, we have identified revealing and contradictory attitudes and actions entangled within protest communities. Many of the most successful and recognizable protest movements have benefited from employing select branding tactics, even while simultaneously disavowing the general concept of branding. We therefore believe that the current understanding of branding does not adequately describe real-world actions and requires re-examination. Titled *Branded Protest*, this publication intends to identify those branding techniques that help a protest deliver a clear, identifying message.

We should begin by describing the current understanding of the two key terms: *protest* and *branding*.

Protest

People want a voice. In the cacophony of the current media landscape, a voice alone is lost until it is amplified by others. Protests start with the individual. But those individual protests that fail to attract attention are destined to remain solitary, and will end when it's time to make dinner. Other individual protests, given the right exposure, can reach and be sustained by millions. Colin Kaepernick kneels alone on the turf during the national anthem when everyone else stands, faces their flag, places hand over heart, and sings. It is a striking gesture performed in front of a score of television cameras (and tens of thousands of smart phones) broadcasting nationally. It makes the news and social media, and the nation retweets and discusses. His gesture catches on. More kneel. Participation spreads.

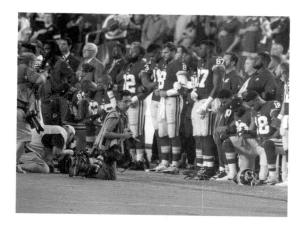

True, an individual can make his or her voice heard when it excites media. But the desire for change manifests itself most powerfully when multiple voices come together in larger-scale protests like boycotts or marches. Group protest actions unite people, and they display and reinforce this unity. The unified voice can raise awareness and – assuming the power of the populace – can hope to spread its call to others in order to inspire further effective action.

We find that many protests consider themselves *grassroots* in that they give voice to an ordinary person, and that such a voice attracts others who wish to have a voice, too.

Branding

A *brand* is a name, design, symbol, or any other feature that identifies an entity or endeavor. You can consider a brand to be the idea or image people have in mind when they think about specific products, services, and activities, or an entity, in both a practical and emotional way. It is therefore not just the physical features that create a brand, but also the feelings and aspirations that people develop towards a brand. This combination of physical and emotional cues is triggered when exposed to the name, the logo, the visuals, or even the message communicated. [1]

Brand-*ing*, on the other hand, is the process of giving meaning to specific products, services, and activities, or an entity, by creating and shaping a *brand* in the public mind. It is a *strategy* designed to help people understand, quickly identify, and experience the brand, and in the fields of commerce and politics to choose one over another. The objective is to attract and retain support that is always aligned with what the brand advocates.

To that end, successful branding is based on the following.
- Definition: Purpose, values, promise
- Positioning: What is the difference? Where do you stand?
- Identity: Name, voice, visual identity
- Communications channels
- Sponsoring, partnerships, collaboration

Branding and Protest

We find that by using elements of branding to express a unifying message, protests can and do amplify their voices. We also find, however, that despite their utility and availability to all the common concepts of brands and branding evoke negative reactions, especially within protest movements. In the many interviews we conducted, an uneasiness about pairing the words *protest* and *branding* was always expressed. The term *branding* is very contentious within a protest movement, and the reason became clear. In the current communications landscape, global corporations represent the term *branding* and imply the notion of profit. Branding implies control: the manipulation of masses by establishment forces. It is the antithesis of a real human having a real voice, and is the enemy of specific efforts to protest against such control. "Grassroots protest is not something to be marketed and sold, with a set of images and memes. It would be irresponsible, even impossible, to try to homogenize us all under one symbol or slogan. With so many perspectives, cultures and aesthetics at risk, it's the sheer variety of our resistance that will express the breadth of our communities." [2]

If there are as many reasons to protest as there are people, collapsing multiple personal voices into a unity seems to be the major affront. Nevertheless, we found that protest movements are increasingly interested in manifesting a visual identity that can unify a group of people and deliver their messages in the clearest possible manner.

We recall that it is basic human nature for our social species to assemble into groups and then identify with the identity of that group. If we are from some small town in central Spain, we root for our high school team against the visiting team from Madrid, but we root for Real Madrid against Valencia, until we as Spanish root for any Spanish team against any from Italy, until we root

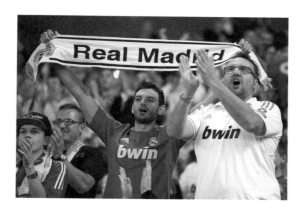

for any European country against the U.S. At each of these contests, group identity is confirmed with jerseys, chants, anthems, and signage. We seek group membership, and we seek identifiers, symbols, and others means to unify the idea of the group and give it a face. People in groups like fraternities even mark their body (including by literal branding!) to identify themselves as affiliates. It is simply in our nature to define social groups, to give form to the group identity, and then to adopt that identity within our person. This is branding in broad strokes.

Interpreting the term *branding* broadly allows us to look at discreet aspects of the traditional understanding of the term and to evaluate their presence within successful protest movements. We found several specific tools that have been put to use, intentionally or not, and observed how they have influenced the way protest may be conducted successfully.

Branding tools categorized

For *Branded Protest*, we researched different branding tools, the particular styles of protest, and the strategic locations for protest that have found success. When we cross-referenced any branding techniques that worked for a single protest, we discovered some commonalities among movements, and between the seemingly incompatible terms *branding* and *protest*. This overlap yields several examples of specific branding tools and how protest movements can

utilize one or more of them to support their causes. We identify four categories of tools: Body, Symbol, Cover, and Message.

Body

It is the ultimate simplicity. The body itself is a form of protest. By just showing up, a person can cast their individual vote of support for a demonstration. Furthermore, the body can stylize a protest. A specific body gesture can become the trademark for a movement. References go from black power salutes to the arms-crossed gestures of the Yellow Umbrella protests in Hong Kong, and those demonstrated by the Rabia movement.

Symbol

Part of effective branding is the use of iconic symbols that carry the protest message in unique and recognizable ways. Fun, awkward, or specific, these symbols give a protest a special vernacular for insiders and outsiders to connect with. By adopting the symbol, people understand they are becoming a part of the same group. The symbol constitutes a "uniform" for the message. The yellow umbrella in Hong Kong's Umbrella Movement or the pink pussyhats in the Women's March are specific and memorable examples.

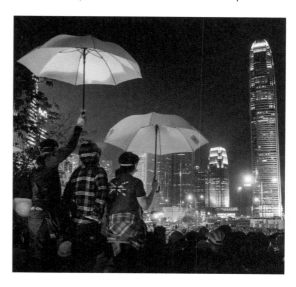

Cover

Wearing a mask is not just about covering up, but about being seen. The argument for hiding your face in public demonstrates a rejection of traditional representative or party politics. Everyone – regardless of his or her identity – is able to participate in consensus decision-making. This is central to some protests, and brings with it a rejection of hierarchy and authoritarianism. Hiding your face in public means that no one can distinguish who is in charge – because no one is; because everyone is. To demonstrate this, we examine the movements of Anonymous and Pussy Riot.

Message

If a picture is worth a thousand words, what is the value of a short phrase? We demonstrate with *Je suis Charlie* how three words (translated: "I am Charlie") can mobilize the world within hours. Similarly, chants can iconize a movement and give protesters support when they need it most. Black Lives Matter and the Umbrella Movement reveal such branding.

During our research, we also focused on three of the best-known global protest organizations operating over the past ten years – Amnesty, Greenpeace, and PETA – as well as Extinction Rebellion, the Arab Spring movements, Brexit and the March for Science, to show how their cases exemplify branding being used effectively to create unity in their messages.

If branding and protest as described in the classical understanding are in conflict, yet coexist, something is missing in that classical understanding. Can we defy branding as we know it and ultimately redefine it? For our discourse we have used *branding* as a broad term to visualize iconic protests that have used unique tools to attract and activate the general public. Our definition of branding is, the visual unification that makes a message distinct. Branding in protest gives voices a visual and verbal form with which to identify.

Branding is a most human exercise and among the basic structures of civilization and culture. Applying the right branding tools to a protest will enable it to influence public opinion, provoke debate, and drive activism. Combining the new, broader interpretation of branding with a protest as *branded protest*, movements can masterfully and creatively draw on contemporary messages and symbols, subverting and transforming them to engender new aesthetics and meanings, and thereby open up a space that eludes control. And by entering this open space of branding concepts, protests can avail themselves of social, cultural, historical, sociological, and political perspectives as well as approaches that draw on visual theory, popular culture, and cultural studies in order to better identify themselves with expressive signs and symbols.

And they would be well to do so. The sphere of social media, which demands short, concise, and punchy messaging, has become the communication platform for society at large, and therefore for social justice. It instantly disperses messages to individuals, the number of whom is boundless. But that demand to be short, concise, and punchy requires messages to be exceptionally well-designed. A tweet informs the person dedicated to the cause what she should write on

her cardboard sign, but also reaches public policy makers in favor of, ambivalent to, or suspicious of the cause. The message has to be immediately meaningful and clear to a variety of audiences. Otherwise it will be passed over for the next message pinging its way out of the purse or pocket.

However, this study is not about social media. Although its ability to launch and organize a protest movement, and spread its message, is incredible, there is nothing more powerful in protest than the street protest, with growing numbers of people on the march. The energy of participating individually, of being part of a unified voice, is tangible only when in its presence. And nothing makes for a greater outreach image than people gathered in numbers in public, collected in expressing that their mission is more important to them than their everyday lives. For those numbers to become excited, to get on their feet, and to join in, they must identify with a well-Branded Protest.

Notes

1 "What is branding?" *The Branding Journal*, October, 2015, https://www.thebrandingjournal.com/2015/10/ what-is-branding-definition/
2 Sarah Schulman
"When Protest Movements became Brands," *The New York Times*, April 16, 2018, https://www.nytimes.com/2018/04 /16/t-magazine/1980s-protest-movements.html

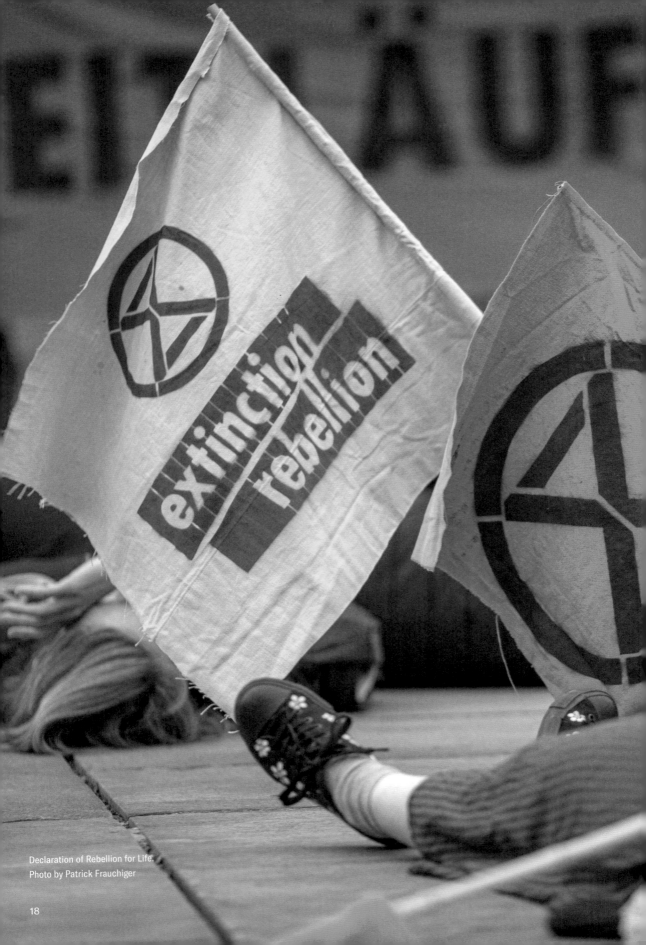

Declaration of Rebellion for Life.
Photo by Patrick Frauchiger

EXTINCTION REBELLION

Tell the Truth Act Now!

Extinction Rebellion is a radical political campaign group working to minimize ecological extinction and the effects of climate change.

Extinction Rebellion

Since it launched in 2018, the group has made headlines with its non-violent resistance techniques and avowed willingness to be arrested – and also for its striking graphics. The visual identity comes from the movement's Art Group, run remotely and out of London-based studio This Ain't Rock'n'Roll (identity + activism for culture + causes). We talked with Art Group co-founders Clare Farrell, Clive Russell, Charlie Waterhouse and Miles Glyn.

Are you all involved in the organization, are you all activists?

Charlie Well, the four of us were already working together before Extinction Rebellion. I think that's quite key to understanding our involvement; that our own relationship is quite deep, and goes quite a way beyond just XR.

Clare I'd started to work with Roger Hallam, who's one of the founding researchers behind Extinction Rebellion. He's worked a lot on the tactics and the methodology. I was working with him on an air pollution campaign, blocking major roads in London. This was in 2017. There were only 10 or 15 of us. We were tiny. And because we needed some banners designed, and we all were already friends and working together, I said: let's do some banners. And so we did the visual identity.

Clive Actually, it was much worse than that. I was basically coerced into attending a road block (laughs). Which was great actually. It's amazingly liberating to be placed in a position that you ordinarily wouldn't want to be in. And it was very clear from that point on that in order to block a road successfully we needed a graphic representation of what we were doing. So that was the beginning of the initial identity, the beginning of Extinction Rebellion.

How do you see the Extinction Rebellion movement in the context of other eco movements like Greenpeace, WWF or Connect4Climate? In what way is Extinction Rebellion different?

Clare Well, I'm not sure if you know this, but one of our first actions was to occupy Greenpeace. The thing is that a lot of the NGO's have staff, they have obligations, and lots of them are gagged by the charity laws in the U.K. So they can't do certain things. Very few of them have come anywhere close to even condoning what we've done.

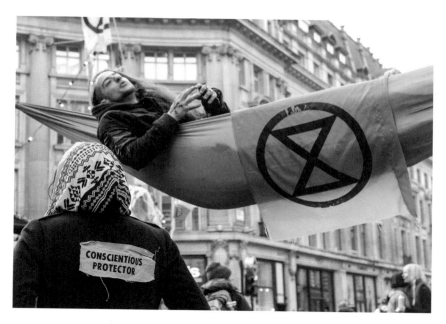

Left
Extinction Rebellion protesters in Parliament Square. London, April 15, 2019.
Photo by Kevin Grieve/Flickr
Center
Extinction Rebellion protesters in Parliament Square hold a funeral for biodiversity loss due to climate change. London, April 15, 2019.
Photo by Ben Gingel/ Shutterstock
Bottom
Extinction Rebellion protesters with banners and placards in Parliament Square. London, April 23, 2019
Photo by Ink Drop/Shutterstock

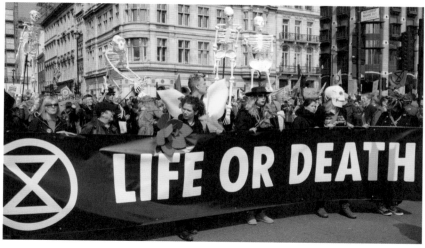

The Extinction Symbol was designed in 2011 by street artist ESP, who loans XR usage on the same basis.
Created by ESP in 2011
extinctionsymbol.info

> ## "It was very clear from that point on that in order to block a road successfully we needed a graphic representation of what we were doing."

Clive Russell, Co-Founder of This Ain't Rock 'n' Roll

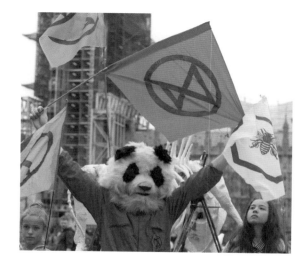

"You know when this all goes to shit, that's all that's going to be left. And it might be a bird skull or a human skull, but it's pretty much the same thing."

Charlie Waterhouse, Co-Founder of This Ain't Rock 'n' Roll

The other big difference is to not trade on hope, which is what they all have done and what we have not done. In "The Talk," and in a lot of our messaging we say, "Hope dies, action begins." We're saying: grieve, be sad – because it is fucking sad, we're fucked. We have a banner that says, "We're fucked" that is 50 meters (99 feet) long. That's a big difference.

Charlie And I would say, anecdotally, that I've come across loads of people who really engage with this approach, because it taps into something that people are already feeling. People have been worrying about this for years, but there's no outlet, there's no acceptance. There is a process that you need to go through that is like the stages of grief. One of those stages is denial, and then you tap into those other things like anger, and then getting on with it. You need to do all that before you can then decide that you're going to make some of the changes that everybody needs to make. So we are very human. We tap into people's inner truth.

So you're all part of the organization and also part of the graphic design branding for the organization. How does branding help to achieve the mission and goals around global environmental issues?

Charlie I think what's happened with the branding and the key messaging is that it's reflecting the truth. From the very beginning, we closely linked what we designed and what we wrote to the strategic plan for the movement. It's a confrontational approach; there's skulls and bones and things like that. It boils everyone's differences down to a core universal truth. You know, when this all goes to shit, that's all that's going to be left. And it might be a bird skull or a human skull, but it's pretty much the same thing.

So all the work that we've done has been closely aligned to the principles – tell the truth, act now and the demand about citizens' assemblies. And on that level, it is a really well done strategic job, totally aligned with the values of the organization and pretty rigid in that sense.

We knew that we would need to engage with a lot of different people. People who are long term activists or campaigners who think they know the right way to do it; people who are first-time activists, who've never done anything like this before. All these

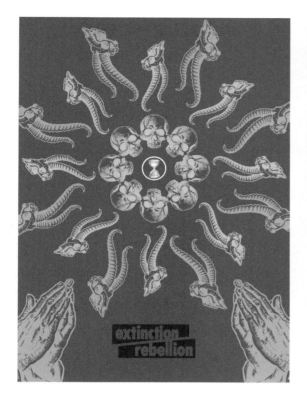
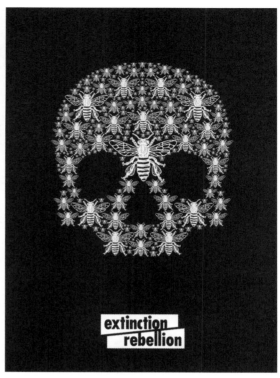
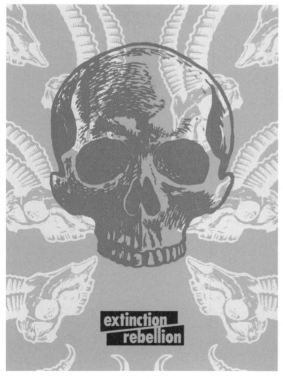
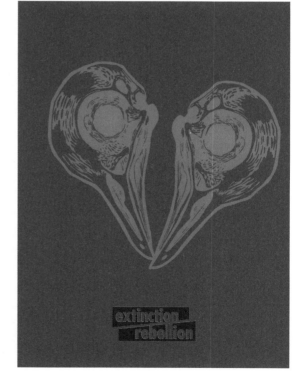

Ready made artwork free to download from
the Extinction Rebellion website.

INTERNATIONAL REBELLION

AGAINST THE CRIMINAL INACTION ON THE CLIMATE AND ECOLOGICAL CRISIS

11AM / 15 APRIL PARLIAMENT SQUARE

extinction
rebellion

Search Extinction Rebellion / Follow us on social media for updates and events

WE'RE SORRY

CHANGE OR DIE

"It's the idea that you see us at the end of the street and you don't know what we're protesting about, but you think, "Whatever it is they're into, they look really cool.""

Charlie Waterhouse, Co-Founder of This Ain't Rock 'n Roll

disparate people would come to the actions and join us. Some people look like hippies and some people look like suits. Some people would be old, young, et cetera. And as the movement grows it gets even more diversified, so that the identity at the heart has to hold a really important space.

That's why you see, when people are being arrested there will be placards in the background that say, "Non violent." When it was reported on the BBC News for the first time, one of the images they chose was a big pink placard that says, "Tell the truth." We know that this branding has to work even harder here than for most things, because of all the differences that we are wanting to accept and be open minded about.

The Extinction symbol, or 'sandtimer logo' as it's sometimes called, already existed prior to Extinction Rebellion, right? When was the logo first used and with what intent. How did that process work?

Clive The symbol is free to use non-commercially. It was created by street artist ESP in 2011. ESP remains anonymous because he doesn't want the symbol to become associated with a person. This anonymity keeps the mark pure; a thing in its own right.

Charlie As commercial designers, we're always encouraged to associate benefits to features. And Extinction is the opposite of the benefit to the feature, you know? And then the Rebellion is the call to action. It's giving people something to do. We needed to make sure that this wasn't just another climate movement or just another ecological movement. We needed to describe the issue in its totality: that it is a climate and an ecological crisis. Extinction as the end.

Clare Rebellion is a technical term, really. It is a rebellion.

Where did you get the inspiration for the the specific branding tools; use of color, illustration and type? Were there other movements that served as examples?

Charlie In its actual manifestation, we drew a lot of inspiration from Paris '68. That has also carried through into the workshops that we've done. Miles in particular does a street printing workshop that allows people to alter their clothing in order to be dressed for protest.

Clare Miles and I did this project called Bodypolitic, where we were thinking about things to put on clothes and we started painting and writing on jackets. We started investigating icons, thinking about how we visually represent things, without words – because you need to communicate in protests and it's always words, words, words. So we looked into symbols and icons, and that's when we found the extinction symbol. And I think that the flags, because they're not text-based, really speak to people.

Charlie Also, the deliberate use of a retro feeling. The font itself that we designed – it's taken from a wood block type that's a sort of bastardized version of Futura. We've altered it to try and create the visual inking that you would get if you were to print it. Softening the edges, that sort of stuff, to give it that "Where is this from?" sort of feeling. "Where do I place this? Is this something old? Is this something new?" You know? And then we added a color scheme that introduces an intersectional nature to it.

We also use a second font, called Crimson. It is actually a Google font, so that people can easily load it onto their computers at home. The point is to have minimal entry. To be able to look XR, all you have to do is print a statement in that headline font, which is only available in caps – and this is deliberate, to say, EMERGENCY! – and it immediately sounds and looks like XR. So what we've done is distribute that. It's freely available through the Extinction Rebellion site. Anyone can use it and grab templates from the website. I think it works really quite well so far; some places better than others. Some countries, for instance, have done a very good job of adapting it. And then other people, they struggle a bit more, but that's kind of cool too. What people have been able to embrace is the messaging and the use of the symbol. And so there's quite a low barrier to entry for these things. We've kept it as simple as possible, in the hope that at least you will get the symbol with the color, or the type with the color. There's been a quite a lot of customization with the symbol. Scotland has a white timer on a blue background, so it's like the Scottish flag. Chicago has five red dots across a light blue background to reflect the symbol for Chicago. It's proving quite robust and resilient at the moment, which is good.

After the name "Extinction Rebellion" was coined, what was the reason for creating a visual voice? Why not just stick with the slogan?

Clive To be an umbrella movement, you can't have complete discord on messaging. But also, we needed to leave room for other designers to interpret the space in their own way. By having a set color space, a set of fonts and a descriptive logo, we're able to

"The link between art and culture and stunts, and between what we do in the art group and what happens in the actions is really important. So we didn't just take Waterloo Bridge the other week, we turned it into a garden bridge. We didn't just occupy Oxford Circus, there was a pink boat that came through."

Charlie Waterhouse, Co-Founder of This Ain't Rock 'n Roll

THE TRUTH

Extinction Rebellion block Oxford Circus in
central London with a pink boat named
Bertha Caceres.

allow other elements to shift. In our version we deployed Miles' brilliant block prints. It helps us look like a peaceful army, marching with a unified purpose.

Charlie It's the idea that you might see us at the end of the street and you don't know what we're protesting about, but you think, "Whatever it is they're into, they look really cool. I'm going to go and find out." And I think that there's a lot of people who have come into the movement saying, "I saw how you looked. And it looked really different, it looked new." That's the attraction.

The link between art and culture and stunts, and between what we do in the art group and what happens in the actions, is really important. So we didn't just take Waterloo Bridge the other week, we turned it into a garden bridge. We didn't just occupy Oxford Circus, there was a pink boat that came through. So we feel like an organization that obviously has a serious purpose, but there is also a collective joy as well, even in the face of grief, and that really resonates with people. Art and branding is a way to hold that all together.

Clive Yeah, it often sends a chill down the spine when you see a group of XR people coming towards you down the street. It's happened to me several times, standing at the other end of the street. You're just struck by how unified, how together it feels.

Do you see graphic design as political?

Clive Milton Glaser said something interesting about that, that if you're designing a fizzy pop label, then you probably need to look really hard into your soul, because you know it's dark. It's about the responsibility of the designer – you're in a rarified space and you can have a larger impact on people's lives than you realize. I think the whole design community needs to come to terms with that and take on the responsibility for all of our outputs. People need to grow a spine.

Clare If you're movement building, it's about working deeply with people and opening that space to tell the truth. But also, leaving some room for people to be themselves. Because the truth is really big and complex and really bad. So you can say whatever the fuck you want. You're telling the truth if you say you're worried about the bees. And you're telling the truth if you say you're worried about your own children. You're telling the truth if you're talking about extreme weather events in Africa. You know, there's so much to it, it's open rather than reductive, it's not like, "this is about this, and here's all the rules."

Charlie These guys might beg to differ, but for me it's a very anarchist approach. Because it places the responsibility on the individual in a way that it hasn't been done before. The environmental movement has often said, "Oh, recycle more," or,

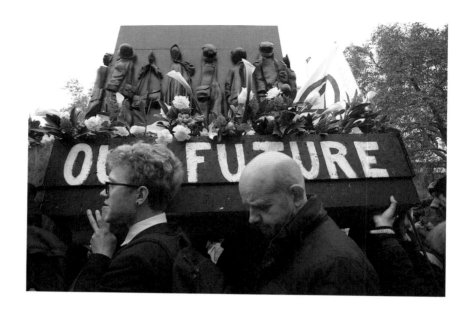

Extinction Rebellion funeral march through London. London, November 24, 2018. Photo by Rupert Rivett/ Shutterstock

"Buy your food more ethically," or those sorts of things. And so the system says, "We can't change, but you can change as an individual." But does that really make you feel empowered? By giving people the space to find their own truth, a totally empowering thing, that actually leads to action rather than just tinkering around the edges, "make sure you sort your recycling," get a pat on the head, business as usual. For me, it's fundamental, and more spiritual, really.

How important is social media in your work? Do you see social media as changing the grassroots of organizing?

Clare Personally, I think what we've done has actually hinged on not needing social media in a huge way. We use means like face-to-face talking, giving a talk, personally asking people to sign up, offering training. I don't think we acquire hardcore activists through social media reach.

I think that's how we get publicity sometimes. I think in terms of organizing, some of these platforms are somewhat useful. But they're also very annoying, right? There's too many of them, it's complicated, some people don't use certain ones. There are a lot of people in the movement that would rather social media wasn't there, as it is quite a toxic space. Some people have said, "You're on Facebook, don't you think that's unethical?" And yeah, I do. To be honest, I think we just use it because it's there.

Charlie In the actions, it is about that personal connection. It's pretty logical, really that people are involved in printing things or making things, or even just realizing that there are other people that actually exist. Social media is heralded for being absolutely brilliant at putting you in connection with people that share your interests. But when you're doing that through a screen, it's nowhere near as good as doing it in an action.

The movement is young, and founded in Britain. What is XR's international reach, has it travelled to other countries, to other cultures?

Charlie We're very conscious of the privileged position that we're in. People have been calling us out for doing things that would be very dangerous in different countries. But some of the things we've done are being replicated. Our second rebellion day was a funeral march,and that has happened in countries around the world. We've seen bridges being taken in Australia, in New York, in Berlin. Now we're going to write a design program, which will introduce some of our working practices. It is a massive undertaking.

Clare Someone shares the principles and values with new groups and the international support team is there to offer advice or resources if needed. And then it's: off you go, do what you want! Now that we've got a bigger movement, it's becoming important that the relationships need to exist in a real way between us and those in other countries and continents. We recently had the first international art coordinators, video call, just to meet and share thoughts. For some groups, they will begin with just artwork, because they're at such a great risk if they undertake protests on the streets where they live. This presents a new opportunity for creative collaboration across borders, which I'm excited to see unfold.

Do you feel there is some sort of political response to the movement? That the political system is waking up to your message?

Clare Politics knows really well how to absorb protest movements. We're working with in a very sophisticated neoliberal system. It's important that we hold fast to real change, and it's hard to hold on while the political space keeps going, "Oh, actually we agree with you, you are right." Or, "Oh, I love them, they're great." That's cool, but shit has got to change.

Charlie It says a lot about the current system's lack of ability to change that what we've done has been so widely liked, because we haven't achieved anything in concrete, practical, political, economic terms. But we have achieved the concept of telling the truth. And we've seen a shift in the way environmental issues are being reported. It's only a start, but we have achieved that, and that is fundamental.

XR Art Group is a continously growing collective
made up of individual designers and artists.
They share their do-it-together ethos to inspire
change through action.

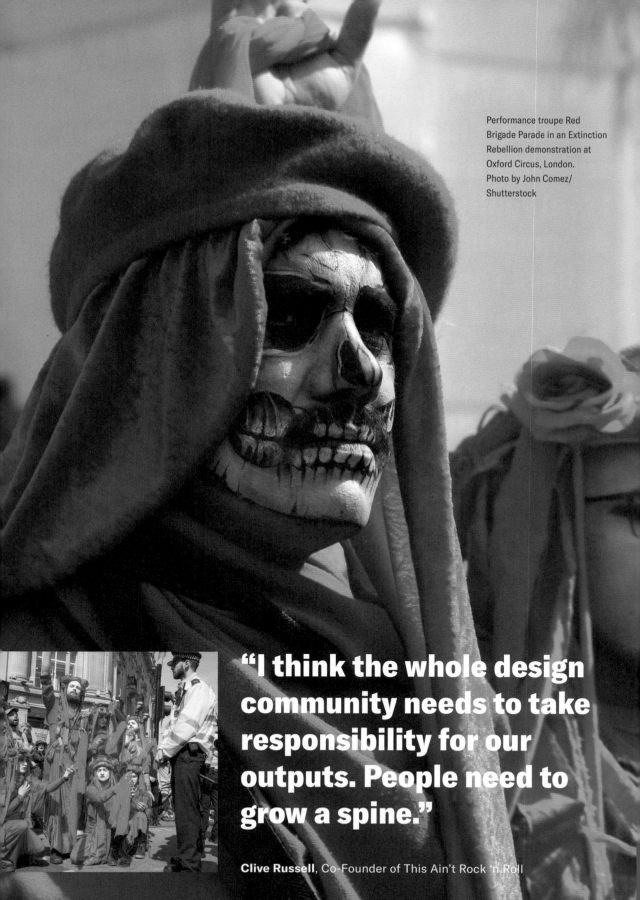

Performance troupe Red
Brigade Parade in an Extinction
Rebellion demonstration at
Oxford Circus, London.
Photo by John Comez/
Shutterstock

"I think the whole design
community needs to take
responsibility for our
outputs. People need to
grow a spine."

Clive Russell, Co-Founder of This Ain't Rock 'n Roll

"Early on, I discovered that when I'm wearing a mask I feel a little bit like a superhero and maybe feel more power. I feel really brave, I believe that I can do anything and everything, and I believe that I can change the situation. We played at being superheroes, Bat-woman or Spider-Woman, who arrive to save our country from the villain, but we were choking on laughter looking at ourselves: a fur hat pissed on by a cat with narrow slits for eyes, a nonworking guitar, and for the audio system a homemade battery that leaks acid. When I put on the balaclava – that fantastic sensation when I did my first performance – I understood that happiness could be this, among other things..."

Nadezhda Tolokonnikova, Pussy Riot Member
Read and Riot, 2018

The Masked Performance of Pussy Riot

"Wearing a mask isn't just about covering up, but about being seen."

Bane, *The Dark Knight Rises*

Behind the Balaclavas

Sometimes a mask can become the face of power. While some may argue that the women of Pussy Riot are hiding behind their balaclavas and risking invisibility or irrelevance, the media attention they have garnered through their performative anonymity demonstrates their reach on a global level. Within this, the group's collective anonymity fosters a collaborative decision-making that rejects hierarchy and authoritarianism. Because every member of the group is counted equally, Pussy Riot cannot be said to only be Maria "Masha" Alyokhina, Nadezhda "Nadya" Tolokonnikova and Yekaterina Samutsevich; the three women who were prosecuted after their anti-Vladimir Putin performance of "Virgin Mary, Mother of God, banish Putin" (also known as "Punk Prayer") at the altar of Moscow's Cathedral of Christ the Saviour in 2012. These three women are Pussy Riot, but so are the anonymous members who have since chosen to distance themselves from them. Pussy Riot belongs to no one and everyone at the same time. This raises certain questions: Is anyone who wears the band's accessory of choice, the balaclava, a member? Is Pussy Riot a band? A collective? An idea?

Founded in August 2011, the Russian feminist punk rock protest group has experienced a variable membership of nearly a dozen women ranging in age from 20 to 33. The group became known for their provocative guerrilla performances in public places. These performances were filmed and then posted on the internet. The collective's lyrics span themes of feminism, LGBTQIA+ rights, global prison conditions, anti-capitalism and opposition to Russian President Vladimir Putin's authoritarian rule and close ties of the Eastern Orthodox Church.

"We just didn't want to be taken or terrorists in black balaclavas. We didn't want to scare people but wanted to bring some fun, so we decided to look like clowns."

Nadezhda Tolokonnikova, Pussy Riot Member

This spread
Pussy Riot, Moscow,
January 20, 2012
Photos by Denis Bochkarev [1]

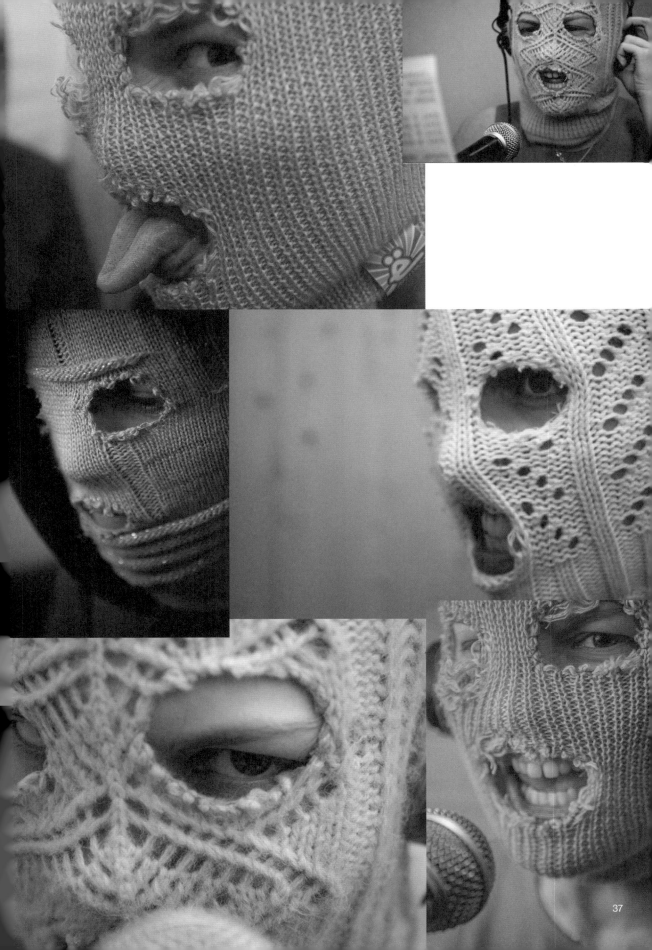

The group speaks out against failings of the state, including corruption and censorship, and has released politically charged songs such as "I Can't Breathe," dedicated to Eric Garner, a victim of police brutality in New York City; "Make America Great Again," a song in protest of U.S. President Donald Trump, and the more recent anti-Putin song "Elections."

Punk Rock and the Knitted Balaclava

The Pussy Riot members' anonymity contrasts against their readily identifiable visual style. Eschewing the less colorful, traditional punk garb of leather and studs, the group's members have chosen instead to hide their identities under bright colors. When the group stages their performances, they dress in multicolored knitted balaclavas paired with neon-colored tights and minidresses in hues such as hot red, faded pink, baby blue and forest green.

Why the bright colors? "It was a really dumb reason; we just didn't want to be taken for terrorists in black balaclavas. We didn't want to scare people but wanted to bring some fun, so we decided to look like clowns," Tolokonnikova explains.

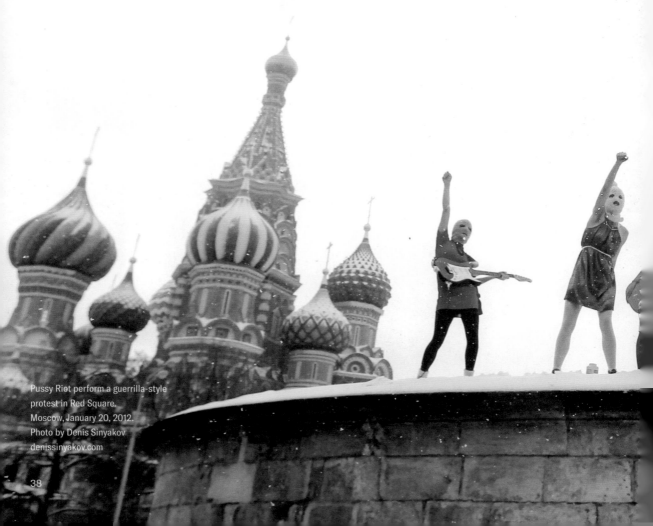

Pussy Riot perform a guerrilla-style protest in Red Square. Moscow, January 20, 2012. Photo by Denis Sinyakov denissinyakov.com

Self-conscious self-presentation is key to Pussy Riot's message. The band screams its lyrics in Russian, most of it impossible to decipher above the cacophony of drums and shrieking guitars. Flailing their arms and legs with rage and frustration, the women's anger needs no translation. Their bright, eye-catching outfits clash with their rants against oppression and censorship, as if to beckon their audiences from the depths where corruption and authoritarianism thrive in the first place. Their colorful balaclavas – thought to be of Russian origin and traditionally worn by soldiers – simultaneously bring to mind both danger and absurdity.

Through unsanctioned concerts, performances, publications, interviews, speeches, clothing, drawings, posters and music videos, Pussy Riot is constantly changing the medium and method through which their message is broadcast, in a manner that represents a diversification of art protest in action.

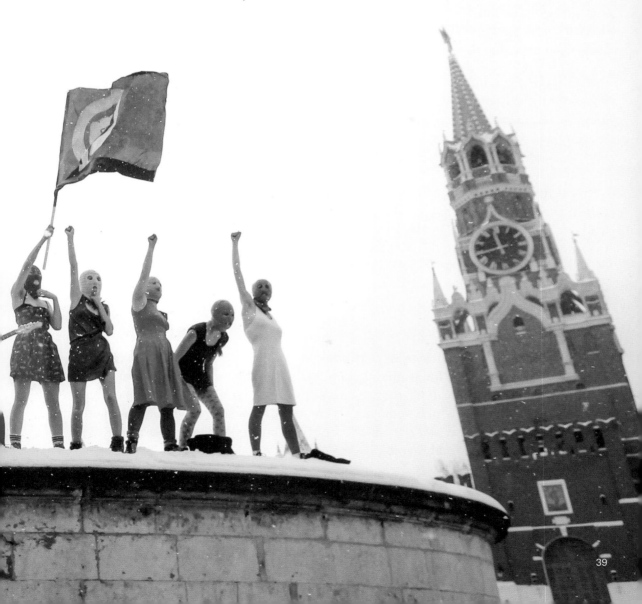

Create a Riot

Carrying on the legacy, Pussy Riot is influenced by the Riot Grrrl movement of the 1990s that merged punk music, feminism and activism to give young women an outlet to vent their frustrations within the era's male-dominated indie music scene. Like the Guerrilla Girls, who formed in 1985 and paired stylish attire with fishnets and gorilla masks at public appearances to "confound stereotypes of female sexiness" in their attempts to showcase the dearth of representation of female artists in some of the world's largest museums. Replicating this mode of anonymity, Pussy Riot members wear the balaclava to simultaneously provide protection against recognition and to suggest that what matters most is their message.

A primary effect of the mask is the evasion of binary distinctions. As the evolution of the feminist movement progresses, a shift in recognition continues. No longer acknowledging the singular "one," or the anonymous "many," the movement chose the descriptor of "anyone." Taking a radical stand in favor of de-personalization, the mask sends the message that the individual can be anyone.

Unlike the many bands that formed the core of the Riot Grrrls movement, however, Pussy Riot does not hold sanctioned concerts, opting instead to make illegal and unannounced appearances in public spaces. This strategy is similar to that of the direct "actionist" style of the Russian street-art group Voina, of which Tolokonnikova and Samutsevich were members prior to forming Pussy Riot.

Cut-ups

Cut-ups, a method of collaging words rather than images described in detail by the Dadaist Tristan Tzara in *On Feeble Love and Bitter Love. Dada Manifesto* (1920), is a favorite medium for Pussy Riot. "When we decided to start a band, we hated the idea of writing poetry. Coming from a conceptual art background we were suspicious about poetry, but we still had to create lyrics for our songs. We ended up composing our lyrics from quotes of our favorite philosophers and media headlines."

Punk Prayer

In mid-January of 2012, Pussy Riot performed one of their guerrilla-style happening in Moscow's Red Square, followed one month later, by the renegade performance of the band's "Punk Prayer" in Moscow's Cathedral of Christ the Saviour on February 21, 2012. Wearing their colorful balaclavas, tights and dresses, five members walked into the cathedral, addressed Mary, the mother of God, and asked her to liberate Russia from Putin and "become a feminist."

The members were arrested after the 40-second "Punk Prayer" musical performance, and a lengthy court case and global media coverage followed. Resembling an absurd theatrical setting – contrary to its purpose – the trial only furthered the exposure of

Панк Молитва

[Chorus]
Богородица, Дево, Путина прогони
Путина прогони, Путина прогони
[End chorus]

Черная ряса, золотые погоны
Все прихожане ползут на поклоны
Призрак свободы на небесах
Гей-прайд отправлен в Сибирь в кандалах

Глава КГБ, их главный святой
Ведет протестующих в СИЗО под конвой
Чтобы Святейшего не оскорбить
Женщинам нужно рожать и любить

Срань, срань, срань Господня
Срань, срань, срань Господня

[Chorus]
Богородица, Дево, стань феминисткой
Стань феминисткой, феминисткой стань
[End chorus]

Церковная хвала прогнивших воджей
Крестный ход из черных лимузинов
В школу к тебе собирается проповедник
Иди на урок - принеси ему денег!

Патриарх Гундяй верит в Путина
Лучше бы в Бога, сука, верил
Пояс девы не заменит митингов -
На протестах с нами Приснодева Мария!

[Chorus]
Богородица, Дево, Путина прогони
Путина прогони, Путина прогони
[End chorus]

Punk Prayer

[Chorus]
Virgin Mary, Mother of God, banish Putin
Banish Putin, Banish Putin!
[End chorus]

Congregations kneel
Black robes brag, golden epaulettes
Freedom's phantom's gone to heaven
Gay Pride's chained and in detention

The head of the KGB, their chief saint
Leads protesters to prison under escort
Don't upset His Saintship, ladies
Stick to making love and babies

Crap, crap, this godliness crap!
Crap, crap, this holiness crap!

[Chorus]
Virgin Mary, Mother of God
Become a feminist, we pray thee
Become a feminist, we pray thee
[End chorus]

Bless our festering bastard-boss
Let black cars parade the Cross
The Missionary's in class for cash
Meet him there, and pay his stash

Patriarch Gundyaev believes in Putin
Better believe in God, you vermin!
Fight for rights, forget the rite –
Join our protest, Holy Virgin

[Chorus]
Virgin Mary, Mother of God,
banish Putin, banish Putin
Virgin Mary, Mother of God,
we pray thee, banish him!
[End chorus]

On Faciality

"The face is very interesting and an unusual aspect of our body that has been given all sorts of cultural, artistic and social significance. It has a political role too.

Faciality – the visualization of power as framed by a recognizable face – fulfills the function of re-territorialization of the subject. Public faces accomplish the branding of the self as the private property of the bounded individual, so as to make it recognizable, consumable and profitable. A face distributes power across a territory it creates and controls; it engenders individual and collective identities as brands, which can be said to be recognizable to the degree to which they approximate that face, that image of power. "

Rosi Braidotti elaborating on "Faciality" by Gilles Deleuze and Félix Guattari, (1977; 1987) [2]

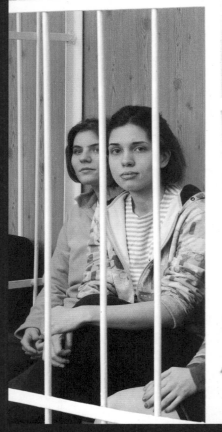

Top
Yekaterina Samutsevich (L), Nadezhda Tolokonnikova (C), and Maria Alyokhina (R), during a court hearing in Moscow on July 20, 2012.
Photo by Natalia Kolesnikova/AFP/GettyImages
Opposite
Maria Alyokhina and Nadezhda Tolokonnikova at the Tagansky District Court. Moscow, June 20, 2012.
Photos by Denis Bochkarev [1], CC BY-SA 3.0
Bottom
Maria Alyokhina and Nadezhda Tolokonnikova of Pussy Riot attend the Bringing Human Rights Home concert in New York, February 5, 2014.
Photo by JStone/Shutterstock

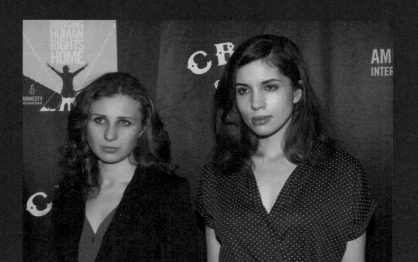

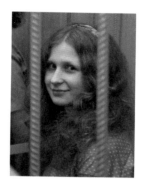

the Pussy Riot brand, and the group was eventually recognized within world-wide discourse. The three women removed their balaclavas and mastered the skill of controlling the proceedings in what amounted to yet another Pussy Riot performance. While Alyokhina, Tolokonnikova and Samutsevich defended their actions from a glass cage inside the courtroom, free Pussy Riot members planned new guerilla performances and spurred solidarity protests across the globe. Following the bizarre and intricate twists of the trial, the three women were found guilty of "hooliganism motivated by religious hatred" and sentenced to prison. The entire world watched, elevating Pussy Riot to the status of modern-day icons.

During their time in prison, each member resisted the authoritarian system using individual creative resources. Alyokhina focused on law and procedure and became a jailhouse lawyer. She initiated and filed numerous complaints on behalf of herself and other inmates, and was even able to win some of these fights in court.

Tolokonnikova chose to interact with the media to generate international attention. Over time, she perfected the art of using her court hearings to her advantage, performing politicized statements publicly. By the summer of 2013 she had grown increasingly desperate and went on a hunger strike that resulted in hospitalization.

After the last members were released on December 23, 2013, Alyokhina and Tolokonnikova took part in a global tour to denounce the conditions of prisons around the world.

Ideas Matter: Art As a Transformative Tool

The balaclava – the iconic Pussy Riot symbol – de-individualizes its wearers for the sake of the collective's mission: pure protest. Symbols and protest replace the individual. As a participant who was quoted in a 2014 article by Masha Gessen in *The Guardian* stated, "Being Pussy Riot is like being Batman: you put on the mask – and you become Pussy Riot. You take it off – and you are no longer Pussy Riot."

In a letter of support for the group, the philosopher Slavoj Žižek wrote, "Their message is: ideas matter. They are conceptual artists in the noblest sense of the word: artists who embody an Idea. This is why they wear balaclavas: masks of de-individualization, of liberating anonymity. The message of their balaclavas is that it doesn't matter which of them are arrested – they're not individuals, they're an Idea. And this is why they are such a threat: it is easy to imprison individuals, but try to imprison an idea!"

After the "Punk Prayer" performance, the three "main" members of Pussy Riot received a disproportionate amount of media attention. During the trial process they had to reveal their identities, surrendering the essence of the group's anonymity. Even after her forced departure from the collective in 2014, Tolokonnikova is still often cast as the "face" of the band – a clear indicator that she has eclipsed her other comrades as well as Pussy Riot's collectivism and anonymity. The media has thus disseminated an image of Pussy Riot that deeply contradicts the values of the collective.

An important reason why Pussy Riot's case attracted astounding public attention and support was art. Reaching beyond existing boundaries, art addresses the unexplainable. Specifically, protest art has the potential to be a driving force behind an activist movement becoming a global human movement.

The Political Message and Philosophy

French philosopher Gilles Deleuze once said that philosophy is "engaged in a 'guerrilla campaign' against public opinion and other powers that be such as religions and laws," which also happens to be an apt description in line with the actions of Pussy Riot. Unsurprisingly, the three most vocal members of Pussy Riot have studied philosophy, journalism and photography, and no doubt have been influenced by the work of such cultural figures. Influences include the feminist intellectual Simone de Beauvoir, radical feminists Andrea Dworkin and Shilamuth Firestone, suffragist Emmeline Pankhurst, feminist theoretician Rosi Braidotti, feminist academic Judith Butler and Marxist revolutionary Alexandra Kollontai.

Adopting a libertarian stance, Pussy Riot fights to define true freedom in the face of authoritarian oppression. Since the band operates under anti-hierarchy principles and rejects many of the traditional methods of other political groups, it is the band's songs, such as "Death to Prison" and "Raze the Pavement," that function as manifestos. In "Raze the Pavement," for example, they appeal for "a Tahrir on the Red Square," calling for both revolt and internationalism, not unlike the message of the song "Putin Has Pissed Himself." These songs are not mere performances; they are calls to action.

The anti-capitalist stance of Pussy Riot is lesser known. The band notably rejects its own commercialization and refuses to hold for-profit concerts. In fact, after Tolokonnikova and Alyokhina appeared as Pussy Riot with Madonna and others for an Amnesty International benefit concert on May 2, 2014, the two members were ousted from the group. In an open letter, the anonymous members of Pussy Riot stated that selling tickets "is highly contradictory to the principles of Pussy Riot'" and that they "never accept money for [their] performances."

Making Headlines

During the 2018 FIFA World Cup, Pussy Riot once again achieved global attention. This time, dressed as Russian police officers, the four activists – Veronika "Nika" Nikulshina, Olga Kuracheva, Olga Pakhtusova and Petya Verzilov – stormed the stadium field and disrupted the final match between Croatia and France in protest of Russia's political and prison systems.

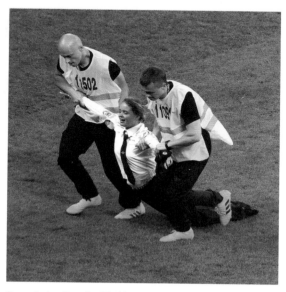

Stewards drag Veronika Nikulshina off the field during the 2018 FIFA World Cup Final between France and Croatia. Moscow, July 15, 2018. Photo by Alizada Studios/Shutterstock

They were dragged off the field, arrested, sentenced to 15 days in jail and barred from attending Russian sporting events for the following three years.

Titled "Policeman Enters the Game," the World Cup protest had an additional purpose: to commemorate the death of Russian poet Dmitri Prigov, the writer who created the image of an "ideal" policeman, which Pussy Riot terms the "Heavenly Policeman." The protest also coincided with the release of the music video for Pussy Riot's song "Track About Good Cop."

Ongoing encounters with the state keep Pussy Riot in the headlines and the unexplained arrest of its members common.

An Activist Clothing Line

Clothing has a long tradition in political protest. Take, for example, designer Katharine Hamnett's T-shirt proclaiming "58% Don't Want Pershing" – a reference to polls showing the proportion of the U.K. public who opposed Margaret Thatcher's policy of stationing U.S. nuclear missiles on British soil. Hamnett wore one of these shirts when she publicly met the prime minister in 1984.

Another example is the now-iconic "Silence = Death" T-shirts worn by members of the AIDS group ACT UP. The logo was designed by artist and activist Avram Finkelstein, who appropriated the pink triangle used by the Nazis to identify homosexuals for the purpose of protesting the U.S. government and public complacency regarding the AIDS crisis in the 1980s.

In a similar vein, galvanized by Russia's burgeoning, youth-powered political activism, Pussy Riot and independent journalists founded the independent media outlet Mediazona in 2014 to report on criminal justice in Russia.

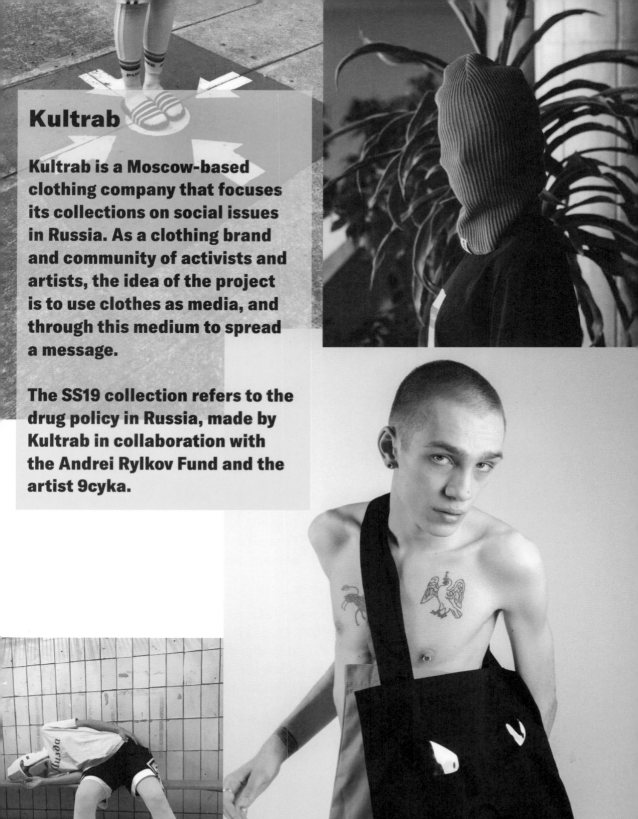

Kultrab

Kultrab is a Moscow-based clothing company that focuses its collections on social issues in Russia. As a clothing brand and community of activists and artists, the idea of the project is to use clothes as media, and through this medium to spread a message.

The SS19 collection refers to the drug policy in Russia, made by Kultrab in collaboration with the Andrei Rylkov Fund and the artist 9cyka.

The clothing collection "It Gonna Get Worse" was lunched at the end of 2017 by Kultrab as a part of a crowdfunding campaign for Mediazona. Named after Mediazona's editor in chief Sergey Smirnov's favorite phrase in response to a constant barrage of bad news, the proceeds will benefit Mediazona's activist journalism.

In spring 2018, Kultrab introduced the collection "Pussy Riot," seeking to support freedom of speech in Russia and the reporting efforts of Mediazona. The collaboration between Pussy Riot, Kultrab and 9cyka features patterned socks, T-shirts, sweatshirts, jackets, shopping bags and the group's infamous balaclavas in a wide array of vibrant colors.

"In the current political situation, where our country has no freedom of speech, clothing became an act of self-expression, a way of showing that we disagree."

Kultrab SS19 Collection
Right
Fluffy Jacket
Opposite page (large photo)
Balaclava Shopper Bag
Photos by Daria Globina
All other photos
"Pussy Riot" collection in collaboration
with Kultrab and 9cyka.
Photos by Aleksanrd Sofeev

Notes
1 Photos by © Denis Bochkarev, dennot.com
https://www.facebook.com/denfoto/media_set?set
=a.10150490162130863.367085.658025862&type=3
(Accessed August 2, 2019). CC BY 3.0
2 https://www.performancephilosophy.org/journal/arti-
cle/view/32/63 (Accessed August 18, 2019).

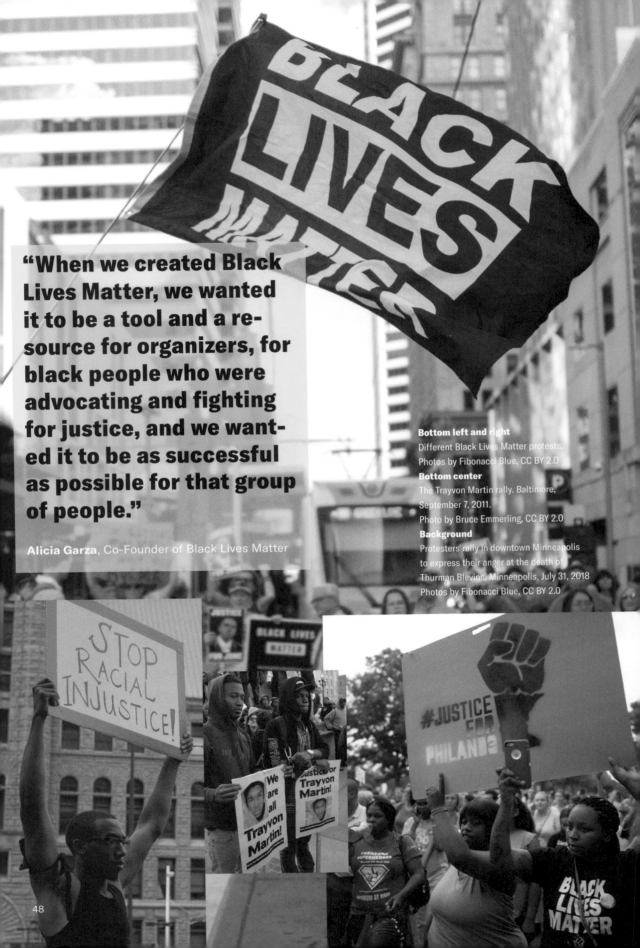

"When we created Black Lives Matter, we wanted it to be a tool and a resource for organizers, for black people who were advocating and fighting for justice, and we wanted it to be as successful as possible for that group of people."

Alicia Garza, Co-Founder of Black Lives Matter

Bottom left and right
Different Black Lives Matter protests.
Photos by Fibonacci Blue, CC BY 2.0
Bottom center
The Trayvon Martin rally. Baltimore,
September 7, 2011.
Photo by Bruce Emmerling, CC BY 2.0
Background
Protesters rally in downtown Minneapolis
to express their anger at the death of
Thurman Blevins. Minneapolis, July 31, 2018
Photos by Fibonacci Blue, CC BY 2.0

48

BLACK LIVES MATTER

The Hashtag That Started a Movement

The building blocks for branding Black Lives Matter.

By RUDY REED

The movement originated in 2013. An unarmed 17-year-old African American teenager named Trayvon Benjamin Martin was fatally shot in Florida by 29-year-old George Zimmerman. Zimmerman, a white Hispanic man, was later acquitted of second-degree murder and manslaughter.

Disappointed by the verdict, Alicia Garza, who had heard the announcement earlier in the day, found herself waking in the middle of the night to post on Facebook. Her post is now recognized as a love letter to black people. "Black people. I love you. I love us. Our lives matter." Garza's activist friend Patrisse Cullors took some poignant words from the statement to create the hashtag #blacklivesmatter. Opal Tometi, an immigration activist based in New York, created Facebook and Twitter pages to connect like-minded activists around the hashtag. These three women are today known as the founders of the Black Lives Matter movement.

Having recognized that, thanks to the momentum the hashtag had gained on social media, the words Black Lives Matter had grown into more than a slogan, the three co-founders enlisted the assistance of Design Action Collective. Founded in 2002, Design Action Collective is a worker-owned spin-off company of Inkworks Press Collective. Started by a small group of activists in 1974, IPC was the go-to place in the Bay Area for progressive organizations with graphic and printing needs for their messaging.

We had the opportunity to talk with designers Josh Warren-White and Sabiha Basrai, who are part of the Design Action Collective team. Both already had extended working relationships with the co-founders of Black Lives Matter and thus had their trust. The designers were tasked with creating visuals to accompany the popular hashtag.

"Initially, that started off with just coming up with a logo and helping them set up a Tumblr page where they could post memes. It grew from there, but that's really where it started. It took off in the public eye. In 2014, the following year, with the Ferguson uprising, those street protests in Ferguson were really what gave a lot more visibility to Black Lives Matter. And I think it was in large part because of these militant street protests and disruptions that it was able to capture the public eye," Warren-White explains.

As the protests grew in scale, the coverage from major news outlets also began to grow. Accustomed to working with organizations "in crisis," Warren-White and Basrai spent about two weeks bouncing around wordmark ideas with the Black Lives Matter cofounders, who were very clear that they didn't want overproduced visuals. They wanted the wordmark, the logo that would be used to identify the movement globally, to be organic and easy enough for supporters to reproduce themselves.

The words BLACK LIVES MATTER are in upper-case sans serif lettering using the Impact font. Warren-White and Basrai chose the font because it's available for free on most computers. The colors yellow and black are another important aspect of the wordmark. Although they contrast greatly, when combined, they're very strong and quickly grab one's attention.

The logo was designed with three words: BLACK, LIVES and MATTER placed vertically. The word LIVES was emphasized in knockout text. The Black Lives Matter movement has always been compared to the civil rights movement of the 1960s. Warren-White and Basrai acknowledge that the branding of that era's protests inspired them. Specifically, the declaration in the slogan I AM A MAN struck a chord. Consisting of four words, that bold text was divided and placed on two lines.

To support the wordmark, an illustration was created. The image chosen was of a young man wearing a black hoodie holding a dandelion with the flower's seeds blowing in the wind. The seeds represent the message of the movement spreading. But because the wordmark became so dominant, Black Lives Matter eventually dropped the image from its graphics and the illustration would go on to be replaced by actual photographs from protests.

While signage, logos and illustrations assist in boosting the movement's image, the co-founders of Black Lives Matter found themselves in an uphill battle to retain their

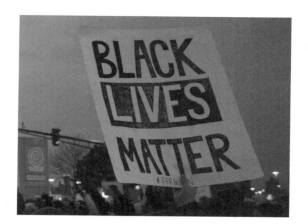

Left
The Black Lives Matter wordmark by
Design Action Collective.

Center right
An illustration of a young man wearing a
hoodie holding a dandelion with the flower's
seeds blowing in the wind. The illustration
by Design Action Collective was another
visual support tool for the movement.

Center left
Hand-drawn placard that mimicks the Black
Lives Matter wordmark.
Photo by Fibonacci Blue, CC BY 2.0

Bottom
Black Lives Matter rally near the White
House. Washington, D.C., August 12, 2018.
Photo by Richard Gunion/Dreamstime

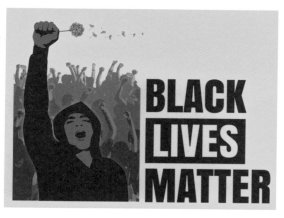

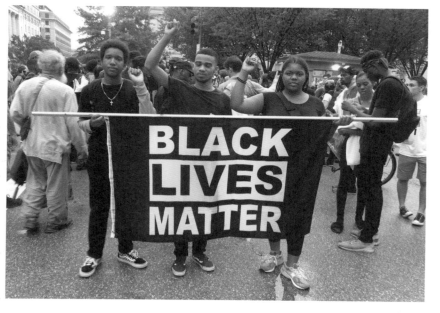

Next page
Different Black Live Matter
placards at separate demon-
strations around the U.S.
Photo (top right) by The All-Nite
Images, CC BY-SA 2.0
Photo (bottom left) by
Tony Webster, CC BY 2.0
Photo (bottom right) by
taylorhatmaker, CC BY 2.0
Photos (all others) by
Fibonacci Blue, CC BY 2.0

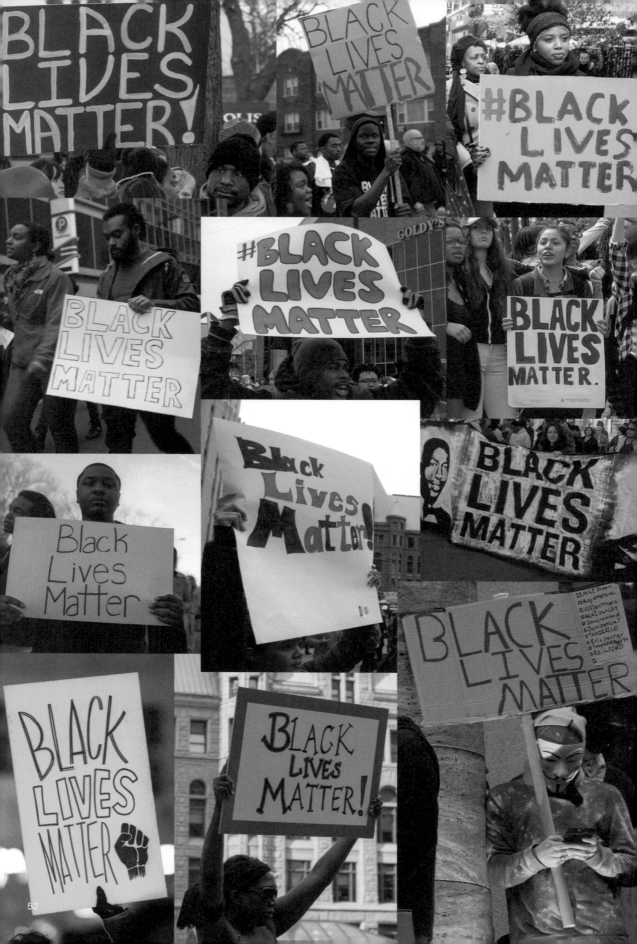

integrity. At various points, supporters relayed messages and displayed behavior that didn't reflect the movement's original agenda.

"We spend a lot of time…trying to counter this narrative that isn't ours because somebody irresponsibly used a piece of our design to further their own political goals."

The Black Lives Matter movement has also faced its fair share of criticism. Groups such as All Lives Matter and Blue Lives Matter formed in an attempt to counteract the movement's message. The group's website has also endured a great deal of hacking. Numerous entities continue to fight to silence the Black Lives Matter movement.

Protesters are angry, and they vent their frustrations verbally. Often, this venting takes the form of rhythmic chants. Black Lives Matters protesters have adopted the movement's name as their primary chant. Even when they must remain silent at demonstrations at police stations and courthouses, supporters mouth the words "Black Lives Matter! Black Lives Matter!"

People of color have endured injustices for hundreds of years. Over time, iconic chants have surfaced during one movement only to reappear during another. "No Justice, No Peace" is one such example. Although its origins aren't clear, these words have been woven through African American protest movements for quite some time.

On July 17, 2014, Eric Garner was accused of selling cigarettes illegally in Staten Island in New York. When an arresting officer put him in a chokehold, Garner began screaming, "I can't breathe." An hour later, he was dead. Black Lives Matter protesters started chanting "I can't breathe" during demonstrations – and the phrase spread worldwide.

Less than a month later, Michael Brown Jr., an 18-year-old African American man, was fatally shot by a white police officer in Ferguson, Missouri. This incident birthed the slogan "Hands Up Don't Shoot." With their hands raised in the air, protesters usually chant the phrase 11 times in a row to mark the number of times Brown allegedly pleaded for his life before being shot. Protesters also raise their hands in unison.

While the deaths of Garner and Brown will be forever tied to these inidividual slogans, protesters have connected the slayings of both men via choreographed actions known as die-ins. In the past die-ins have been used by the animal rights, anti-war, AIDS and gun control movements. The choreographed body gesture became a signature action for Black Lives Matter as well.

The Black Lives Matter die-ins blocked train stations in New York and Philadelphia, major thoroughfares such as the Brooklyn Bridge, intersections in San Francisco, college campuses and highways in Minneapolis. Die-in participants lie down motionless

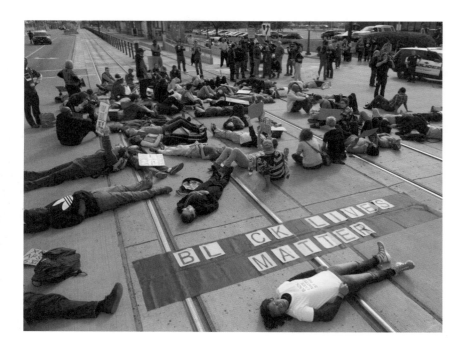

in solidarity, pretending to be dead. Although die-ins are not hostile demonstrations, they can be very disruptive. In the case of demonstrations protesting the killing of Michael Brown, protesters have been known to stage die-ins for four and a half hours – the amount of time that Brown's body lay in the street after his death.

Since the civil rights movement, the raised fist has been a staple gesture among African American protesters. Known as the Black Power salute, the gesture was most famously on display at the 1968 Olympic Games in Mexico City. Standing barefoot on a podium as the U.S. national anthem played, athletes Tommie Smith and John Carlos each raised a black-gloved fist after receiving their gold and bronze medals. The athletes later explained that their gesture was meant to protest the continuous racial discrimination of black people in the United States and show support for human rights around the world. The gesture has resurfaced today at Black Lives Matter demonstrations.

"I think if you look at that photography or videography from those street protests, where Black Lives Matter had a lot of impact, you see the black power fist, everywhere. That's not an accident. I think that the Black Lives Matter movement very much see themselves as direct descendants of the Black Panthers in the '60s and '70s, and very much see themselves as that kind of new wave of the Black Power movement. I think those physical representations of those movements are clear, and we can see them everywhere. I think it carries over into a very popular chant during this time that was directly pulled from Assata Shakur, a former Black Panther who was convicted of participating in killing a cop in the '70s and is still in exile in Cuba," explains Warren-White.

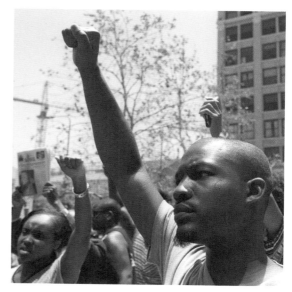

Shakur may be in hiding, but for supporters of the Black Lives Matter movement she is a very present inspiration. Protesters have adapted lines from a poem included in her autobiography into their own call to arms known as "Assata's Chant."

It is our duty to fight for our freedom.
It is our duty to win.
We must love each other and support each other.
We have nothing to lose but our chains.

These words have been printed on the backs of hoodies with the words ASSATA TAUGHT ME printed on the front.

According to Nielsen Reports, African Americans make up the largest proportion of smartphone owners. Since the Ferguson riots, black activists have deemed it imperative to utilize their phone cameras to expose injustices against people of color. Through the clever use of social media, easy-to-remember catchphrases, simple logos that are easy for supporters to duplicate and even apparel, the Black Lives Matter movement appeals to today's youth, ensuring the longevity of the movement.

"Hands up, don't shoot."

"This has become the new symbol, a new statement – a statement wherein people around the country now are calling to the attention of those who don't quite understand that this is a movement that will not dissipate. It will not evaporate. It's a movement that is going to continue because young people – a new generation – has decided that they're going to engage themselves in the liberation movement."

Al Green, Members of Congress

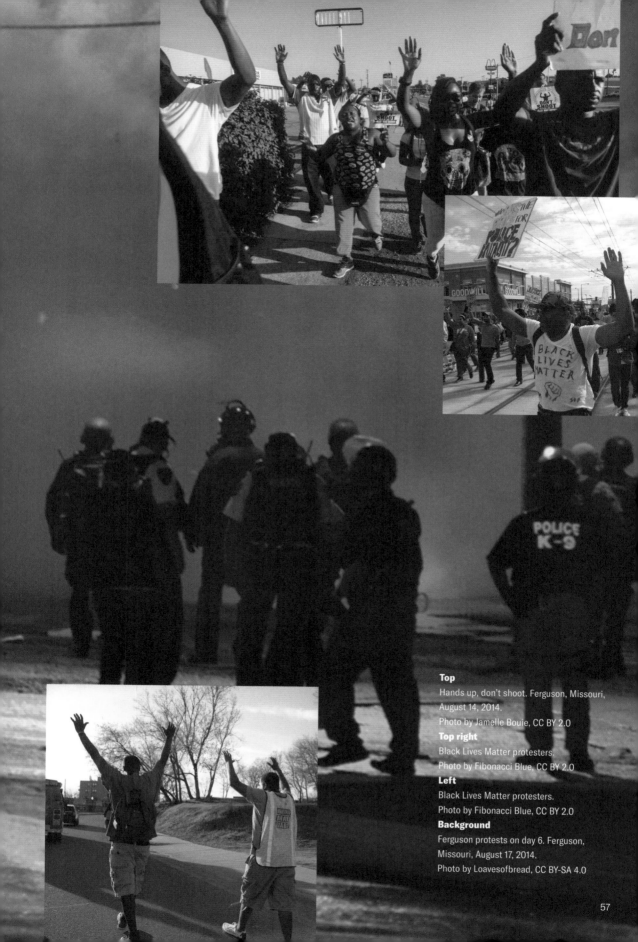

Top
Hands up, don't shoot. Ferguson, Missouri, August 14, 2014.
Photo by Jamelle Bouie, CC BY 2.0
Top right
Black Lives Matter protesters.
Photo by Fibonacci Blue, CC BY 2.0
Left
Black Lives Matter protesters.
Photo by Fibonacci Blue, CC BY 2.0
Background
Ferguson protests on day 6. Ferguson, Missouri, August 17, 2014.
Photo by Loavesofbread, CC BY-SA 4.0

The Man Becomes a Brand
DeRay Mckesson

By RUDY REED

At only 33 years of age, civil rights activist DeRay Mckesson has been mentioned in sentences alongside such historic names as Martin Luther King Jr. and Malcolm X. Mckesson is primarily recognized for drawing attention to the protests in Ferguson, Missouri, and for his work as a member of the Black Lives Matter movement. His clothing choices have made him one of the more recognizable figures among a new generation of activists. Almost always interviewed and photographed wearing a blue Patagonia vest, Mckesson has made the garment his signature – so much so, in fact, that the vest is mentioned in almost every article written about the activist. The vest even has its own Twitter account.

His drive to inform seems to know no limits. In 2018, Mckesson attended the 2nd Annual Wearable Art Gala. Not dressed for the occasion in the least, Mckesson wore a clear PVC trench coat made by LA Roxx. Mckesson teamed up with stylist Franc Fernandez, who helped transform the trench by printing two Jean-Michel Basquiat-inspired crowns on the shoulders, along with the following four key statistics:

"One in three killed by strangers are killed by police," "Police arrest more people for weed than for all violent crimes combined," "White high school dropouts have more wealth than black college graduates," and "America's 100 richest have as much wealth as black population."

He may not have received any best-dressed awards for the evening, but Mckesson was able to educate attendees about mass incarceration, police violence, income inequality and racial disparities in the war on drugs. With this genius "costume," Mckesson and Fernandez managed to merge fashion and activism.

Although Mckesson is widely respected as a good leader, his activism has been met with a fair share of controversy. Some people consider him too young to speak for the black community, while many others consider him a capitalist. And because he never resided in Ferguson, many have accused him of becoming involved in the protests to satisfy a longing for notoriety. What many don't know about Mckesson, however, is that he has always had a passion for social justice. In 2013, a year before police officer Darren Wilson fatally shot and killed 18-year-old Michael Brown, Mckesson was already collecting data on people killed by the police. The project is called "Mapping Police Violence."

"The movement is much bigger than any one organization: it encompasses all who publicly declare that black lives matter and devote their time and energy accordingly."

DeRay Mckesson, Activist

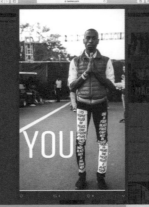

GARAGE

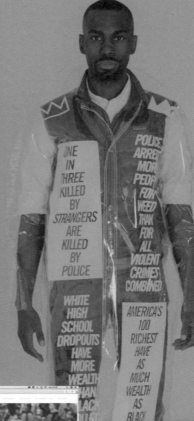

Top right
DeRay Mckesson with printed
slogan trousers. Seen on
@deraysvest, deray's blue
vest twitter account.

Below left
Campaign Zero, website
homepage

Bottom left
Mapping Police Violence,
website homepage

Bottom right
Stay Woke, website homepage

Background
"DeRay Mckesson Used a
Plastic Jacket to Educate
Gala Attendees about Police
Violence" magazine article by
Rachel Tashjian in *Garage*.
Garage, April 6, 2018.
Photo by Klaus Kempenaars

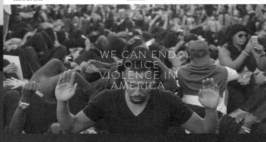

During interviews, Mckesson's responses are always well articulated and easy to comprehend, whether you agree with him or not. Now with over 1 million followers on Twitter, the well-educated and well-spoken young activist is dominating social media. Unfortunately, Mckesson's political messaging has faced some hurdles. In 2016, his Twitter account was hacked. Although he had taken the precaution of setting up dual authentication – which requires anyone attempting to log in to a user's account to be in posession of the account holder's phone information – the hackers had found a way to circumvent this privacy setting. After a bit of tedious work, Mckesson regained control of all his information.

Bots and hashtags are now all the rage in relaying messages and grabbing attention. And despite all the good work someone could be doing for the cause of equality, not everyone appreciates such efforts. As a result of the hack, Mckesson, whose public image has grown tremendously, found himself trying to helpfully answer valid questions from followers on social media only to have naysayers chime in and derail his message.

So in 2015, the activist partnered with tech gurus and internet artists Darius Kazemi and Courtney Stanton and Black Lives Matter organizer Samuel Sinyangwe to create the Stay Woke Bot (@staywoke). The Stay Woke Bot serves as a liaison between activists and their curious social media followers. The bot saves an activist time by generating answers to the questions being asked. Not to worry. The responses are the actual thoughts of Mckesson and Sinyangwe. Additionally, the bot auto-replies to tweets that mention it by name and includes information about how to contact local legislators according to the ZIP code from which the tweet originates, encouraging followers to take action.

"DeRay was concerned about morale in the black community and wanted to give people a joyous interaction," says Kazemi.

With a podcast titled *We the Protesters* and a book titled *On the Other Side of Freedom*, we can rest assured that Mckesson has every intention of making his voice heard using every platform at his disposal.

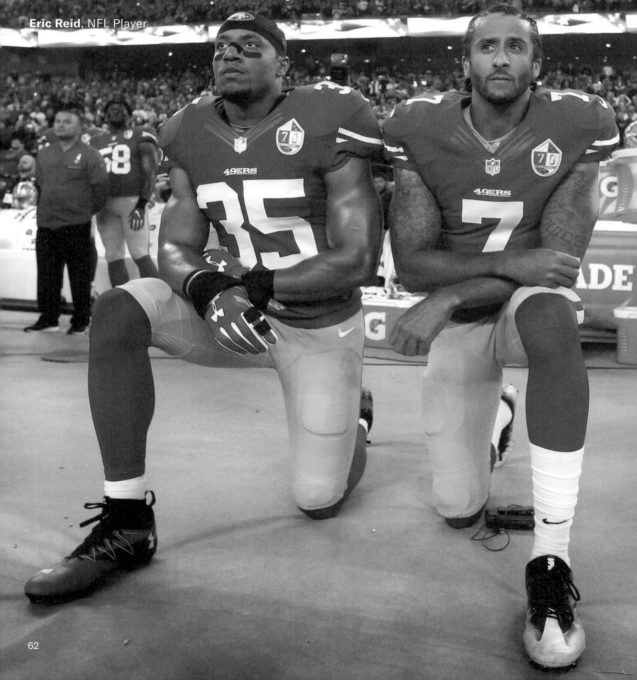

"While taking a knee is a physical display that challenges the merits of who is excluded from the notion of freedom, liberty, and justice for all; the protest is also rooted in a convergence of my moralistic beliefs, and my love for the people."

Eric Reid, NFL Player

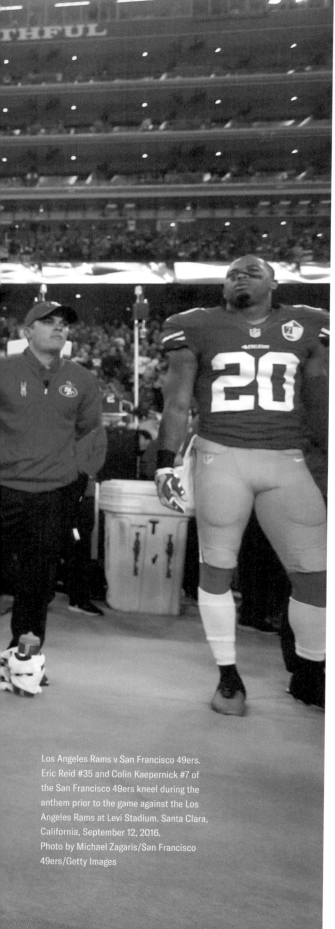

Los Angeles Rams v San Francisco 49ers. Eric Reid #35 and Colin Kaepernick #7 of the San Francisco 49ers kneel during the anthem prior to the game against the Los Angeles Rams at Levi Stadium. Santa Clara, California, September 12, 2016.
Photo by Michael Zagaris/San Francisco 49ers/Getty Images

Kneeling Down... Rising Up
The Journey of Colin Kaepernick

By RUDY REED

He was considered to be on the fast track to greatness in sports – that is, until his moral compass interjected. It all started in 2016 during a San Francisco 49ers NFL preseason game. Colin Kaepernick (who played quarterback) was seen sitting during the national anthem, "The Star-Spangled Banner." When asked why he behaved in such a manner, he responded, "I am not going to stand up to show pride in a flag for a country that oppresses black people and people of color. To me, this is bigger than football, and it would be selfish on my part to look the other way. There are bodies in the street and people getting paid leave and getting away with murder."

Kaepernick's frustrations and concerns echo those of the Black Lives Matter movement: the killing of African Americans at the hands of police officers is rampant.

While many agreed with Kaepernick's statement, many rejected his chosen method for raising awareness of the situation. One person in particular, Nate Boyer reached out to the quarterback. Boyer, a former Green Beret who also had a short career playing for the Seattle Seahawks in the NFL, was offended.

Upset, Boyer wrote Kaepernick a letter explaining the symbolic reason veterans stand during the anthem. In turn, Kaepernick extended an invitation to Boyer to talk. The two men would discuss their views, and Boyer would attempt to persuade Kaepernick to refrain from sitting. But Kaepernick couldn't be convinced. It was then that Boyer suggested Kaepernick kneel, which he considered a more respectful way to protest. Kaepernick agreed to do so. The next game, Kaepernick and his teammate Eric Reid kneeled for the first time. The gesture would become one of the most high-profile protests against racial and social injustices in modern sports.

Throughout history, the act of kneeling has held different symbolic significance to various groups and organizations. For example, one kneels when proposing to a future spouse. During medieval times, a man was required to kneel before his king or queen before being knighted.

The army also has a very long tradition of kneeling. And it has nothing to do with protest. Military men and women assume this stance in situations where they need to take a break from action or when they must take a step back to analyze a situation. The position allows them to relax their bodies while remaining alert.

In August 1960, a small group of African Americans visited a prominent church in Atlanta. This was during segregation, and many churches had closed-door policies barring people of color from worshipping. Sometimes, they were allowed in; most times, they were not. When they were refused, people would kneel in unison outside the church. The collective gesture of protest later became known as the "kneel-in" campaign.

For the most part, the act of kneeling has never been regarded as threatening. It's a submissive position that leaves the kneeler quite vulnerable, and one that has for centuries been regarded as an honorable gesture – all of which makes people's contempt for Kaepernick's form of protest all the more baffling.

The silent protest began to spread. Players from other teams could be seen "taking a knee." As many as 36 players were seen protesting during any given week. Ticket holders, television watchers and social media users all had access to the movement. Players on college and high school football teams across the United States have also been seen protesting. Kaepernick's actions obviously did not go unnoticed.

Between 2016 and 2017, Kaepernick was released from the San Francisco 49ers, making him a free agent. In the third week of the 2017 season, the outspoken President Donald Trump attempted to use his influence to put an end to the non-violent protests. During a campaign speech in Alabama, he wished that NFL owners would fire players for kneeling during the national anthem. He considers the gesture unpatriotic.

"Wouldn't you love to see one of these NFL owners, when somebody disrespects our flag to say, 'Get that son of a bitch off the field right now. Out. He's fired. He's fired.'"

Since his time in the White House, Trump and his advisers have attempted to rebrand the protest as a sign of contempt toward the American flag.

The fact of the matter is that the protests are about police brutality and racism; issues that Trump never addresses and has actually helped worsen during his time in office.

Although Kaepernick is no longer playing football and limits the number of interviews he does because he doesn't want his image to distract from his message, his name is still on the tip of many of our tongues.

Ironically, despite no longer being an active athlete, Kaepernick was named as the new face of Nike's "Just Do It" campaign. In honor of the campaign's 30th anniversary, Nike began running an ad featuring a black-and-white photo of Kaepernick with the tagline: "Believe in something. Even if it means sacrificing everything." Praise came in heaping doses but so did the backlash. Competitors shared videos and images of consumers destroying their Nike merchandise. And though the sportswear giant's stock briefly slipped, the brand made out like bandits in the end.

Thanks to his bold silent protest, historians can now add the name Colin Kaepernick to the list of courageous athletic greats that includes John Carlos, Tommie Smith, Muhammad Ali and Jackie Robinson.

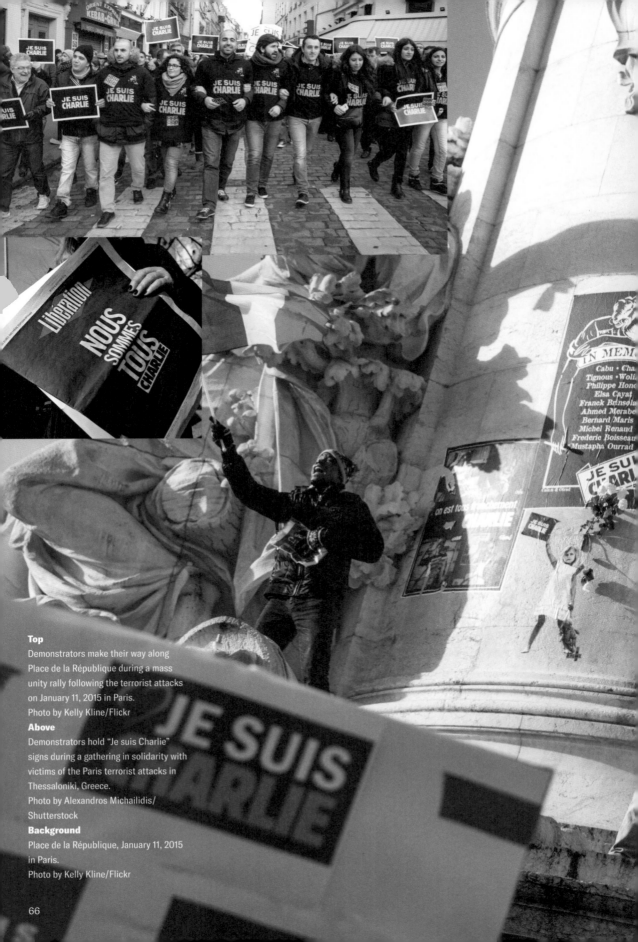

Top
Demonstrators make their way along
Place de la République during a mass
unity rally following the terrorist attacks
on January 11, 2015 in Paris.
Photo by Kelly Kline/Flickr

Above
Demonstrators hold "Je suis Charlie"
signs during a gathering in solidarity with
victims of the Paris terrorist attacks in
Thessaloniki, Greece.
Photo by Alexandros Michailidis/
Shutterstock

Background
Place de la République, January 11, 2015
in Paris.
Photo by Kelly Kline/Flickr

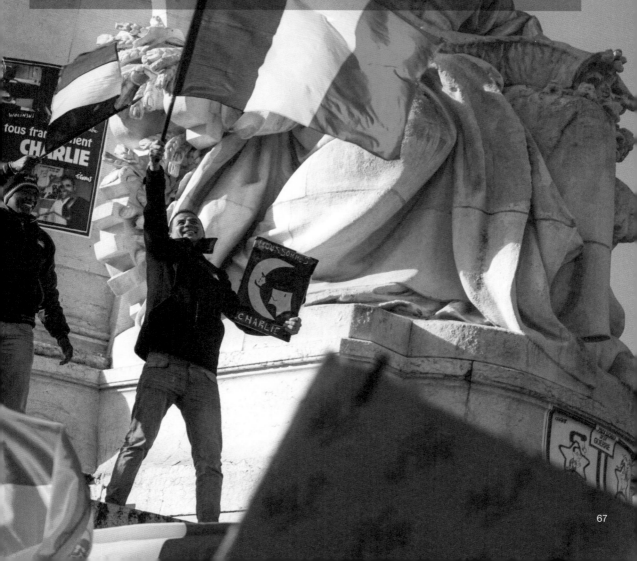

Je Suis Charlie

"Je suis Charlie" is a slogan created by Joachim Roncin in reaction to the 2015 terrorist attack on the offices of French satirical weekly magazine *Charlie Hebdo* in which 12 people were killed.

We Are All Charlie

Roncin first posted #JeSuisCharlie on Twitter on January 7, shortly after hearing of the attack. The hashtag was retweeted thousands of times and within days became the most retweeted news hashtag in history.

Je suis Charlie was embraced worldwide and translated into dozens of languages. Thousands made placards with the slogan or displayed it on their mobile phones at vigils and demonstrations. The slogan has been used in music, appeared in animated cartoons including *The Simpsons*, and is the name of a town square in France. Je suis Charlie remains almost five years after it went viral widely recognized as a symbol of freedom of speech and freedom of the press.

Can you tell us about the process you went through when you created Je suis Charlie? What was the first emotion or idea you had in your mind?

When the Charlie Hebdo attack happened, I was in the conference room of *Stylist* magazine, where I work as an art director. One of my colleagues saw the alert on Twitter saying that there had been an attack on *Charlie Hebdo*. We started following the messages on Twitter, following everything that happened minute to minute.

I wanted to see the logo of *Charlie Hebdo*. I always react with images because this is what I do, this is my job. So I looked at the logo and I thought about what this logo means to me. As a child I never read the magazine, but there were piles of them in our house because my father did read it. So *Charlie Hebdo* was part of my childhood.

I downloaded the logo and I made the wordmark. It was done in just a few seconds, and so I posted it. At that time, we didn't yet know that 11 people had already died. I just let it go and about five or six minutes later I saw a lot of retweets and my editor said: well, it did something! And then, an hour later, there were hundreds of retweets. And then hundreds of thousands. It was never actually my intention to make it go viral. It was just a spontaneous act. I just wanted to express myself.

Continued on page 73

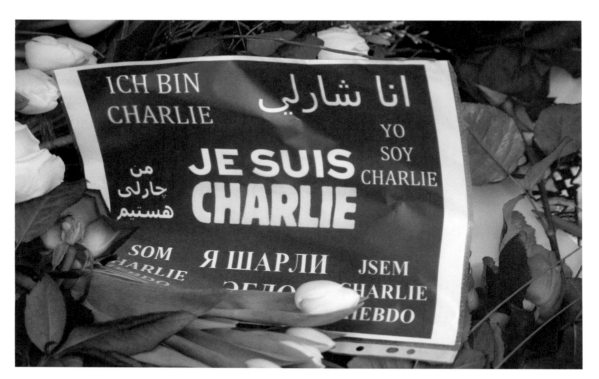

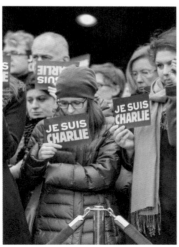

Top
Mourning at the French embassy in
Berlin for the victims of the attack.
Photo by 360b/Shutterstock

Above left
Council of Europe employees in Strasbourg
attend a silent vigil to condemn the attack.
Photo by Hadrian/Shutterstock

Above right
Ceremony to commemorate victims of
the terrorist attack.
Photo by Melanie Lemahieu/Shutterstock

A few hours after the attack, the *Charlie Hebdo* website, which had gone offline, returned live with a homepage featuring the words "Je suis Charlie" on a black background. A week later, the magazine published a new edition: the cover featured a cartoon of the Islamic prophet Muhammad shedding a tear while holding a Je suis Charlie sign beneath the words "All is forgiven" ("Tout est pardonné").

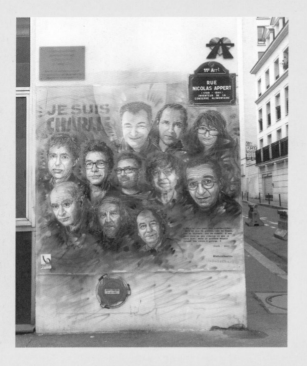

Top right
Previous cover of *Charlie Hebdo*.
Left
The former office of *Charlie Hebdo* on Rue Nicolas Appert in Paris. Today the site is a Memorial to the victims of the terrorist attack.
Photo by Ingeborg Bloem
Opposite
A woman poses with the first issue (three million copies) of *Charlie Hebdo* published after the Paris terrorist attacks. Saint Germain en Laye, France, January 14, 2015.
Photo by Pascal Le Segretai/ Getty Images

Page 72
Top
Candlelight vigil at the French embassy in Berlin.
Photo by Informationswieder-gutmachung, CC BY-SA 4.0
Center
Mass unity rally in Paris.
Photo by Serge Carrie, Flickr
Bottom left
Demonstrators in Place de la République, Paris.
Photo by Pixinoo/Shutterstock
Bottom right
Actress Helen Mirren attends the 72nd Annual Golden Globe Awards in Los Angeles.
Photo by Jason Merritt/ Getty Images

"I decided early on that this slogan was not mine. It belonged to everyone. Because, actually, I didn't do anything. It's social media that did all of this."

Joachim Roncin, Creative Director

What began as a normal day became outrageous. Press from all over the world wanted to interview me. It was a very strange experience to become famous as a person for this really emotional event and have people even calling me the leader of a movement, which I am not. I was mourning like the rest of the world.

What does the logo "Je suis Charlie" mean? Was it solidarity with the magazine, a reflection on what happened, or was it a statement against terrorism in general?

I talk about it as a slogan, not a logo, because design-wise it is a very poor logo. The two fonts don't go well together. I just used the font of *Stylist* magazine, where I work. It's called Sweet Sense and I combined it with the logo from the cover of *Charlie Hebdo*. If I had thought about it, I would have chosen something different. But in these kind of situations, there is no time to think about typefaces, you just act.

It was a sign of solidarity, really, for freedom of the press and freedom of speech. Not only in Paris. I think the whole world felt attacked. And so it was about being able to unite and identify with others, and that was what Je Suis Charlie did. If you say today, Je suis Charlie, it means you are for freedom of speech, for freedom of the press, for the right to draw Muhammad. It doesn't mean, I am for *Charlie Hebdo*. It means: I am against violence, against terror attacks, I am for this general idea of being free in a free world. It's a positive way of saying: I am not afraid.

Most branding is the result of long strategic sessions with different stakeholders. In the case of "Je suis Charlie," it seems you could capture the values and emotions of the whole world instantly with only three words. How is it possible that so many people who had never heard of the magazine *Charlie Hebdo* suddenly identified with this name?

My theory: first of all, it is very simple. It's like, "Just do it" or "Yes we can." Just three words. And because it's simple, you can put anything inside this sentence, and then that is what it will be about. Plus, the name Charlie. It's a very positive name. And the last thing is, it is a sentence that is spontaneous and sincere. It's not fabricated, it's not the result of a think tank, and people feel this.

Your slogan was used and re-used, placed in contexts you probably never had imagined, and it was even used commercially. How did you react to these developments and how did that effect the original message?

I decided early on that this slogan was not mine, it belonged to everyone. Because, actually, I didn't do anything. It's social media that did all of this. But when I saw it being used over and over commercially I did contact a lawyer, and he put an end to all of the commercial use on T-shirts and so on.

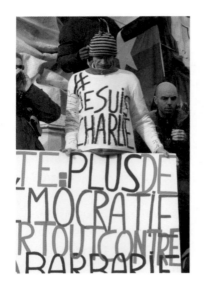

In the beginning, the slogan was not political, it was just something that I felt personally. But soon enough, the slogan became political because two or three days after, people started saying "Je ne suis pas Charlie," because they did not agree with the way that *Charlie Hebdo* had offended Islam with their drawings of Muhammad. The slogan went completely crazy. People started to say "Je ne suis pas Charlie," or "Je suis Ahmed." [ed: Ahmed Merabet was a policeman who was killed in the attacks.]

The original message starting fading out. People took it and made something different out of it. Instead of forming a community, people were suddenly standing against each other. Because people are afraid, and when they are afraid they shut down. The worst is not those who say "I am not Charlie." The worst thing people could say was "I am Charlie, but..." – this is the worst. I can get a bit emotional about this. Because "I am Charlie, but..." means that the people who made the cartoons about Muhammad deserved it. It's exactly the opposite of the society we're trying to live in. Je suis Charlie was interpreted in so many ways, but basically it is about the fact that you cannot kill somebody just because he is drawing cartoons.

With social media at our fingertips, one could argue that street protests are no longer necessary. What do you think, after your experience with Je suis Charlie? What was the effect of social media on street protests and vice versa? Do we still need to take to the streets with printed signs?

I think that social media is a way to communicate and to burn the first match. Today, it's the way to start. All major protests begin with some kind of media. Yesterday was about television. Now, today, the media is social media. I don't know if it's the way to put some more wood on the fire, but I think it's the way to start the fire, a positive fire.

On the Monday after the attack, January 11, there was a big march. 4 million people were in the streets; more people together on the streets of Paris than at any time since World War II. And everywhere people were holding the Je suis Charlie sign. Everywhere in Paris there were posters with the slogan.

Even though we're together on social media, you never feel as much a part of something as when you're in a demonstration. At a certain point, we have this animal reac-

tion to connect. So this is why I think that no matter what happens on social media, there will always be a point where you have to be together, physically. We are not numbers. We are human beings.

The slogan was translated in 34 languages. Within a couple of days we were all "Charlie." What is left after all these years? And what effect did the success of the slogan have on you and your work?

I joined Reporters Without Borders. For two years, I was a member of the administration. I attended meetings every two weeks. I was working with them, giving my free time. Today, I'm acting, not looking and commenting. I think that we're in a situation today where social media is very good with commenting but not good with acting. This is a very problematic situation, because people think that because they post, "Pray for Sri Lanka," they did their job. And it's very easy on social media to hide behind something that somebody else came up with. You just have to say yes or no or re-tweet it. Some think that social media is liberating people and enabling them, but I think, on the contrary, that people are acting on social media but not acting in real life. They're just commenting. I think it's the next big problem.

Jochaim Roncin is Creative Director at *Stylist* magazine, Head of Design of Paris 2024 olympic Games, and member of the board of the Art Director Club.

Opposite top left
Je suis Charlie demostration in Place de la République, Paris.
Photo by Arenysam/ Shutterstock
Opposite left
A dog with a Je suis Charlie sign.
Photo by Alexandros Michailidis/ Shutterstock
Bottom
People hold banners in Thessaloniki, Greece during a protest in memory of the Charlie Hebdo shooting victims.
Photo by Giannis Papanikos/ Shutterstock

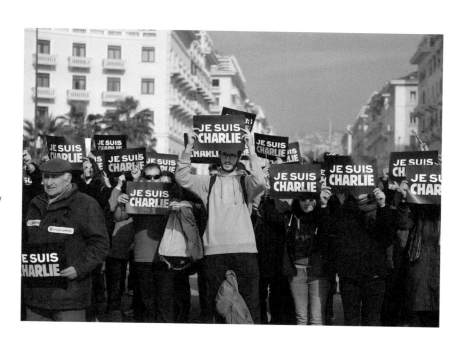

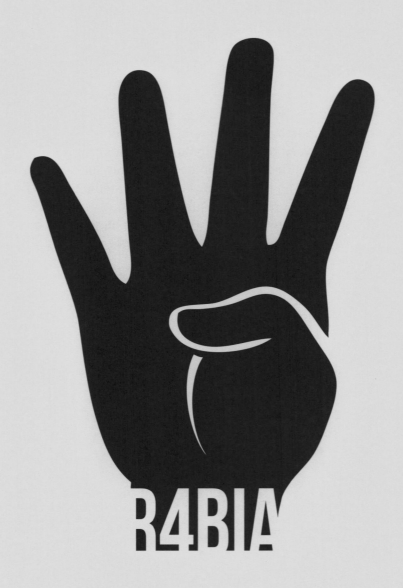

Rabia sign, a common insignia used by
opponents to the recent coup d'état in
Egypt. Saliha Eren and Cihat Döleş are the
Turkish design duo that created the sign and
initiated the historical campaign.

The Symbol That Must Not Be Named

By SHEHAB AWAD

It is difficult to contextualize the Rabia sign without finding oneself spiraling almost endlessly back in time to recall the events that led to its conception. This contextualization has become even more challenging given the Egyptian state's concerted effort to erase that convoluted memory, largely with the help of its media apparatus. Where does one start a story that has no apparent beginning or end?

The Rabia sign is a most conspicuous symbol, and its story is interesting because of the extreme transformations of the sign's value and signifying power, from first serving a purely utilitarian purpose, to becoming so dangerous that anyone who flashes the Rabia sign (or otherwise distributes or shares it) could risk terrorism-related criminal charges and time in prison.

Resembling a hazard or warning symbol, the Rabia sign, in its most basic form, depicts a black hand holding out four fingers, gesturing the number four, against a solid bright yellow background. The word Rabia literally translates to the "the fourth one." Before 2012, Rabia was just the nickname of a well-known public square in Nasr City, Cairo, and the site of the mosque that it is named after: Rabia el-Adaweya, named in turn after the 8th century Sufi saint. Rabia Square is a crowded, informal, yet fully functional transportation junction where one can catch a bus, or microbus, to pretty much anywhere else in the vast governorate of Greater Cairo. The four-fingered hand gesture was originally widely used by commuters to flag down any Rabia-bound transportation. Now, the Rabia sign is a symbol of a heinous crime, which has sadly (but not surprisingly, like so many others) almost been forgotten.

On June 30, 2012, Mohamed Morsi, the representative of the Muslim Brotherhood political party, won the country's first official presidential elections following the ouster of Hosni Mubarak's regime in 2011. As the anniversary of Morsi's first year in office approached, and his failure to deliver any of his one-year promises became evident – and as the Muslim Brotherhood was simultaneously drafting changes to the Egyptian constitution that would grant Morsi extrajudicial powers – the opposition began rallying, calling for mass protests demanding Morsi's removal from office. On June 30, 2013, exactly one year after his election, a record-breaking number of protesters took to the streets demanding the same thing: for the military to depose Morsi and the Muslim Brotherhood. In a prompt reaction, the military forcefully removed the democratically elected president from office, and an interim government was installed.

After his ouster, supporters of Morsi and the Brotherhood who believed that his deposition was unconstitutional, and that what had occurred was actually a military coup, started protesting for his return. A sit-in began forming and growing in Rabia Square. Morsi's face was plastered across posters and picket signs everywhere, but, following some violent clashes between the police and protesters at the sit-in, his image was replaced with the now infamous black-and-yellow symbol.

On August 14, 2013, the military and interim government launched a massive attack on the sit-in following short-term warnings to evacuate, killing over one thousand protesters within the span of hours. I remember hearing loud bangs thundering midday and watching the smoke billow across the windows of my apartment. No media coverage was allowed in the square, apart from a few brave journalists who risked their lives to document the horrendous scene, and who, for the sake of their sanity, I hope by now have forgotten its images.

Following the massacre, the Rabia sign began appearing more prevalently in Egypt, and quickly began spreading across social media networks and university campuses. The Rabia logo was printed on pins and stationary and sold in stores and on the streets.[1] This widespread production raises the question: Does a political symbol lose its social value and political potency once it becomes marketed as a product? Answering this question is complicated. One could simply resign oneself to the reality that no cause or process, no matter how altruistic, is free from the grasp of capitalism and commodification. After all, commodification can enable a concept to spread more widely, and sociopolitical change is most often predicated on widespread public awareness. Should branding studios play a bigger part in the production of political campaigns?

The Rabia sign was indeed the product of a design duo from Turkey. In an interview on Mada Masr, Egypt's leading resource for independent bilingual news, one half of the duo, Turkish designer Saliha Eren, stated, "We were telling people about the Arab Spring from the very start; people that were seeking justice and freedom touched us

THE NUMBER BEFORE FIVE

Satirical sign depicting Rabia as the square
root of the number 16 with the proverb, "those
who fear keep safe" in Arabic underneath.

Below

Protesters hold up four fingers as they march
in Cairo, August 23 and September 20, 2013.
Photos by Hamada Elrasam for VOA

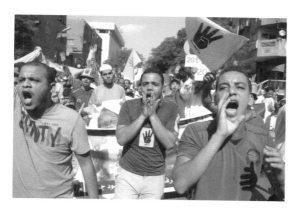

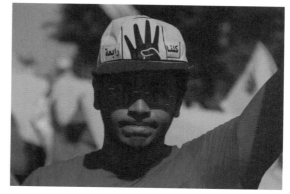

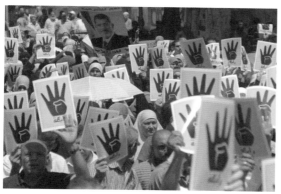

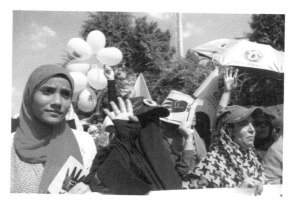

greatly, but we were shocked when the Egyptian military killed civilians in August 2013. The people courageously continued to resist in Rabia Square, so we decided to make this resistance visible. We did this driven by our consciences."[2] The Rabia sign became a site of polarization, as its use was not only limited to supporters of Morsi – it was used and shared by those who had been opposed to Morsi's government, but who nevertheless were sympathetic to the victims of the massacre and wanted to alert the masses to the crimes committed by the military and interim government as a reminder not to trust the alleged "saviors" of the revolution – the only alternative to Morsi's government – and warn of what was to come.

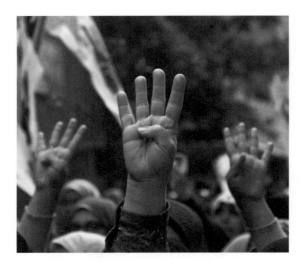

Ensuing decisions by the interim government made participating in a Brotherhood protest a crime punishable by up to five years in prison, after the party was deemed a terrorist organization. Anyone who was proven to be a member of the outlawed organization, propagated its ideologies in writing or verbally, or possessed publications or recordings supporting the Brotherhood could also face prison sentences upwards of five years. This applied to anyone who carried, printed, or posted the sign on social media.

This meant that as the sign's use grew more prevalent, the state's retaliation grew more immediate and more violent. One high school student was arrested for carrying a ruler with the logo, and the prosecution went so far as to detain the student's father for allegedly encouraging his son to spread the symbol at school.[3] And when Ahmed Abdel Zaher, a member of the Egyptian national soccer team, performed the gesture after scoring a goal, he was called in for questioning and faced being banned from representing Egypt in its international soccer matches.

To take the sign's criminalization and the erasure of any memory of the massacre or opposition even further, the government attempted to change the name of Rabia el-Adaweya Square to Martyr Hisham Barakat Square in honor of the public prosecutor who was assassinated by a car bomb in 2015. Nevertheless, despite the overwhelming level of grief and trauma that encompassed the country at the time, humor and sarcasm were and continue to be tools of survival used to soften the harshness of reality. When use of the Rabia sign was officially criminalized, social media immediately reacted by creating an array of cheeky alternatives to the now-illegal sign.

Top right

A masked protester holds up four
fingers as he marches in Maadi, Cairo,
September 20, 2013.

Below

Anti-coup protesters in Nasr City,
Cairo, October 11, 2013.

Photos by Hamada Elrasam for VOA

Opposite

Protesters raise their hands with the four
finger sign during a march in Maadi, Cairo,
February 14, 2014.

Photo by Hamada Elrasam for VOA

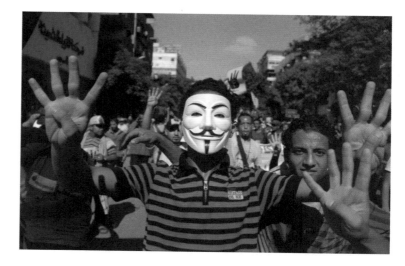

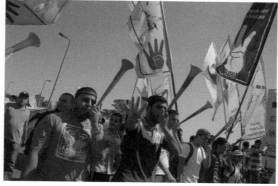

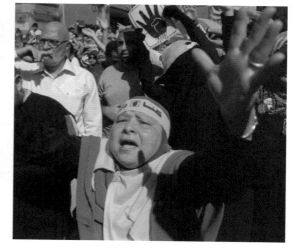

Notes

1 The Rabia sign was also used internationally by
Turkish President Recep Tayyip Erdoğan, who raised his
hand in the four fingered salute to signify his sympathy
with the Muslim Brotherhood and his resistance against
coups. World Bulletin. "Rabia sign becomes anti-coup sym-
bol in world." Worldbulletin.net. https://www.worldbulletin.
net/middle-east/rabia-sign-becomes-anti-coup-symbol-
in-world-h176151.html (Accessed May 25, 2019).

2 http://www.madamasr.com/sections/politics/qa-
turkish-designer-rabea-symbol-its-still-alive (Accessed
May 10, 2019).

3 Hamama, Mohamed. "The famous yellow Rabea logo:
What has it achieved?" Madamasr.com, https://madamasr.
com/en/2016/08/14/feature/politics/the-famous-yellow-
rabea-logo-what-has-it-achieved/ (Accessed May 10, 2019).

Next spread notes

4 https://madamasr.com/en/2013/12/30/news/u/how-do-
you-write-a-banned-number/ (Accessed May 10, 2019).

5 https://www.trtworld.com/opinion/the-rabaa-story-
who-created-the-iconic-hand-gesture--9732 (Accessed
July 30, 2019).

"The Rabia sign was created by sympathizers of the victims of a political crime that, in comparison to its gravity, seems to have been ignored by worldwide media. It was used by both the opposition (Morsi supporters), and the opposition's opposition (protesters who opposed Morsi's return to office, but who empathized with his supporters in their rejection of the interim government). It is a sign whose memory is important to keep alive, as its ability to garner the use and sympathy of those with opposing political opinions places it in a mutable, almost anarchist category of images. It is a symbol of past indignation, present perseverance, illegal memory and distrust of any governmental regime." [4]

Morsi death sentence protested in Istanbul, June 16, 2015
Photo by Elif Ozturk/Anadolu Agency/Getty Images

"We came up with one symbol that has, more than anything, encapsulated the Rabia massacre and the wider coup. We saw people holding up the four-fingered Rabia sign, which has become a sign of resistance against the coup. We combined the colors of the Kaaba, black, Islam's holiest site, and that of Al'Aqsa as the sun hits the golden dome, Islam's third-holiest site. I worked with my co-designer tirelessly, bouncing ideas off of each other to create an image that could capture people's attention.

When we were working on this symbol we never imagined that the Rabia sign would spread across the world. It spread like wild fire across social media, T-shirts, flags, banners, and to this day it has become one of the most potent symbols of that fateful event."[5]

Saliha Eren, Designer
Saliha Eren and Cihat Döleş are the Turkish
graphic designers of the Rabia sign.

Marchers attend Women's March
Los Angeles, Los Angeles, January 20, 2018.
Photo by Presley Ann/Getty Images

"Oh, my gosh. We have a movement!"

Less than a month before the November 2016 election that would bring Donald Trump to the White House, the U.S. was rocked by the discovery of a video in which Trump boasted of being able to use his wealth and power to "grab women by the pussy." Despite the outrage generated by the revelation, Trump was elected president. So when on post-election night a fashion designer named Bob Bland posted on Facebook that "women should march on Washington, a million pussy march," her words touched a chord. Within 48 hours, over 250,000 people said they would attend the march. One of the respondents was Teresa Herd, global creative for tech giant Intel. Reading the thousands of responses, Herd realized that a movement was being born, and also "that it was going to require a uniting brand." She activated her network and organized a pitch, and within days Amy Stelhorn, CEO at Big Monocle, was on board to design the campaign logo. Stelhorn brought in creative Wolfgang Strack and later illustrator Nicole LaRue, and together they created the striking logo of three women in silhouette, which would spread rapidly around the world. We talked with Amy Stelhorn about how the process came together.

How did you come to be involved with the Women's March?

As the Women's March was shaping up globally, with women all over the world starting to join in, there was suddenly this realization that, "Oh, my gosh. We have a movement!" And the only graphic the movement had was this weird image on Facebook. So that's when Theresa Herd – head of Global Branding at Intel, and a client of ours – reached out to the Women's March organizers and said, "Hey, it looks like you need to step up the marketing and the branding, would you want our help?" So Intel wrote

a creative brief and distributed it to several agencies. I think we had a week – it was really an all-hands-on-deck kind of thing! And then Intel presented all the ideas to the Women's March, and we got the brief.

I really wanted to help, but there was so little time and my team was already super-duper busy. So I recruited Wolfgang Strack, creative director at Strack Design, who I have a longstanding work relationship with, and I pulled in people on staff, including designers from Big Monocle, and we did an initial sketch phase. And one of the ideas we really liked was a sketch of three women's silhouettes that Wolfgang made. We needed someone to illustrate it so I reached out to Nicole LaRue, who I've worked with over the years, and went to school with. I said, "Hey, we have this idea and we need someone with illustrative skills to bring this icon together the way we're envisioning it." And she was able to turn it around so fast – I think she literally had 24 hours to do the sketch.

What are the values behind the image? Is it a symbol of resistance, of the fight for equal rights? Was it about showing a strong message to the then president elect?

I think it sprung out of anger, to be honest, in response to the threatening and really devastating language and treatment of women throughout the 2016 U.S. presidential election. It was crushing to see how women were being treated, even female reporters, and then to hear recordings of our now-president saying awful things about women. It sprung out of that. And it wasn't just women, or just for women, but for everyone

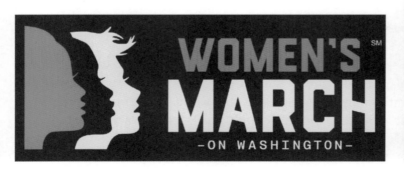
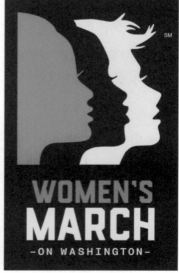

who wants to stand up against all this bigotry and these threats to human rights. We live in a really frightening time in history, and we should stand together to protect our rights, our families and the kind of community we want to live in.

You designed the logo, together with Wolfgang and Nicole. Were there other items?

Yes, we did the T-shirt that you see everywhere, and Nicole created some typographic posters. There's a company called Bonfire that helps raise money for marches, and we worked with them to help the Women's March raise over 1.3 million dollars. Holding a march is really expensive – you have to put up money for insurance, for police, for security, for health, ambulances and support around that, for Porta Potties, for the sound system. So we helped raise this money, mostly from T-shirt sales.

The movement started out as a Women's March on Washington, right, in reference to the 1963 civil rights movement March on Washington?

Yes, that's right. In fact, the full name in the original logo was Women's March on Washington. Then, during the execution, when we were creating all the brand assets, we kept noticing, "Well, now there's a march in France. Oh, now there's a march in Antarctica," and so we ended up dropping "on Washington" halfway through the project. But because the logo had originated with this idea, we were kind of in a red-white-and-blue frame of mind. So we tweaked it to be a bit more pink, white and blue.

From brand and communication guidelines for the Women's March, by Big Monicle, Utah. Logo design by Nicole LaRue, Amy Stelhorn and Wolfgang Strack.

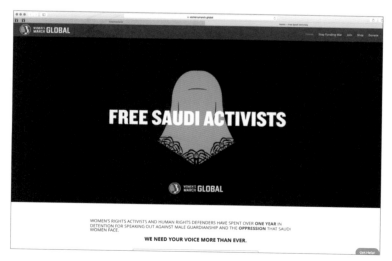

"When the opportunity presents itself, do it! Helping something that you believe in be successful through design is really a crazy and powerful thing."

Amy Stelhorn, Founder and CEO of Big Monocle

Are you still involved in the branding of the movement?

It's complicated. We went on to do the brand guidelines for Women's March Global, which is a separate organization. And the global organization has had to distance themselves from the U.S. organization, because the U.S. organization took stances on things that couldn't apply for all the women active globally. It's really interesting to see all these actual organizations spring up and then try to navigate these questions and build something around them. Our creative brief wasn't "design a symbol for women around the world," but "design a symbol for the March on Washington." But it resonated so well around the globe and it got so much momentum that it really became something. And it's still becoming something, it's still trying to figure out what it is and how it will go. Ultimately, I'm really proud that we helped it gain the momentum it did by giving it a strong brand. I think without that strong, iconic symbol, the Women's March wouldn't be what it is.

Do you have anything you would want to share with our readers, from your experience with branding a movement?

I would say, when the opportunity presents itself, do it! Helping something that you believe in be successful through design is really a crazy and powerful thing. We essentially were able to give a movement legitimacy through a symbol, and that's thrilling. Art is so powerful. Design, symbols – these are so powerful. This is a skill that we can bring to the world. On a practical matter, you have to be protective and be a good custodian. Because, before you know, people will want to take advantage of it and sell merchandise for their own pocket. And if you're working on a protest movement, be mindful that even though you create it, it doesn't belong to you. I didn't make this logo for myself. I made it for the women of the world, and it belongs to the women of the world.

Amy Stelhorn is founder and CEO of Big Monocle, based in Utah. Big Monocle designs experiences that connect people to brands at an emotional level.

Below right

Founder of the Women's March L.A. Emiliana Guereca at the 2018 Women's March L.A. at Pershing Square. Los Angeles, January 20, 2018. Photo by Araya Diaz/Getty Images

Below and bottom

750,000 people participated in the Women's March L.A.: activists protesting Donald J. Trump in the nation's largest march the day after the Presidential Inauguration, 2017. Photos by Joe Sohm/Dreamstime

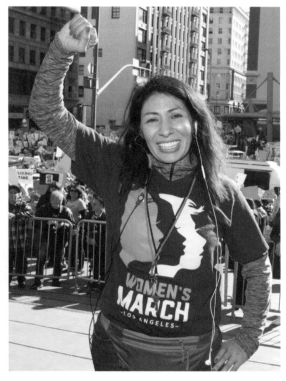

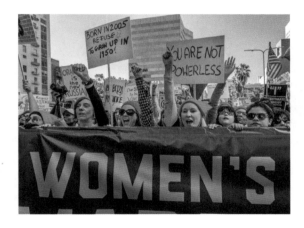

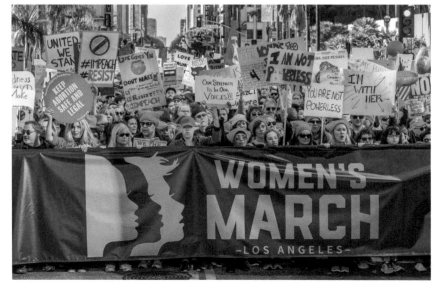

Women's March on Washington

On January 21, 2017 we will unite in Washington, D.C. for the Women's March on Washington. We stand together in solidarity with our partners and children for the protection of our rights, our safety, our health and our families – recognizing that our vibrant and diverse communities are the strength of our country.

The rhetoric of the past election cycle has insulted, demonized and threatened many of us – women, immigrants of all statuses, those with diverse religious faiths, particularly Muslim, people who identify as LGBTQIA, Native and Indigenous people, Black and Brown people, people with disabilities, the economically impoverished and survivors of sexual assault. We are confronted with the question of how to move forward in the face of national and international concern and fear.

In the spirit of democracy and honoring the champions of human rights, dignity and justice who have come before us, we join in diversity to show our presence in numbers too great to ignore. The Women's March on Washington will send a bold message to our new administration on their first day in office, and to the world that women's rights are human rights. We stand together, recognizing that defending the most marginalized among us is defending all of us.

We support the advocacy and resistance movements that reflect our multiple and intersecting identities. We call on all defenders of human rights to join us. This march is the first step towards unifying our communities, grounded in new relationships, to create change from the grassroots level up. We will not rest until women have parity and equity at all levels of leadership in society. We work peacefully while recognizing there is no true peace without justice and equity for all.

Amy Stelhorn attending the Women's
March on Washington. Washington, D.C.,
January 21, 2017.
Photo by Amy Stelhorn

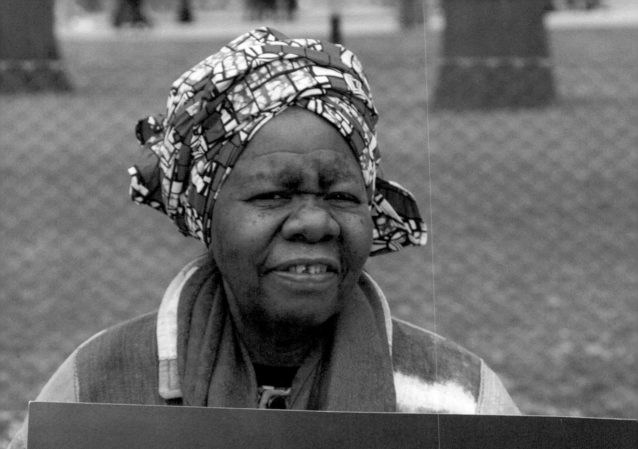

WOMEN'S MARCH
—ON WASHINGTON—

#WhyIMarch @WomensMarch

Protester attends the Women's March on
Washington. Washington, D.C., January 21, 2017.
Photo by Brian Stukes/WireImage

Empathy Is the Driver in Design

This was a dream job for a designer. You didn't have to make up a story, as is often the case with commercial clients – the story was already there. Instead, it was about finding something that is like a canvas or a container for projecting ideas onto. In this case, the core idea was to picture this movement as a diverse group; we wanted to make sure that this would not be an exclusive and privileged movement. It needed to be inclusive of everybody. So when we started creating the concepts, this was the background. The concepts really tried to picture this, to find a way to communicate that "This is a movement of all women."

I really had empathy with the ideas, and empathy is always the big driver in design, so I think that was why I was able to come up with a concept so quickly. At the time, there was a lot of fear. The slogan "Let's Make America Great Again" meant for many people: let's bring everything back to the 50s, which was not fun for women and it was not fun for people of color. That fear was part of the movement, and so it was also part of picturing the logo and the symbol.

The idea was not to create a logo in the traditional branding sense but more of a symbol, which is illustrative, which could also work on a T-shirt, or on a big poster or on a banner. So it's a little bit more detailed and more illustrative than what you would have for a traditional logo. But on the other hand, it's still abstract enough that people can use it for their own marches, or add other city names. It creates a system. And, of course, we could not capture "woman," but this works

like a metaphor. It literally shows women of all races, all genders, ages, cultures and they are in a march, looking into the future, going forward in solidarity and unity.

There's not a brand department like with a big organization; it is all done pretty much voluntarily. I think the fact that most people have adapted it in a good way is a testament to the movement. Also, the design is done in a way that people have really felt like it's something they want to be seen with, something they want to carry onto the streets. I think these two elements came together to make it such a successful program, without any "management" in the traditional sense.

It was so exciting to see how much it was appreciated, and how much it was adapted. It spread like wildfire! It was crazy. It popped up on the Instagram feed of Amy Schumer, then on Saturday Night Live, and very soon it was popping up globally.

This is the beauty of social media, and that is fine, but really it's all about what's happening in the real world. Social media helps as the catalyst in bringing those movements together, and in connecting like-minded people to those movements overnight, and this is amazing. But the street is the ultimate event. You need the streets!

Wolfgang Strack is a designer and creative director based in Oakland, California.

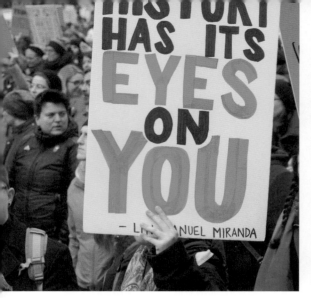

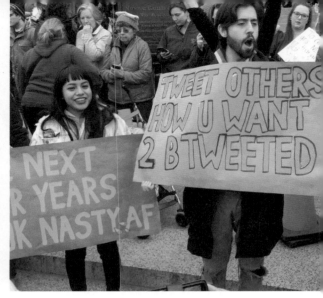

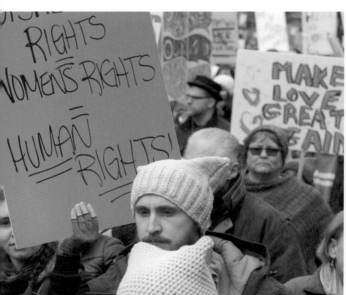

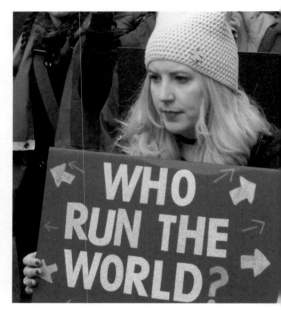

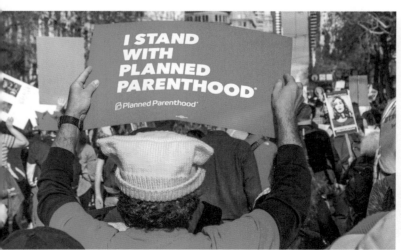

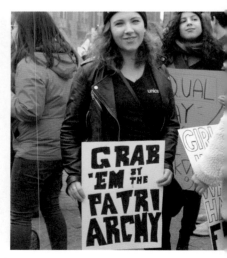

Photos by Martin Reis, Ingeborg Bloem, Beth Miles, Andrei Gabriel Stanescu/Dreamstime, Joe Sohm/Dreamstime

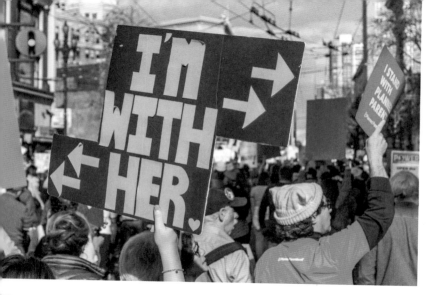

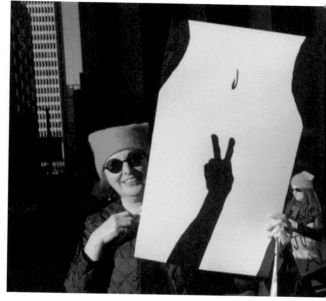

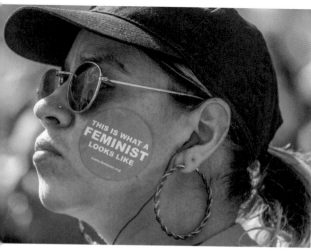

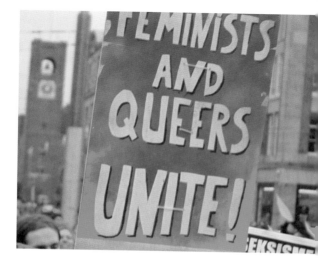

A Sea of Pink

While the Women's March was shaping up, radical ideas were brewing in of all places: a knitting workshop in Los Angeles where, days after the election, the iconic Pussy Hat was born. We asked Jayna Zweiman, co-creator and co-founder of the Pussyhat Project, how the hats came into being.

The initial idea started two days after the election, on November 10, 2016. I got together with my co-creator, Krista Suh, in a knitting class in Los Angeles. We learned how to knit together, and she was also thinking of things she could do. We talked about it and let it sit for a couple days, and then we got back together the next week in our knitting class and started working.

Kat Coyle, our knitting instructor and the owner of The Little Knittery, made the pattern. We wanted something that was both a distinctive silhouette and also very economical to make and very easy. The pattern is one of the easiest you can do. Anybody could make one, even kids. It's just a rectangle folded on its side, and then you stitch from the crease to the ends and you put it on your head. When you put it on, your round head creates the triangular ears.

The idea was to make a strong visual statement on the Mall, so that activists could be better heard. A sea of pink, like pixels – not one specific shade of pink but a huge spectrum, so that when you see everyone from above, you see this mass of people, but you also see all these individuals coming together to make this image. Also, we really wanted to create a way for people who couldn't be at the march to in some way be physically present in support of the marchers. Because not everyone can go to Washington, whether due to physical reasons, financial reasons or scheduling. So we set it up as a platform for participation. Anyone could get involved. But also, it's something kind that you're doing for someone else; you're making something for someone to keep warm and comfortable. People want to do things with their hands. It's an opportunity to express yourself with different colors and different patterns, and I think that really resonates. It really harnessed a lot of people's emotions in a lovely way.

We wrote a manifesto on why we were doing it and we set up the website, created a group on Ravelry, which is like Facebook for knitters, and we had Twitter, Facebook and Instagram feeds. We really thought about, "How do we get a sea of pink on the Washington Mall with only a couple people doing this?" Then we connected with 175 local yarn stores across the country that also act as community hubs. Some people were already going to Washington, so they could take all their groups' hats. And we suggested including a personal note about what is important to you and some contact information. For example, if Planned Parenthood is really important to you; you put this on your note and someone will read it. So, unlike many marches where you just go by yourself or maybe with your friends, the pussy hat connected you with someone new on a topic of women's rights, and you were actually heard. We were very clear about why we chose the name Pussyhat. You know, people had very strong reactions to the idea that someone was running for president who had flaunted the idea

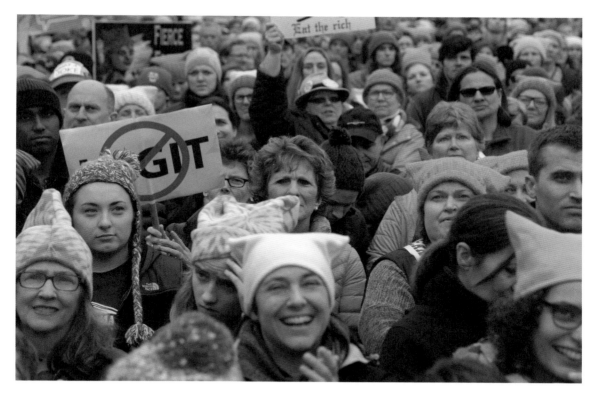

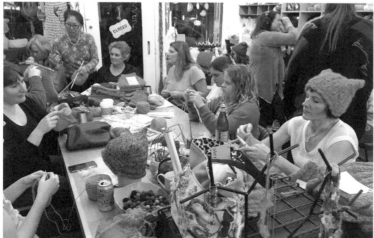

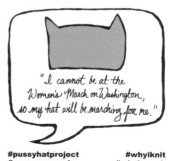

#pussyhatproject #whyiknit
#womensmarch #whyimarch

Top
Women's March on Washington, January 2017.
Photo by Julie Hassett Sutton/Shutterstock
Center left
The Knittery Los Angeles.
Photo by Jayna Zweiman
Center right
Pussyhat Project
Bottom
Women's March Amsterdam.
Photo by Ingeborg Bloem

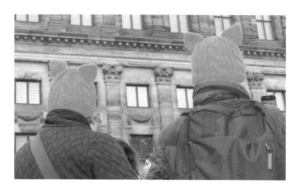

"I think design, and designers, have this incredible opportunity to help lead the way in social movements, and to really make a difference."

Jayna Zweiman, Co-Creator of Pussyhat Project

of committing sexual assault. And it's a racy name, it's quite memorable. We hit just the right moment when the news cycle was quieter and people weren't quite sure how to take action, and this was a proactive, positive response. It wasn't about just posting articles on Facebook, or just getting mad. It was about taking positive action. And it's cross-generational. We had so many volunteers contacting us. So many people made one hat, five hats, a hundred hats.

I'm really interested in the relationship between physical and digital spaces. One could live in only digital space. One could live in only physical space. But to have a truly rich experience, I think you need both. I believe they enhance each other, and that paying attention to both can make a project much stronger. Pussyhat Project harnessed social media into something physical, existing in physical space. And the personal contact is important. One of the strongest experience for me was going through all the notes and seeing all these different points of view. We had writers, photographers, knitters. It's a way of connecting that's so personal, especially in the age of social media.

There were all these conversations happening among people who weren't talking about politics before. It's given people power to realize that they can do things, that they are political. We've heard from people who've said, "The first thing I've ever done politically was take part in this Pussyhat Project. Now I'm on the town council."

I think design, and designers, have this incredible opportunity to help lead the way in social movements, and to really make a difference. It's so important to try to leave this world better than we found it. I think it was successful because it comes from the heart. This is a project about everyone chipping in together, and it's filled with so much love and love for other people. Everyone had something to give.

Jayna Zweiman is a multidisciplinary artist and designer and co-creator of Pussyhat Project.

Opposite
Women's March on Washington, January 2017.
Photo by Brian Allen for VOA

"The idea was to make a strong visual statement so that activists could be better heard. A sea of pink..."

Jayna Zweiman, Co-Creator of Pussyhat Project

"We cross our arms to express our dissatisfaction with the government."

Joshua Wong, Student Leader

Cross Your Arms

A perfect example of body-gesture protest originated in Hong Kong in 2014. The crossed-arms gesture evolved into one of the key branding tools of the Umbrella Movement.

Student pro-democracy group Scholarism convenor Joshua Wong (C) makes a gesture at the Flag Raising Ceremony at Golden Bauhinia Square. Hong Kong, October 1, 2014. Photo by Anthony Kwan/Getty Images

GESTURE AND SYMBOL

Pro-democracy campaigners widely adopted the crossed-arms posture during the Umbrella Movement protests. Also known as Occupy Central, the protests took place in 2014 to demand freer elections of Hong Kong's top leader. Over 79 days, a civil disobedience campaign brought parts of the busy city to a standstill. Crossing the arms symbolized resistance to the political status quo, while simultaneously underscoring the peaceful nature of the protest. With this posture, demonstrators emphasized that they were carrying no weapons. The gesture transmitted the message that they were neither using nor advocating violence to achieve their aims.

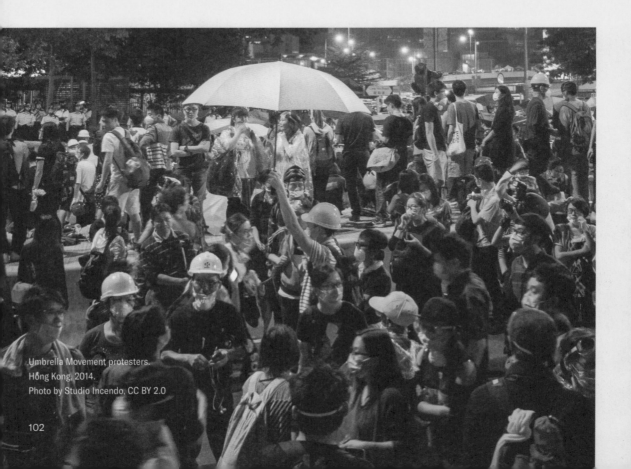

Umbrella Movement protesters.
Hong Kong, 2014.
Photo by Studio Incendo, CC BY 2.0

The Umbrella Uprising

Two days after the September 26, 2014 occupation by protesters of Admiralty in Central Hong Kong began, riot police used pepper spray and tear gas against protesters. In an attempt to protect themselves from the chemicals, protesters took cover under their umbrellas. The ultimate symbol of the Hong Kong protests – the yellow umbrella – was born. The yellow umbrella became a potent symbol of political protest: a global icon of the pro-democracy movement in China.

Because of the sheer scale of the movement, the umbrella helped launch open discourse within a political situation lacking certainty and clarity.

A Mirror for Protesters

As a symbol, the umbrella was embraced by a plethora of protest organizations based in Hong Kong. It also continues to serve as a great inspiration to artists. One example is the *Umbrella Man* – a wooden human figure reaching 4 meters (13 feet) tall created by an artist who calls himself Milk. A recent college graduate, Milk shared in a rare interview that he got the idea to make the sculpture during the early stages of the movement's sit-ins. With the assistance of a few friends, Milk debuted the now-iconic work of art on October 5, 2014 at the Admiralty demonstration site in front of the Hong Kong government's headquarters. Constructed of plywood blocks with a metal support frame, the figure was designed with its right arm extended, brandishing a yellow umbrella. The face is painted white, a reference to the protesters struck by tear gas and pepper spray used by the police. *Umbrella Man* tells the people's story of the protest. Adopted by the movement as an emblem of freedom and peace, *Umbrella Man* became a mirror in which the protesters could see a reflection of themselves.

Umbrella Man makes a great many people – especially those from older generations – nostalgic, for they see the figure as a second coming of the Goddess of Democracy, a 10 meters tall (33 feet) statue that was created during the Tiananmen Square protests of 1989. The statue was constructed in four days and was made of foam and

papier-mâché over a metal armature. The two works of art – each being giant three-dimensional sculptures, similar to Roman equestrian statues – are a quintessential form of branding.

Art As Protest

Many artistic works were created during the Umbrella Movement, many of which were displayed at the three main protest sites at Admiralty, Causeway Bay and Mong Kok. Often forming an integral part of protest and activism, art is a primary means of expression as well as a way of documenting events.

The key symbol of the Hong Kong protests, the umbrella, has a long history as a signifier of shelter, protection, power and dignity. The protesters' use of the umbrella to deflect police pepper spray and tear gas transforms the everyday object, ordinarily used to protect against the elements, into an icon. On a political level, the umbrella has become a symbol of resistance against social injustice. Used en masse, Hong Kong's occupied streets became a vast creative canvas; an enormous arena for artistic and political expression.

"When the rules that bind your action are suddenly lifted, you are given the freedom to redefine everything," said one artist. There was a proliferation of artworks featuring umbrella forms. These included umbrellas covered in drawings or decorated with calligraphy, balloons twisted into umbrellas and mobiles made from origami umbrellas. Many of the artworks created were characterized by an elevated aesthetic sensibility.

Protest Logos

Artist Kacey Wong (a former assistant professor of design at the Hong Kong Polytechnic University) initiated an international contest for a protest logo. The competition's goal was to raise awareness and generate more concern around the demand for democracy in Hong Kong. Wong once stated that the use of social media (such as Facebook) allows for the creation of a safe platform for universal participation, which in turn generates awareness. Entries were received from all over the world, many by professional artists – among them was an artwork created by French urban artist Invader.

Yellow Ribbons

Used to represent the women's suffrage movement in the United States and subsequently embraced by suffrage movements elsewhere, the yellow ribbon was adopted by the Umbrella Movement early on. Activists adorned street railings and barricades with yellow ribbons, pinned them on their shirts and used them on their Facebook profiles. The symbolic use of the color yellow crossed over onto the umbrellas. "Not everyone can be there on the front lines," says Wong. "The ribbon is a way to show your support."

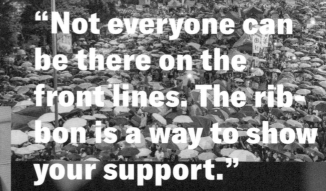

> **"Not everyone can be there on the front lines. The ribbon is a way to show your support."**
>
> **Kacey Wong**, Artist

WHERE HAS MY DREAM CITY GONE?

UMBRELLA REVOLUTION 渣打革命

Top left
Yellow ribbons on Civic Plaza.
Photo by Cecilia Pang, CC0 1.0

Top right
Protesters with umbrellas at Admiralty.
Photo by Studio Incendo, CC BY 2.0

Top center
Yellow ribbons, Umbrella Revolution.
Photo by Cecilia Pang, CC0 1.0

Background
Umbrella Man by Milk at Umbrella Square.
Hong Kong October 11, 2014.
Photo by Paula Bronstein/Getty Images

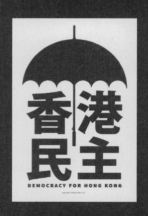

DEMOCRACY FOR HONG KONG

1

2

3

4

遮打革命
HONG KONG
UMBRELLA
REVOLUTION

5

撐起雨傘

#UMBRELLAREVOLUTION

6

Protest Logos

During the Umbrella Movement Hong Kong artist Kacey Wong launched an international online competition for the best logo design. The top three prizes for the contest were: "Justice, Democracy and Freedom."

"Social media has changed the way one participates in social movements, such as a revolution. I started the contest as a disguise to generate more concern for our cause," said Wong. "The objective is to create a 'safe platform' for everyone to participate. It is through this kind of participation that we can generate enough awareness."

1-4
Chris Lee and
Hon Cheung Wong
5
Sunny Yuen
7
Lance Chiu
7
Evangelo Costadimas
8
MA

All artwork courtesy
Umbrella Movement Art Preservation
via Facebook

HONG KONG 28SEP2014

7

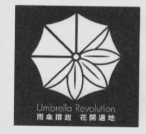

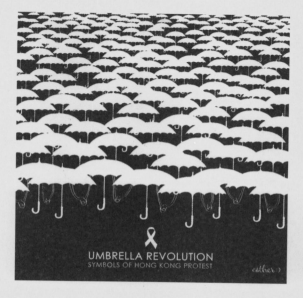

UMBRELLA REVOLUTION
SYMBOLS OF HONG KONG PROTEST

8

"Hong Kong is a city that periodically takes refuge under umbrellas against seasonal typhoons that threaten the city. The turmoil is another storm Hong Kong is trying to weather."

Bryan Druzin, Assistant Professor of Law, Chinese University of Hong Kong

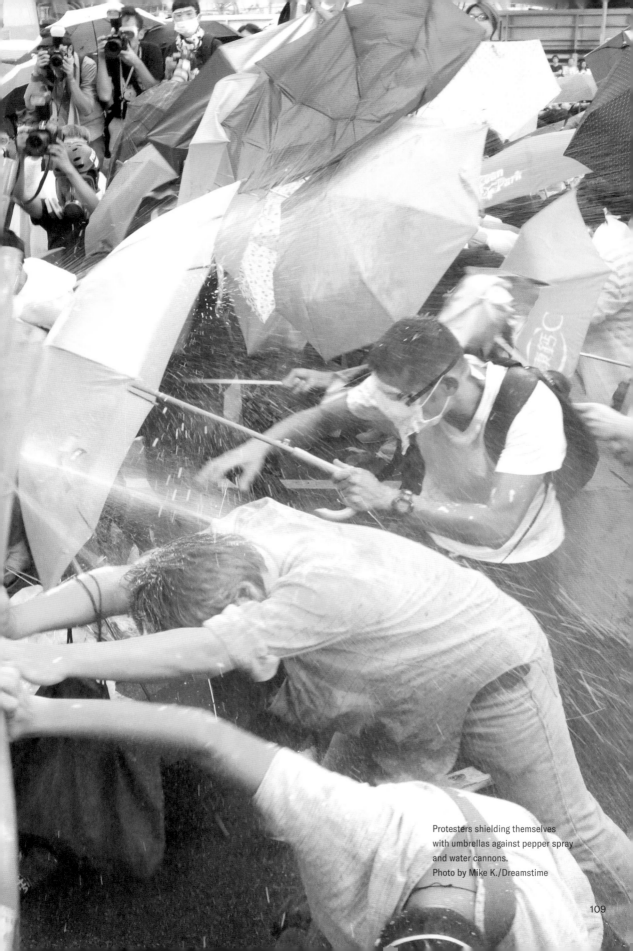

Protesters shielding themselves
with umbrellas against pepper spray
and water cannons.
Photo by Mike K./Dreamstime

Silent Messages

Sometimes actions speak much louder than words. The participants in the Umbrella Movement began to use their yellow umbrellas indoors as well as outsite. This action spoke volumes.

Take Paul Zimmerman, a district councilor and member of the Civic Party. Zimmerman was one of the first individuals to protest in this manner. Two days into the movement, Zimmerman proceeded to open a yellow umbrella at an indoor reception following the China National Day ceremony, an event attended by representatives of the government of the People's Republic of China.

Installations

As well as distinct sculptures, various larger installations emerged at protest sites. One of the largest was the *Umbrella Canopy*. Suspended in the center of Umbrella Square (a roadway in Admiralty that was filled during the protests), the patchwork piece was made of fabric sewn together from hundreds of broken umbrellas, many of which met their demise during the riot actions of September 28. Police forcibly snatched umbrellas from the hands of protesters and broke them. Others were stained with tear gas. Tse, the project leader, characterized the canopy of broken umbrellas as a symbol of extended physical protection for citizens and a reminder to support others. At Admiralty, large yellow umbrellas were installed across many lampposts. The mixed media installation *Happy Gadfly* created by mainland artist Miso Zo was inspired by Ethel Lilian Voynich's book *The Gadfly*. About the installation – created from discarded plastic bottles, umbrellas and other waste materials – the artist says, "They can destroy the movement, but like the fly it will come back again." A pepper spray installation at Causeway Bay and a shrine to Guan Yu at Mong Kok are other notable works to emerge from the movement.

Playlist

Hong Kong's pro-democracy protests developed a rich musical culture. During the actions, demonstrators often burst into song, creating a distinctive soundtrack for the Umbrella Movement. Pop stars and indie bands took part in the protests from the start, singing about the demand for universal suffrage, encouraging civil disobedience and condemning the police's use of tear gas.

The most legendary protest anthem is "Under a Vast Sky," a '90s rock ballad by the band Beyond. In order to set the tone, crowds often used this as their go-to song.

Hong Kong pop stars Anthony Wong and Denise Ho joined the large number of protesters at Occupy Central. Wong and Ho went on to lead a number of local musicians on a version of "Raise the Umbrella," a song originally composed by Pan Lo and released online to support the movement.

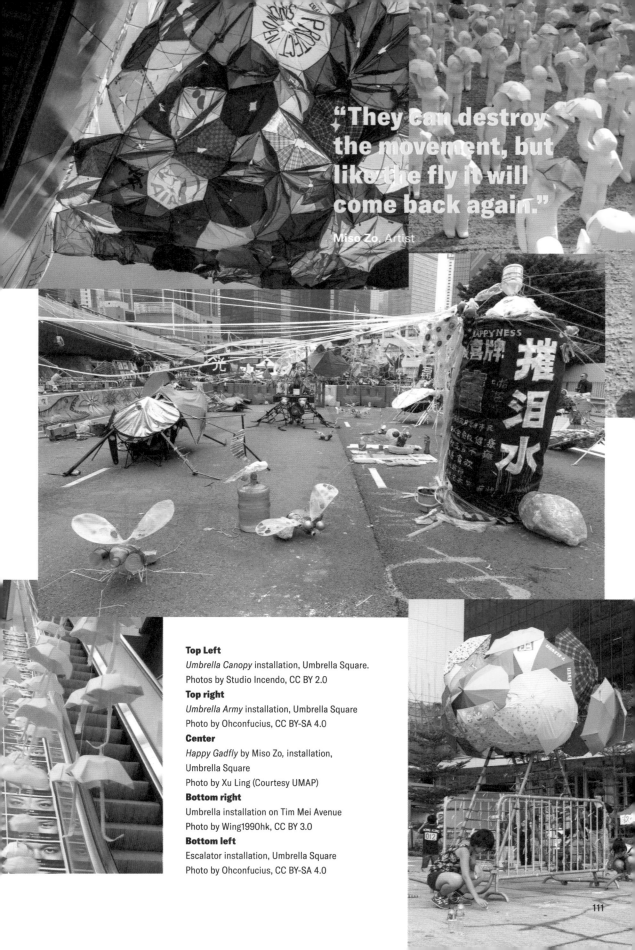

"They can destroy the movement, but like the fly it will come back again."

Miso Zo, Artist

Top Left
Umbrella Canopy installation, Umbrella Square.
Photos by Studio Incendo, CC BY 2.0

Top right
Umbrella Army installation, Umbrella Square
Photo by Ohconfucius, CC BY-SA 4.0

Center
Happy Gadfly by Miso Zo, installation,
Umbrella Square
Photo by Xu Ling (Courtesy UMAP)

Bottom right
Umbrella installation on Tim Mei Avenue
Photo by Wing1990hk, CC BY 3.0

Bottom left
Escalator installation, Umbrella Square
Photo by Ohconfucius, CC BY-SA 4.0

Like any urban culture, Hong Kong's Cantonese-language culture is known for its quick and evolving use of slang and profanity. It came as no shock, then, when the song "If I Call You a Stupid Dick, I'm Afraid You'd Be Mad," went viral on social media.

Another favorite is "Do You Hear the People Sing?" from the musical *Les Miserables*, with Cantonese lyrics substituted for those of the original.

"Imagine" by John Lennon and songs by My Little Airport added to the list. The musical culture created by the movement will stand the test of time.

Xi Jinping Parodies

After an image of an umbrella-holding Xi Jinping, the general secretary of the Communist Party of China and leader of the People's Republic of China, won a photojournalism award in China on October 22, 2014, cut-out parody versions of the photo depicted a yellow umbrella instead. The altered image was used on stickers, posters, life-size cut-outs and banners. The cut-outs of figures, many featuring anti-communist and pro-democracy slogans, were a popular backdrop for selfies by mainland visitors.

Message Boards

Many walls and spaces in Umbrella Square were plastered with posters and messages of encouragement during the protests. Buses and barricades were abandoned along the streets of Mong Kok after crowds started gathering. These vehicles also became alternative message boards.

The Lennon Wall, named after the one in Prague, was a mosaic of multicolored Post-it notes from supporters. The handwritten messages were mostly in Chinese and English, although supporters from various countries left messages in a range of other languages. Many notes expressed support, peace and words of encouragement, while others called for a genuine democracy and political change.

Support Statements

Stand By You: Add Oil Machine was a spontaneous four-month art project by artists Sampson Wong, Jason Lam and others. Its aim was to display messages of support to Umbrella Movement protesters. The name refers to "add oil," an idiom conveying encouragement in Chinese. The project included a website where people from all over the world could post messages. These were then strategically projected onto the sides of buildings. More than 30,000 messages were sent by well-wishers from 70 different

countries. The *Stand By You* project received messages of support from, among others, Pussy Riot and Peter Gabriel, who were photographed with open umbrellas. Peter Gabriel said, "Water gets everywhere – like the will of the people." The project was very successful and won first prize in the 2015 Freedom Flowers Foundation Awards.

Lion Rock's Yellow Banners

The occupation site was beginning to clear, and Hong Kong police were doing all they could to restore normalcy. Or so everyone thought. A large yellow banner was placed on a mountain known as Lion Rock (located in Kowloon). Fourteen mountain climbers placed the 28-meter-long banner on the mountain. The banner displayed a now familiar umbrella with the phrase "CY Step Down," a message directed at Chief Executive Leung Chun-ying. The banner could be seen throughout most of Kowloon. The plot was documented and posted on YouTube.

Written in Chinese, the banner had the words "I want real universal suffrage." The banner was taken down a day later, but just days after that, similar banners emerged on top of Fei Ngo and Tai Mo Shan.

The Lion Rock banner would go on to inspire many artists to create copies.

Top
Stand By You: Add Oil Machine website addoilteam.hk.
Stand By You: Add Oil Machine projections in Umbrella Square.
Photo by doctorho, CC BY-SA 2.0
Bottom right
Lion Rock yellow banner.
Photo by Studio Incendo, CC BY 2.0
Opposite
The Lennon Wall in Umbrella Square.
Photo by doctorho, CC BY-SA 2.0

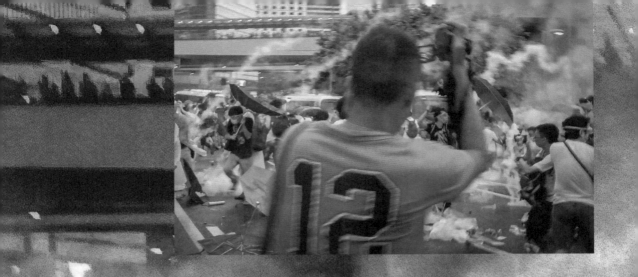

The now famous "umbrella man" photo was taken on September 28. The image shows an unnamed protester holding an umbrella in each hand while walking through tear gas fired by riot police. The image was retweeted thousands of times, along with multiple similar photographs posted during the protest, which show individuals using umbrellas to protect themselves from tear gas and water cannons. The picture's popularity, as well as that of similar images, caused the media to dub the protests the Umbrella Revolution.

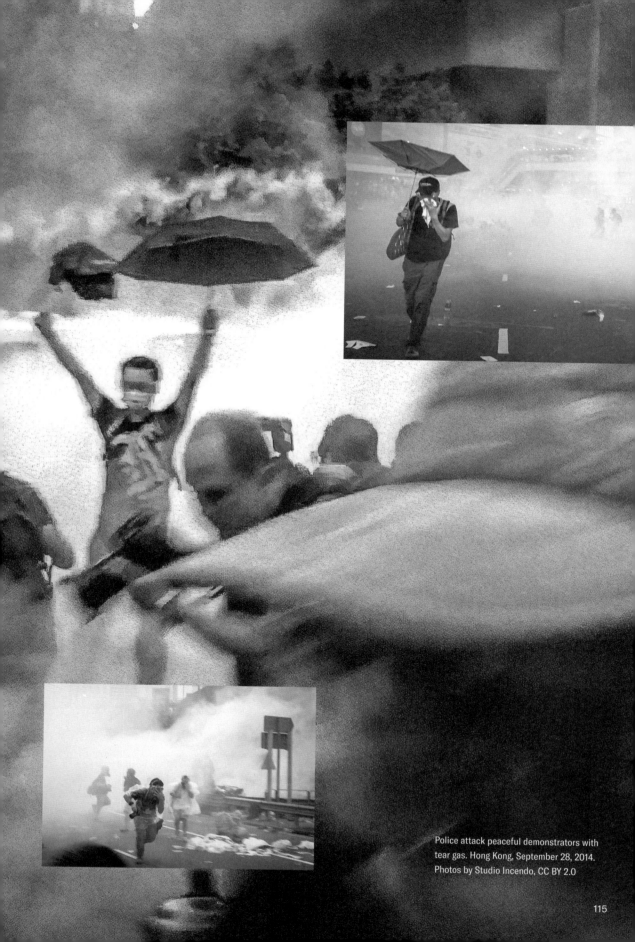

Police attack peaceful demonstrators with
tear gas. Hong Kong, September 28, 2014.
Photos by Studio Incendo, CC BY 2.0

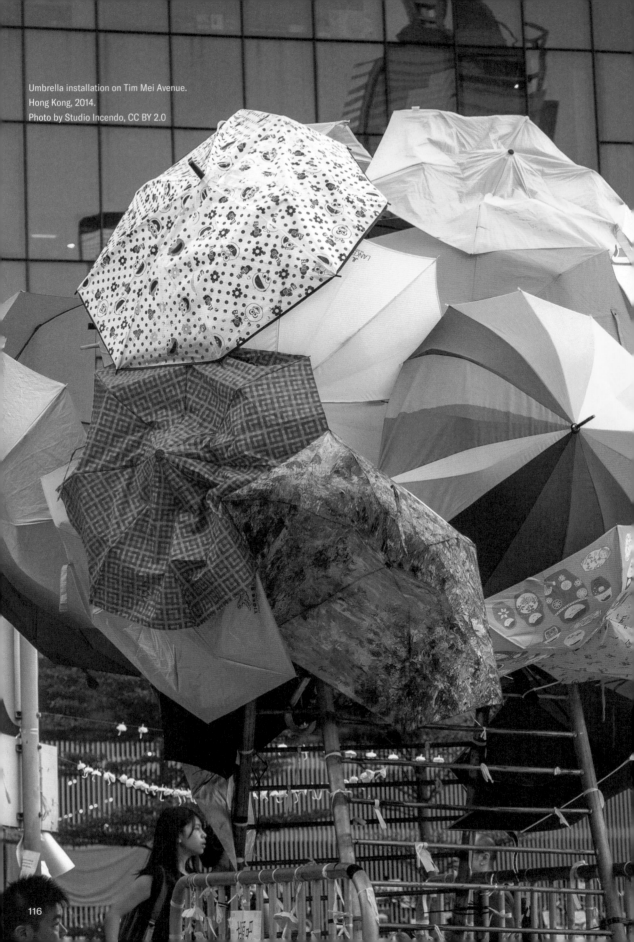

Umbrella installation on Tim Mei Avenue.
Hong Kong, 2014.
Photo by Studio Incendo, CC BY 2.0

Five Points of Protest Art

By KACEY WONG

I often ask myself, "What is the point of partici-pating in public demonstrations? Would it change anything?" If you are thinking like this, then you are thinking in a problem-solving way. Yet in the world of art and design, it is more than just problem-solving. One can bring forward issues by using art and design so that people can see problems more clearly, generating more discus-sion and reflection. Imagine if we transformed public demonstrations and protests into our own private gallery – what would that look like? This is actually already happening. There were many protesters creating their own props and bringing them to protests, allowing everybody to see the problem visually, apart from listening to slogans or reading words.

Five Points of Protest Art

When we are studying, we need to have some bullet points in order to memorize complicated concepts easily, these are my Five Points of Protest Art:
- Big
- Light
- Easy to Understand
- Artistic
- Quick Release

Big

There are many things to see during public demonstrations. If your "object of demonstration" is small, then no one will see it. Make sure your sculpture is large enough to be seen from far away.

Light

Public protests and rallies often start in Victoria Park in Causeway Bay and end in Admiralty. If your protest art is heavy, then you will end up

Roving Classroom lecture by Kacey Wong

punishing yourself – please do not do that. You can add wheels, just like those on the Drift-ing Classroom I stand on. Students said they would boycott classes, and I replied, "It's OK. I will chase you, since I've got wheels." Anything could happen during a public demonstration; you should equip yourself. Prepare for the worst; hope for the best.

Easy to Understand

There are so many things happening during a public demonstration. Things get quite confus-ing at times. Therefore you must communicate by creating an easy-to-understand artwork. The media is constantly on the lookout for something interesting – a snapshot of your work could be seen and shared by thousands on the internet. Focus on taking advantage of your right to speak by spreading your message to as many people and as far as possible.

Artistic

As a creative artist or designer, you have a stronger visual sense and technique than other protesters. The protest art you create should

feature craftsmanship and have an artistic meaning. Some people might think political artwork is not art, but they are wrong. There was an exhibition at the Victoria and Albert Museum in London titled *Disobedient Object*. It showcased protest-related objects dating back to 1970. We should put in more effort when creating political art and try to achieve a high aesthetic level and bring out the truth.

Quick Release

The final point is to release your work as quickly as possible – the timing must be correct. We are living in the era of new media, and new posts go up almost every single minute. Everything comes and goes so quickly. Nowadays all you need is a smartphone; anyone can be a temporary leader – even one who is not physically at the protest site.

Example 1: Attack of the Red Giant

My first artwork, *Attack of the Red Giant*, is a derivative work based on the Japanese comic *Attack on Titan*. It's a giant sculpture made of cardboard built on a trolley. It stands out in a crowd due to its red color and height. The color is from the plastic adhesive tape, which also makes the sculpture waterproof. When pushing this giant sculpture, you don't need to yell any political slogans because your artwork is speaking for you visually. The work was juxtaposed against the protesting crowd and the architecture on both sides of the road, creating an interesting contrast.

Example 2: Grass Mud Horse

Grass Mud Horse was created back in 2011 when mainland Chinese artist Ai Weiwei was arrested and detained by the Chinese government. Art community members in Hong Kong felt this was not right, so we organized a public protest calling for the immediate release of Ai Weiwei in which 2,000 people participated. Getting him released was actually quite a difficult goal, but that didn't

mean we couldn't do or say something. We should all come out and resist, because when you see what happened to Ai Weiwei, you see the future of Hong Kong. As an artist, this was my moment of political awakening.

After the Ai Weiwei incident, I was curious to find out why the Chinese Communist government is so afraid of this fat guy. Reading up, I discovered that Ai was trying to improve building laws by revealing the death toll of young students in the Great Wenchuan Earthquake. He was trying to prevent jerry-built projects. In a highly corrupted system, you might expose government bribery cases, and that is one of the main reasons why Ai is suppressed. It is so difficult to be a good guy in mainland China.

Philosopher Goethe once said: "Knowing is not enough, we must apply." This is why I created the *Grass Mud Horse*, since it is related to a photograph done by Ai Weiwei, and the subtext is extremely powerful (it sounds like "fuck your mother" in Putonghua [the standard spoken form of modern Chinese]). There are four wheels underneath the *Grass Mud Horse*. When it reached the Cultural Centre in Tsim Sha Tsui, I rode on top and gave a speech. Try to make yourself comfortable so you will have the energy to resist. Resistance does not bring success immediately; you may even not see success during your lifetime. Consider it sowing a seed; the plant will grow later.

Example 3: The Real Cultural Bureau

I was saying that artworks need to be big, but how big is really big enough? Let's look at another work, *The Real Cultural Bureau*. The Hong Kong government was trying to set up a Cultural Bureau a few years ago. The official they were trying to appoint didn't really know much about art and culture policy. Many art and cultural people worried that the bureau might become

another brain-washing tool to be used against its citizens. If you are planning to create political artwork, then you must pay more attention and link it to the news around you. Prior to creating *The Real Cultural Bureau*, the People's Liberation Army (PLA) purchased some armored personnel carriers (APCs). When Hong Kong citizens saw these armored cars, they were very afraid because they associate these types of vehicles with the killing of many innocent Chinese students and citizens back in the 1989 June 4 Tiananmen Square Massacre.

Linking to the above news, I created a tank-like APC by using wood and cardboard on a trolley so it could be pushed and moved in all directions easily. I also dressed up as a low-ranking Communist Party official whose responsibility was to bribe the Hong Kong people. I printed a suitcase of fake money and then shouted to the protesters in an official tone: "I now order all of you to leave immediately! Do not put up any resistance! Here is some money, 100 million each! Take it!"

Ever since then, I put on my Chinese tunic suit, Ray-Ban sunglasses and red pins and play the role of Real Cultural Bureau Director. My bureau is still in operation yet the government's cultural bureau was eventually dismissed due to objections from the public. The greatest achievement of *The Real Cultural Bureau* is that its photo got published on the Communist newspaper *Ta Kung Pao*. The reporter didn't know the sarcastic meaning of the artwork and took a photograph of me with the students. I infiltrated them!

Example 4: The Pinocchio
We shout a lot of slogans during protests, but how long can one yell continuously? When I was portraying the Real Cultural Bureau Director my voice became hoarse in two hours, and later I finally lost my voice. Lesson learned. So I developed

a new strategy for my next work, *The Pinocchio*. A loudspeaker was installed at the bottom of the sculpture, connected to my smartphone. A recorded sound clip of Henry Tang Ying-yen questioning CY Leung during a public debate was looped and played loudly: "You lied. You are lying. How come you are always lying?" Let technologies help your cause – it makes life much easier.

Example 5: Hong Kongese Warning Squad
The *Hong Kongese Warning Squad* was exhibited during the July 1 protests in 2014. Hong Kong police usually display these plastic banners before they execute violence: "Stop Charging or We Use Force." The flag is a movable police line, and I decided to create a work to reflect and criticize it. Four friends and I dressed up like police waving five warning flags: "Party-State," "Fake Commie," "Redden," "Love thy Party" and "Corruption." These are the issues Hong Kong is facing on a daily basis.

When we met the policemen, we decided to take some photographs with them to "exchange" a bit. The police turned away; maybe they still have some sense of shame. Other protesters saw this and clapped their hands. A photograph of the *Hong Kongese Warning Squad* was posted on Apple Daily's web page and attracted 15,000 likes! This is actually very sad since the Hong Kong police is paid by taxpayers to protect the citizens, but they have been transformed into a tool of suppression, executing the law selectively. We wish the Hong Kong police would perform its true duty: to be good civil servants and safeguard the citizens of Hong Kong.

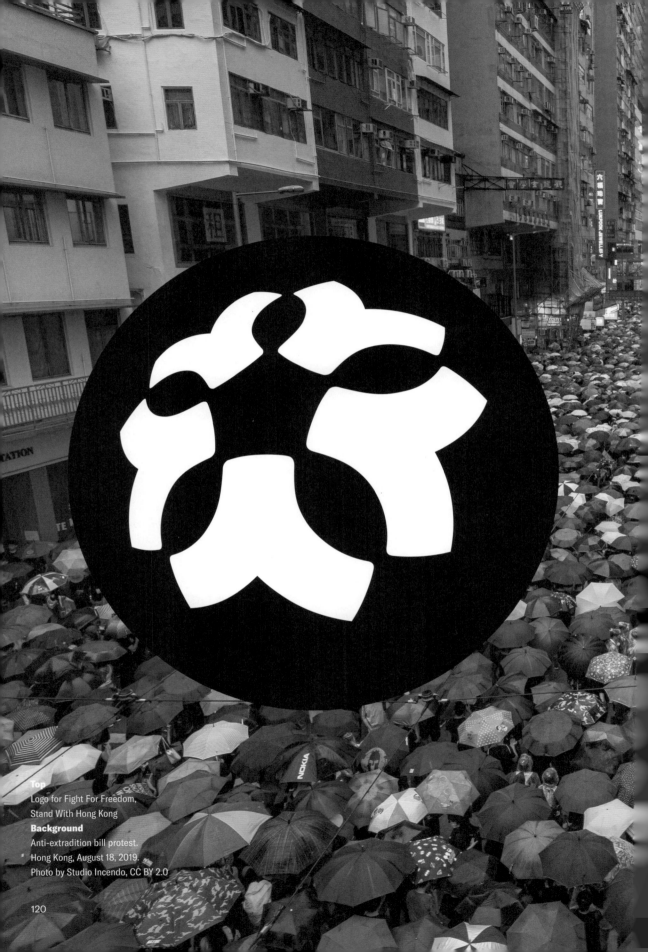

Top
Logo for Fight For Freedom,
Stand With Hong Kong
Background
Anti-extradition bill protest.
Hong Kong, August 18, 2019.
Photo by Studio Incendo, CC BY 2.0

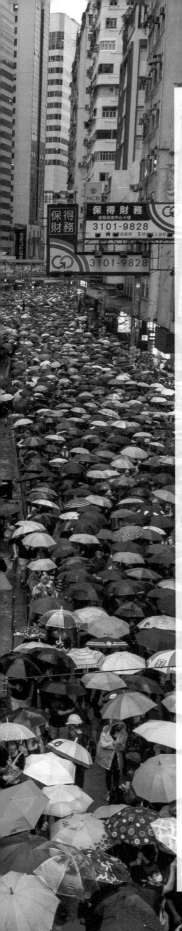

Five Years On

By TERRIE NG

Five years have passed since the Umbrella Movement. The symbolic umbrella image reoccurs in the midst of a new social movement in Hong Kong. In June 2019, an extradition bill proposal by the Hong Kong government prompted more than 2 million people to take to the streets. In this bill, the Hong Kong government proposed an amendment to the Fugitive Offenders Ordinance and the Mutual Legal Assistance in Criminal Matters Legislation Ordinance, which would allow extradition of criminal suspects on a one-off, case-by-case basis, with the authorization of the Hong Kong chief executive. What worries Hong Kong citizens the most is that the bill also allows for extradition to China, and Hongkongers have no confidence in China's judicial system.

On the surface, current anti-extradition bill protests may seem different to the 2014 Umbrella Movement, yet they both share a fundamental problem: China's violation of Hong Kong's semi-autonomous status, which is why universal suffrage is urgently called for as a defense mechanism. The shadow of the Umbrella Movement remains highly visible in the course of the current protests. For instance, the emblematic yellow color is borrowed from the yellow ribbon, which now represents pro-democracy spirit, and is widely employed on numerous posters and illustrations. The extended use of the umbrella symbol on pro-democracy campaigns is also highly prevalent. For instance, the popular petition Fight For Freedom, Stand With Hong Kong employs an umbrella-like logo, which consists of five identical Chinese characters: "人." The character, meaning "person or people," conveys several meanings: the convergence of people around the globe in Hong Kong; five key demands made by the protesters; five petals of the bauhinia flower on the Hong Kong SAR flag; and, of course, in the shape of an opened umbrella, the symbol of the Umbrella Movement.

"What is the picture that, if people were to see, with no logo on it, how would they know it is Amnesty?"

Thomas Coombes, Head of Brand and Deputy Director of Communications at Amnesty International

STAY UNITED, STAY HOPEFUL, STAY STRONG.

#KIAKAHA

MOONDAY THE WEEKEND MOVES ON...

- EVERY MONDAY DEEP-TECH-HOUSE -

04-05-15 SUN JAMO | YOSH HOUZER
11-05-15 TORUS PROJECT | N.O.B.
18-05-15 EDUARDO DE LA TORRE | TORUS PROJECT

01.11.2015

"It's better to light a candle than curse the darkness."

Amnesty International is a global movement of more than seven million people who take injustice personally. Amnesty is campaigning for a world where human rights are enjoyed by all.

As we reflect on the past, we recognize the milestones in the branding for Amnesty. In the '60s and '70s, individual's made beautiful posters. The rather unique posters allowed each individuals voice to be heard. Then, in 2005, Amnesty started a large scale rebranding project with brand consultancy Wolff Olins. Currently, there's another shift in strategy based on a more optimistic approach. We asked Thomas Coombes and Simon Pates from Amnesty International about it.

Thomas Coombes Basically, the two big moments that forced us to reevaluate how we communicate was the refugee issue in Europe and the election of Donald Trump. I saw that our goal was raising awareness. I think what's happened with the Amnesty brand and in the organization is what's happened with the human rights movement in the post–Cold War era. We were very much focused on implementation of the law rather than focusing on shifting the attitudes that support those laws. There's actually a quote from Peter Benenson. He created Amnesty. He said, "Governments are only prepared to follow where public opinion leads," but we actually moved away from that and were focused very much on naming and shaming.

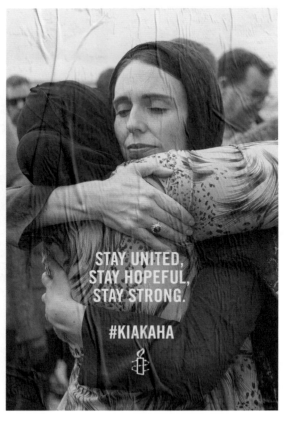

STAY UNITED,
STAY HOPEFUL,
STAY STRONG.

#KIAKAHA

ADIÓS

GOODBYE TO GOVERNMENTS
RESTRICTING REPRODUCTIVE RIGHTS,
TO THE THIRD LEADING CAUSE OF
MATERNAL DEATHS WORLDWIDE,
TO CLANDESTINE ABORTIONS,
TO ABORTION BEING A CRIME.

IN 2019, WE'LL FIGHT TO
DECRIMINALIZE ABORTION IN
ALL COUNTRIES WHERE IT IS
STILL A CRIME.

JOIN THE FIGHT.

JOIN US

HOPE-BASED COMMUNICATIONS IN FIVE STEPS

AGAINST ☞ FOR

SAY HOW THINGS
SHOULD BE

HOPE-BASED COMMUNICATIONS IN FIVE STEPS

FEAR ☞ HOPE

HOPE LEADS TO EMPATHY,
EMPATHY LEADS TO SOLIDARITY,
SOLIDARITY LEADS TO JOY

HOPE-BASED COMMUNICATIONS IN FIVE STEPS

VICTIMS ☞ HEROES

CELEBRATE THE
HUMANITY IN PEOPLE

Amnesty International campaigns showing
the new strategy based on hope.

But what we realized was, "How do we name and shame in an era where leaders are shameless?" That prepared us to actually look again at how we're doing things. It's not enough just to bring suffering to light. At the same time, we were looking at research from neuroscience and cognitive linguistics that made us realize that the environment that was opening people up to the rise of the far right is actually caused by fear. We have to ask ourselves, "Are we actually inadvertently reinforcing that fear and that doubt ourselves?"

There is a crisis, but there is a solution. "Build a wall" was a lot more vivid than our solution, which is that we wanted safe and legal routes for refugees. We weren't doing a good enough job of making the case for what we wanted. We started shifting, basically completely transformed the way we do communication. We used to fear attacking the other side and now we realize we need to actually just make the case for the things we believe in.

I think you see that happening a lot in politics as well, that we realize people have to stand up now and say that humanity is something that we need to defend. In her book *Evidence for Hope*, the academic Kathryn Sikkink quoted a colleague of mine who works in Egypt, and in that quote she says that she has no hope for Egypt because things are worse than they were before the Arab Spring. It's a brutal dictatorship. I just remember thinking of my own family history, how my parents found refuge in Switzerland. But that moment before, when they were fleeing, there was no hope for them, and there was no hope for most people in Europe in 1942, but they survived. So there was hope. I realized what the human rights movement needs to give people is actually not telling them how bad things are but that there's hope. That's the starting point of this major shift.

It's interesting, because in terms of the Amnesty logo, people interpret the Amnesty candle in different ways. My boss assembled the communications program and said that Amnesty had a saying that, "It's better to light a candle than curse the darkness," but our communication teams spend a lot of time cursing the darkness, rather than lighting a candle.

To me, brand is about: what is the picture that, if people were to see it with no logo on it, how would they know it is Amnesty? It maybe comes from a more social media focus, as I want our story to be told through other channels. For some people, Amnesty is a researcher in the field speaking to a victim; for others, it's a protest. And to me, there's a big danger – again, speaking to the emotions – that if we show angry people, protests then appear angry and we're actually alienating a large part of the people we need to reach.

The rebranding 10 years ago was like a rationalization. Having one single logo was basically creating more design consistency. We created consistency about our look and feel, but we didn't actually achieve or even try to achieve consistency about what we

stand for, what we are trying to achieve, what our beliefs and values are. We started to work at a brand manifesto, which was just taking injustice personally and mobilizing the humanity in everyone.

What was missing was basically a value message in terms of brand. But that was the level we had gotten to, where people weren't aware of our values, and they're quite obvious: solidarity, universalism, mutual respect. But people didn't know they were written there.

Colleagues in Amnesty think we're a research organization, while our colleagues in South Africa think we're a movement. That image we want people to have in their head when they think of Amnesty was not consistent. But, above all, what's the idea that we want people to share? That wasn't consistent either. We're not necessarily going to force people to all use the same things, but we have a strategy; some very basic ideas about how the world works. Our worldview – that we're all human and we should all treat each other that way – is actually something that's becoming weaker in the world. And so to me, brand is part of the strategy of changing that. It's actually crucial to achieving our goals.

So much of the visual material we produce these days is what we're against, not what we're for. That's again why our current design project is to try to actually articulate this. I ask people, "What will the world look like?"

It's not easy – that's for sure. I definitely get some instinctive resistance from people who say, "Sometimes we need to be angry." I'm telling them they have to be hopeful 100% of the time. And so right now, we're 95% angry and 5% hope, so we can see it's a little bit more hope; but in the future, it will be more about hope than anger.

We're constantly – in our material – saying, "Refugees are not criminals," for example, which actually reinforces the idea that refugees are criminals. Or: "We are against hate," or we talk about a world free from the death penalty. But we never actually say what we want then. When we say we want the world free from the death penalty, what we're actually saying is, "Everyone deserves a second chance."

At Amnesty New Zealand, right after the attacks in Christchurch, their response was going to be, "We stand against hate," and then they said, "Let's apply the checklist," and they shifted it to messages of hope. They asked their supporters all over the world, who sent messages of solidarity and hope to the Christchurch victims, and then they put posters all over the country with those messages.

In Ghana, they ran a campaign, and instead of saying, "End the death penalty," they said, "Give life a chance." Our basic principle at Amnesty is that human rights are universal, and this applies everywhere. Definitely, in terms of emotion, the way the brain works is also the same everywhere.

ADIÓS

COMPLICATIONS FROM UNSAFE ABORTIONS
ARE THE LEADING CAUSE OF MATERNAL
DEATHS IN ARGENTINA.

ON AUGUST 8, SENATORS IN ARGENTINA
COULD CHOOSE TO CHANGE THIS IF THEY VOTE
THROUGH A BILL TO DECRIMINALIZE ABORTION.

THE WORLD IS WATCHING.

#AbortoLegalYa

Amnesty International

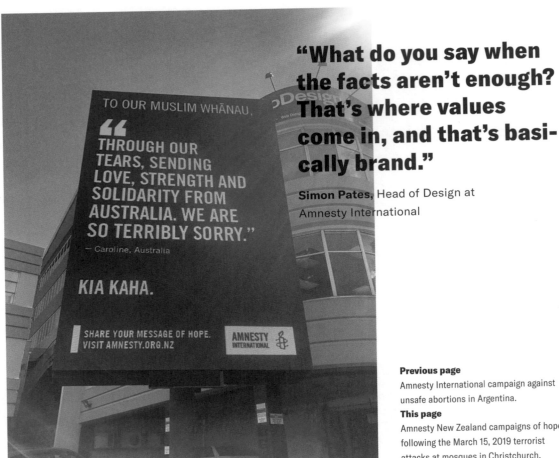

> **"What do you say when the facts aren't enough? That's where values come in, and that's basically brand."**
>
> **Simon Pates,** Head of Design at Amnesty International

Previous page
Amnesty International campaign against unsafe abortions in Argentina.

This page
Amnesty New Zealand campaigns of hope following the March 15, 2019 terrorist attacks at mosques in Christchurch.

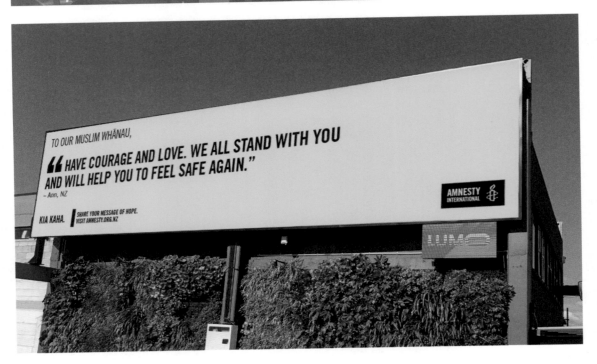

Simon Pates This is the first time that we've had this kind of major change in tone since the '60s. Our visual identity has always been summed up in spirit, in the way that people thought about us in the '60s. What we've been doing with our new hopeful approach is almost reducing the amount of space that the word Amnesty takes up. Because I think what happens to people is that they see Amnesty, they think about the angry mobs in a way. And so in order to cut through again, we've had to concentrate on people finding our content and then discovering that Amnesty is talking to them and not seeing Amnesty first. That's been a quite important, subtle change that we've made in terms of the way that we employ that brand so that we can actually get people to listen to what we're saying.

Thomas Anger and fear lead to that more closed world. What are we trying to achieve? It's actually empathy. The policies we're looking for depend on there being greater levels of empathy in the world and people being able to share that empathy more widely. Basically, we are all humans, rather than Dutch or Irish or British. Actually, if you go back to the origins of Amnesty, it wasn't about angry protest. It was groups of people who would get together and take part in letter writing. That's an act of communicating with one other person in another part of the world, which is the ultimate act of empathy. You sit down and you try to put yourself in someone else's shoes. "Imagine if that was you."

Human rights should be seen as the glue that binds us all together in our shared humanity. So human rights is an opportunity for you to act on your better self and your identity of yourself as a good person and stand in solidarity with another human somewhere out in the world.

How do words of hope and solutions translate in a visual?

Simon We're turning up the content, what people are saying. We stripped the past visual identity back to the bones. It's quite possible that in the future, you will see the Amnesty identity change. It's going to be led by what we do and what we say.

We are, in many ways, with our new tone of voice, giving our brand back to the people that it's for, rather than owning it like a corporation and setting up a bunch of guidelines. It's been a long-term change in the way that we disseminate our brand. We've freed it up. We've made it usable so it's simple to use for people in all sorts of different places.

Thomas For me, the brand is much more about the idea of what we stand for. We worked with around 20 sections; national sections from around the world, with participants from every continent. The question was: how do we articulate those values so that we have a consistent value message to talk about? But also, rather than essentially producing brand material, we want this to be brought to light through the stories that we tell.

Instead of talking about victims, we talk about heroes. So, for example, to bring out individuals, say, an 80-year-old Norwegian woman who goes to the Saudi embassy every month, or, rather than the person who's being deported, we make a story about the person's friend who organized protests. So that shows what solidarity looks like or what humanity looks like. Basically, we're just calling our brand humanity. The line we use now is: "We stand with humanity." But also that human rights actually is about humans together, acting on the basis of their common humanity.

I think you're still going to need to get the message across that this is Amnesty, right? It will be interesting to see how that can work in that sense.

Simon Did you look at the Greta Thunberg the climate activist ("School strike for the climate")? There's not a real organization behind this. It's a young 16-year-old girl in Sweden and a huge movement. The movement and sentiment is what came first. There's no branding there at all. That is how Amnesty started. We realized that perhaps through time, people are not listening carefully to what we're saying. That's maybe because our brand has become something that people associate with something that isn't great. We're not using our brand, first and foremost. It's about people within the organization and what we stand for. That's what Amnesty has always been about.

You'll find certain people in Amnesty who disagree with us on concepts of branding all together and have never wanted to be involved in that. That fight has definitely happened, and it still rages on. But what people do understand – and that's the reason why we've been so successful in this – is the need for us to be heard and that we're able to mobilize people in a positive way. We're saying what's really happening, but we're saying it in a way that can make people act positively and feel like there's hope.

I would say it's the same that can be communicated with different messages. So rather than having a specific set of words that everyone has to translate and use, what we're trying to focus on is the belief. You could call it a meta-narrative or a worldview that we want audiences to share. Then it's up to all our colleagues around the world to bring that to life in different ways according to what's culturally relevant. That's this underlying basis of human rights: issues divide, but values unite. What do you say when the facts aren't enough? That's where values come in, and that's basically brand.

Brand is how we transmit and share our values with people.

Thomas Coombes is Head of Brand and Deputy Director of Communications at Amnesty International.
Simon Pates is Head of Design at Amnesty International.

The Amnesty Logo

In 1961 Amnesty International was founded by Peter Benenson. Two years later the design of Diana Redhouse, a candle in barbed wire, was chosen as the image on Amnesty's first Christmas card. The card design would eventually become the organizations logo because of its "simplicity and the effectiveness of its symbolism."

The design is composed of two recognizable images, and was inspired by a Chinese proverb, "Better to light a candle than curse the darkness."

The barbed wire signifies "the darkness" and hopelessness of individuals who are jailed and thinks no one remembers they are there. The lit candle is giving light and hope into the darkness.

The logo was refined in 2000 by Simon Endres, while he worked at Kirshenbaum Bond. It has become the global symbol of Amnesty. Recognized as a sign of hope, the design represents optimism over repression and the collective ability to change the world.

AMNESTY
INTERNATIONAL
 1

AMNISTÍA
INTERNACIONAL
 2

AMNISTIE
INTERNATIONALE
 3

 منظمة العفو الدولية **4**

Top
The Amnesty International logo in different languages.
1 English, **2** Spanish, **3** French, **4** Arabic.
Bottom right
Amnesty International Brand Hub website. A manual on how to use Amnesty branding.

"The challenge is to create brands that people can participate and feel engaged with."

In 2008, Amnesty International was moving on to a new phase where they were really dealing with many issues having to do with human rights. There was a diversity of issues, and the brand had to express a much broader picture. The issues were many things, from violence against women to the right to be whatever you want to be in terms of gender, the right to love whoever you want to love, the right to freedom of speech, the right to live without violence, many things you associate now, in our times, with human rights. We had to try and create a unifying language for all those different issues and also, really, an extremely simple one because this sometimes has to be reproduced by people who are not designers. It's someone in a little garage that is doing some silkscreen or photocopy or something. Everything that we were trying to propose was very straightforward. We always look at the role that the organization plays, and they are fighters. They really are dealing with emergency situations. We needed to create something that could convey that immediacy and emergency of it.

The idea that we were proposing was to intervene; to raise alarm and to change behavior in areas or to help to deal with an emergency. The intervenience often appeared as an obstruction, but it's really to command people's attention and to turn it around into an action. There is a degree of alarm because issues like the death penalty, if you don't intervene today or this week, it might be too late. In that way, we created this language of intervenience. The audiences became many because they are everywhere, and they are dealing

with many issues. There was also a problem that every country had a slightly different language for Amnesty. The candle was the same. We used a very straightforward font and this language using the yellow, which is the color of light, obviously, and the candle as a way to unify the language and to create something very simple using that way of behaving, which was about intervenience.

I think Amnesty went through big changes after we worked with them. I was happy to see that many countries were using this language. With time, it's possible that even the Amnesty brand, which was built on a flexible system, might have become a system with more heavy guidelines than it should have had. I can see that times have changed; there's sometimes a concern about having a strong voice, and people want to be more suaver.

The challenge is to create brands that people can participate in and feel engaged with. I think if you are a little coffee shop in Shoreditch or in Brooklyn, it's great not to have a brand, but if you want to fight corporations and save someone in Guantanamo Bay without a brand, good luck with that. I think it's a real strategic challenge because you do need to unify.

Graphic design, whatever you choose to do, communicates messages, and it's just a spectrum. It can be very lightly political. We recently did the Kubrick exhibition at the Design Museum, and Kubrick was very provocative. So, if you see what I mean, we are always engaged with some degree of a political angle.

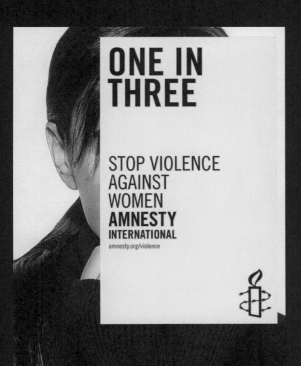

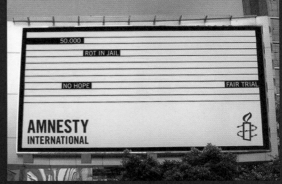

Rebranding for Amnesty International
by Marina Willer and the team at Wolff Olins,
London, U.K.

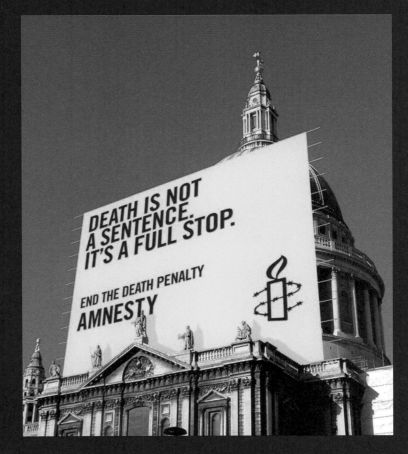

Marina Willer is a graphic
designer and filmmaker. Before
joining Pentagram (London) as
Partner, she was Head
Creative Director for Wolff
Olins in London. Willer and her
team at Wolff Olins worked
together with Amnesty Inter-
national on the rebranding of
the human rights organization
in 2008.

Greenpeace activists preparing to climb the
53,000-ton Leiv Eiriksson in Greenland.
Paul Simonon, former bass player of The Clash,
is on the right.

Non-Violent Direct Action

Greenpeace's goal is to "ensure the ability of the Earth to nurture life in all its diversity."

Greenpeace

Greenpeace focuses on worldwide concerns such as climate change, deforestation, overfishing, commercial whaling, genetic engineering and anti-nuclear issues. We spoke with Ana Hristova and Elaine Hill about Greenpeace's campaign strategies.

Strategy and Implementation

Greenpeace was founded in 1971. In those days, environmental issues had a different status and level of public awareness; they were not seen as urgently as they are today. During the last decade, a vast number of brand messages have come to compete with Greenpeace to save our planet. Especially with the rise of social media, an increasing number of organizations worldwide are launching awareness campaigns to highlight climate change, toxic impact, sustainability and anti-nuclear issues, among other topics. Does this affect the way Greenpeace is communicating? How do you stand out?

There are definitely more organizations and groups out there today working on similar issues. The more voices the better, considering the environmental emergency we are in. Not everyone is going to love Greenpeace and that's okay. Everyone needs to find their "tribe." However, we work often with various coalitions and movements, which binds these different voices together to have a more strategic impact. Only through working with others can we change the very system fueling the climate crisis and biodiversity collapse that threatens an insecure future for all life on the planet.

We are a campaigning organization. People recognize us, follow our work and trust us because we have stayed true to our mission over the years. We have remained financially independent, taking no money from governments or corporations, and continue to base our campaigns on our exemplary science and investigation work. We continue to bear witness to environmental destruction with our ships and award-winning photography, holding governments and corporations accountable and giving voice to the voiceless.

As Greenpeace activists, we continue to put ourselves on the line in non-violent direct actions, with a presence in 55 countries supported by our vast volunteer network. Our end goal is not necessarily to stand out. Rather, we seek to strategically reach the people who can make a difference on a particular issue, whether they are decision makers, CEOs or ordinary people. In order to do that, we have always stayed at the

"People need to know who we are in order to trust us. Our brand is more than just the logo."

Ana Hristova, Global Campaign Strategist at Greenpeace

forefront of technological developments. We use data insights to inform our decision making and to innovate and experiment with different approaches, trends and ideas. We have evolved to be more open, sharing our brand platform with the voices that need to be heard. We often partner in movements and sometimes this is unseen or very much in the background.

Do you think branding is more important nowadays than in the early days of Greenpeace? With the introduction of the internet and new technologies, the media landscape shifted. The public is confronted with a daily overload of news and visual information. Do these changes ask for a different approach?

Branding has always been important to our work. Greenpeace produces scientific reports and investigations, and engages with corporations and politicians. People need to know who we are in order to trust us. Our brand is more than just the logo.

Greenpeace blockade of soy cargo ship in France

In the beginning, branding was important because we were establishing ourselves, but it has been equally important over time. We have had to adapt to the times in the way our organization has developed. There are now 29 national or regional Greenpeace organizations, with presence in 55 countries. We are still establishing ourselves in certain parts of the world and must keep developing and adapting in order to stay relevant to our supporters.

There is definitely more competition for attention these days. On the one hand, we are still true to our core purpose and DNA: Non-Violent Direct Action, science-backed investigations, bearing witness and volunteer organizing. On the other, as the world has become more open, so have we. We are giving more voice to the people, whether they are supporters, affected communities or other networks. We are trying not

"We have to defend and build our brand support in places where we come under attack for the work we do."

Ana Hristova, Global Campaign Strategist at Greenpeace

to transmit in only one direction, instead seeking to engage people in conversation and empower them to take action, to start their own movements and to connect with existing ones.

Which campaign strategy works best for Greenpeace?

It is difficult to pick one. Depending on specific objectives and audiences, we combine different tactics. For example, we use NVDA (non-violent direct action) as a way of drawing attention to an issue. This can be quite effective in the right context – and contexts are always different and changing, both locally and globally. Despite being core to our brand, we don't use NVDA in everything that we do. It needs to be strategic, it needs to have purpose and help bring about change. Our reports are trusted and generate coverage and debate. Our corporate campaign engagement activities, both online and off, often use humor and can have a great impact.

Using humor and non-violent direct action moved McDonald's to take a vital role in creating the Amazon soya moratorium, saving massive areas of the Amazon rainforest from destruction for soya plantations. I think that our best strategy is not defined by one channel. Instead, it is about opening our campaigns to work with the bigger climate and civil society movements. We often lend the Greenpeace brand podium and global network to other organizations, communities and individuals that need to be heard. Our partners do the same, and our voices are strong and carry more power for that. Together in chorus, our impact is bigger.

How does Greenpeace support particular campaigns or individual causes? Are there fundraisers for this?

Usually not. We have short- and long-term strategies, and based on that we design our campaigns. Funds are allocated to campaigns based on shared priorities.

Who are your stakeholders? The clients, donors, volunteers or government institutions?

Greenpeace stakeholders are our supporters, volunteers and online communities, plus our staff, research partners, campaigning allies and the local communities we work

Top right

Stop Fracking Patagonia action in Vaca Muerta, Argentina. Dozens of Greenpeace Argentina activists blockade the entrance to a toxic waste facility north of Patagonia owned by Treater S.A. and used by oil companies like Shell and Total to dispose of the waste created by their dangerous fracking operations in the region.

Center right

Forest Action at McDonald's in London. Greenpeace chickens invade McDonald's outlets after a report revealed the role played by the fast food giant in the destruction of the Amazon rainforest.

Bottom

Plastival in Nijmegen, The Netherlands. The Beluga II and the Plastic Monster ship, which carries a huge artwork made of plastic waste, arrive at the Plastival.

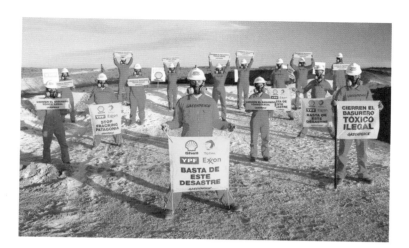

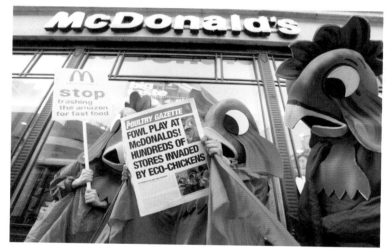

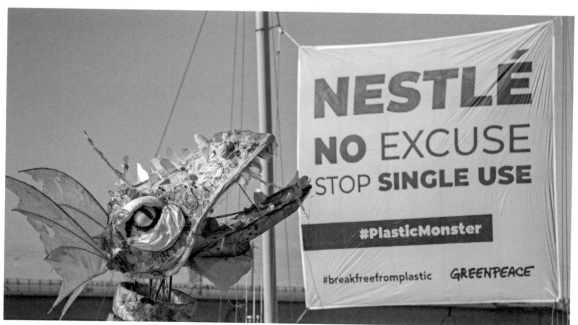

"Aesthetics, symbolism and storytelling are different around the world. People relate and respond to different things. Even global campaigns are adapted to the national context by local campaigners and volunteers."

Ana Hristova, Global Campaign Strategist at Greenpeace

Background
Ice sculpture at Petersberg Climate
Dialogue in Berlin.

Bottom left
Greenpeace activists protest at the Shell
oil refinery in Fredericia, Denmark to expose
the company's plans to drill for oil in the
fragile Arctic region.

Bottom center
Plastic found in the Great Pacific
garbage patch.

Bottom right
Arctic 30 action. Greenpeace activist
dressed as a polar bear, wearing a message
for Russian president Vladimir Putin during
his visit to Rome.

Top
Team Aurora arrives at the North Pole.
Right
CETA/TTIP demonstration in Berlin.
Opposite
Investigation Report that delves into the hazardous chemicals used in the production of high street fashion.

alongside. In addition, our stakeholders include those who we seek to persuade, such as governments, corporations, individuals and the media, and those who depend on the industries and ecosystems impacted by our campaigns.

Who are your audiences? Do you communicate differently with these target groups? For example, is it different when speaking to youth about these topics?

Our audiences depend, in part, on our campaign strategies; who we need to move, directly or indirectly, to make something happen. We use different written, spoken and visual languages to communicate with different audiences, though we speak with

one voice. We try to always communicate in a way that they will understand. Young people are a key audience as they become more emboldened and empowered to stand up and protect their future. Their voices and actions are crucial in the fight against climate change. Young people grew up with technology. They embrace the concept of being authentic and true to oneself; of sharing and participating rather than just observing. We strive to empower today's youth by providing opportunities to engage and feel agency around climate change, introducing tools to help them become leaders. We don't have the budget to rival corporations when producing videos or other communication materials, nor do we need to. We offer many things that corporations can't, including a sincere sense of purpose. We talk about solutions and show that another, better world is possible.

Are specific campaigns tailored to specific countries or cultural heritages?

Always. Aesthetics, symbolism and storytelling are different around the world. People relate and respond to different things. Even global campaigns are adapted to the national context by local campaigners and volunteers.

Creative Process
Can you explain the creative process of a new slogan or campaign?

Our campaigns are not designed centrally, so the creative processes vary from country to country and project to project. We start with the baseline: what is the change we want to see, who do we need to influence and what do we need to do to get there? Based on that, we design our tactics and materials.

We are deeply rooted in grassroots activism. We work with supporters, volunteers, affected communities and partner organizations from the outset, doing what we can

to build and strengthen movements and involve them in the development of relevant projects.

Some ideas and materials are produced by agencies when the budgets or pro-bono opportunities allow, but the bulk of our creative work is done in-house. We use a range of tools and techniques for developing creative concepts, including design thinking and creative facilitation with our teams, supporters and volunteers. Some of the best ideas develop in teams as they work on the campaign, and others come out of the blue, inspired in down-time outside of the office.

Brand Management

Greenpeace uses strong, bold sans serif and script fonts; the perfect combination in a daring situation. The color of choice is green in combination with yellow. Greenpeace is a global network, and everywhere we see the same recognizable logo, strategy and implementation. How do you manage the brand? Are there particular branding tools used for photography, graphic elements, online, etc.?

Greenpeace International provides the basic style and communication guidelines for Greenpeace globally. This allows considerable flexibility, and some campaigns take on their own personalities. For some of our work, it's more important from a communications standpoint to maintain credibility through consistency, for example in science and investigative reports. While we develop many global campaigns and share creative content where relevant, Greenpeace offices across the world have different levels of brand management and are relatively independent in terms of how they design campaigns or adopt branding to their national context.

Some of the individual campaigns have a strong brand-oriented approach. For example, the "Stand for Forests" or the "Save the Arctic" campaigns come with detailed style guides. Does the art department review all forms of communication before it is produced? Are there strict branding guidelines as a starting point?

We don't have a central art department. We do have a global style guide and communication guideline but, as mentioned above, visually we are more flexible and some campaigns (like "Save the Arctic") take on their own personalities. The campaign style guides are often produced on a project level with the purpose of providing easy-to-use practical tools for offices with different design capacities and skills, sometimes with volunteers helping to adapt content to their national context.

Branding in Protest

In your opinion, what role does design and branding play in protest?

It shows your identity – who you are; what values you represent. It's an anchor that resonates for people, for them to recognize and relate to. If used correctly, this brings credibility, trust and a certain level of influence. If not, it could be a distraction, potentially overshadowing or delegitimizing a movement.

Do you think that branding is (or can be) used against protesters?

It can be, especially in countries with totalitarian regimes or shrinking democratic spaces where there is a greater risk of backlash. We have to defend and build our brand support in places where we come under attack for the work we do.

Ana Hristova is Global Campaign Strategist at Greenpeace.
Elaine Hill is Engagement Director at Greenpeace.

Top left
Fashion Duel Vertical Catwalk in Milan.
Greenpeace is demanding brands engage
in the smartest trend: beautiful clothes
untainted by forest destruction and toxic
pollution of our water's resources.

Top right and above
Identity for "Stand for Forests" and
"Save the Arctic" are brands of their own,
debranded off and interconnected with the
Greenpeace campaign family.
Design by Fakecrow, Los Angeles

The Brand to Keep You Safe

One of the things a brand does for NGOs that it doesn't do for companies is it keeps people safe. An activist who is arrested during a Greenpeace protest can rely on the fact that there is a globally recognized brand-name attached to them, meaning the authorities will probably know that they're part of a peaceful organization. These kind of things really can keep people safe. If you look at what happened when the Arctic 30 were arrested by the Russian authorities – even though their treatment was terrible and we had an awful time getting them released – it could have been worse if the eyes of the media weren't on them. The eyes of the media were on them because they were attached to a well-known organization. One of the things I used to tell people when they came to work, particularly if we were working on campaigns in dangerous regions, was: "Okay. The Greenpeace brand is important. We have to protect it. It has to stand for certain things because it keeps people alive." Greenpeace faces threats, but that's nothing compared to what Médecins Sans Frontières deals with. They have a brand that stands for political neutrality and if that is ever compromised then everyone who works for them is put in danger

Campaign Strategies

Campaigns vary by country, by medium and by message type. The key thing about Greenpeace is that we've always been largely defined by what we do. So if you look at our reputation in different countries around the world: in Western Europe the ships are a big part of our identity, and we're the same in North America, yet not so much in places in Asia or Africa where we haven't been working as long, and where those parts of our identity aren't part of the cultural memory. For us, a campaign always starts with the questions:

"What is the change we're trying to effect in the world? How do we get there? What do we need to get there?" Next we ask, "Okay, can we do some fundraising or communications around this?" I always describe Greenpeace as a very pragmatic organization. If we need to learn how to do something to win a campaign, we'll learn it. Some campaigns you just win by lobbying; you don't have to do that in public at all. We have ships because that was the only way for us to get to Amchitka in Alaska.

Today we have light airplanes because we need to be able to see forests from above. We also now have a lot of people working on satellite imagery analysis because we've discovered that if you want to document deforestation, forest fires and certain types of illegal fishing, you need those resources. Greenpeace is not known for its expertize in analyzing satellite imagery, but that is something we've built upon that should be talked about more. So too with some of the original science and policy development we do.

We build partnerships and alliances as needed. Part of the answer as to how to stay relevant these days definitely lies within your own network: who you work with, and what people expect when they work with you.

Martin Lloyd was Communications Manager at Greenpeace International from 2008 to 2013 and Communications Director at Greenpeace Netherlands from 2013 to 2019.

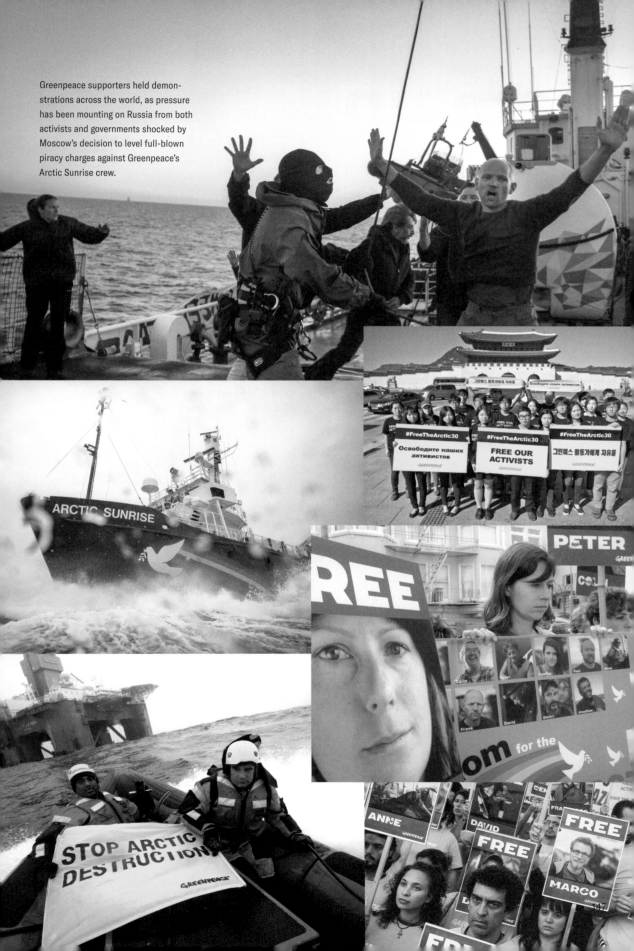

Greenpeace supporters held demonstrations across the world, as pressure has been mounting on Russia from both activists and governments shocked by Moscow's decision to level full-blown piracy charges against Greenpeace's Arctic Sunrise crew.

BREXIT

Remain...

On June 23rd, 2016 Great Britian held a referendum over whether to remain a member of the European Union or to leave the Union. The two questions on the ballot were simple: "Remain a member of the European Union" or "Leave the European Union."

Stronger In

M&C Saatchi were appointed in May 2016 to lead the Vote Remain advertising campaign, inspired by the British flag with bold type in blue and red accents. Other agencies involved in the project included Adam & Eve/DDB and WPP. The "Stronger In" campaign centered around Britain being stronger in Europe, with the idea that the U.K. faced a possible financial meltdown post-Brexit.

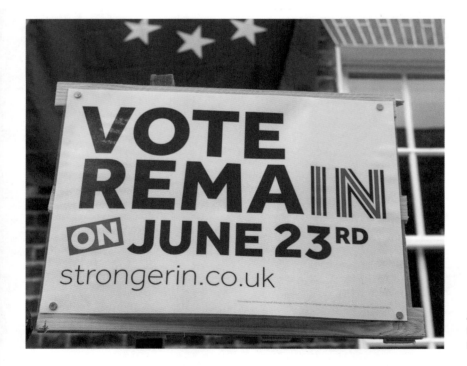

A "Vote Remain" sign in
Holborn. London, May 25, 2016.
Photo by Phil Rogers, CC BY 2.0

or Leave

Months prior to the vote on June 23rd, the two parties underwent a fierce debate on whether to stay in or to drop out of the EU. Simultaneously, branding visuals and slogans went into overdrive, consuming the British people for years to follow.

Vote Leave, Take Control

While the politicians campaigning to keep the U.K. in the EU consulted with some of the brightest minds in advertising, the Vote Leave ads were developed by a 25-year-old with an inadequately sized team. The "sense of injustice" in bright red that the Leave campaign carefully crafted – even if some claims weren't truthful – ultimately swung the referendum vote.

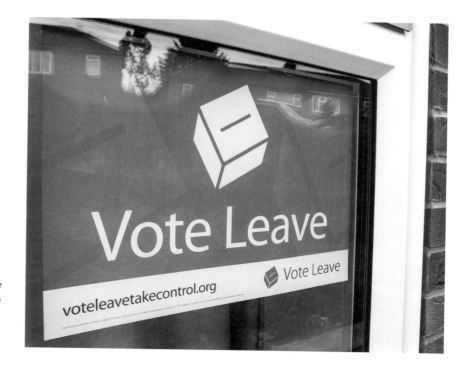

A "Vote Leave" campaign poster displayed in a residential house in London, March 3, 2016. Photo by Chris Dorney/ Dreamstime

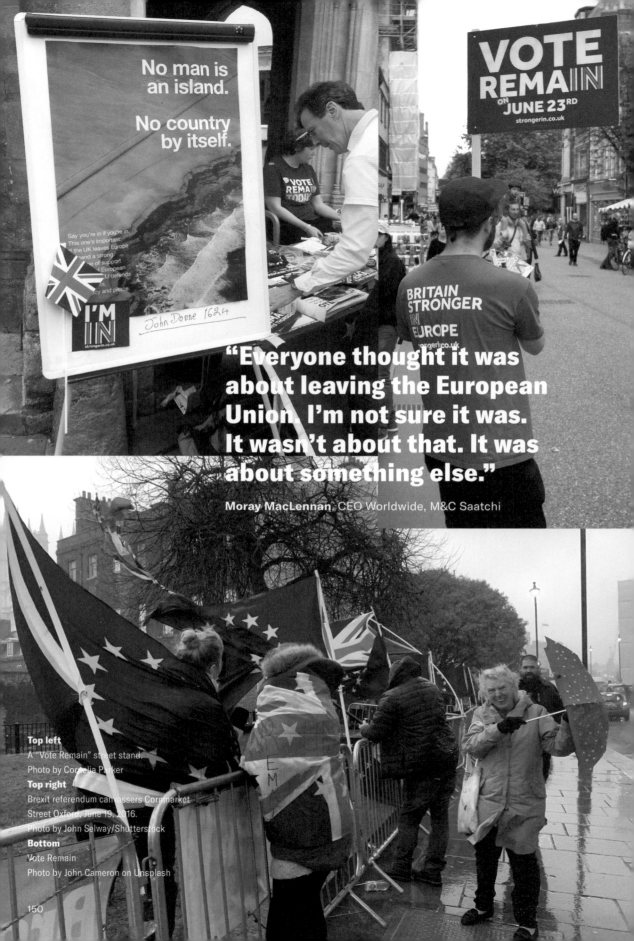

No man is
an island.

No country
by itself.

Say you're in if you're in.
This one's important:
If the UK leaves Europe
...end a strong
...e of European
...U defends
...ts.
...cy and peace.

I'M
IN
strongin.co.uk

John Donne 1624

VOTE
REMAIN
ON JUNE 23RD
strongerin.co.uk

"Everyone thought it was
about leaving the European
Union. I'm not sure it was.
It wasn't about that. It was
about something else."

Moray MacLennan, CEO Worldwide, M&C Saatchi

Top left
A "Vote Remain" street stand.
Photo by Cornelia Parker
Top right
Brexit referendum canvassers Cornmarket
Street Oxford, June 19, 2016.
Photo by John Selway/Shutterstock
Bottom
Vote Remain
Photo by John Cameron on Unsplash

We Voted Leave

We send the EU **£50 MILLION EVERY DAY**. Let's spend it on our *NHS* instead. Vote Leave

we want our ... Vote to Leave

"We did some groundbreaking work in nearly every aspect of the campaign, particularly in the creative stuff we produced, that pushed the envelope and redefined what things like a political broadcast could be, for instance... but despite this it's been an unfairly toxic brand to be associated with, though I imagine history will tell a different story."

Alexander Thompson, Head of Film, Vote Leave

Top left
Demonstrator holds a repurposed "Vote Leave" placard aloft in Parliament Square on the day of a parliamentary vote.
London, January 15, 2019.
Photo by Ian Stewart/Shutterstock

Top right
"Vote Leave" poster, Market Street, Omagh
Photo by Kenneth Allen, CC BY-SA 2.0

Background
Vote to Leave EU Brexit flag.
London, June 22, 2016.
Photo by AerialFlights/Shutterstock

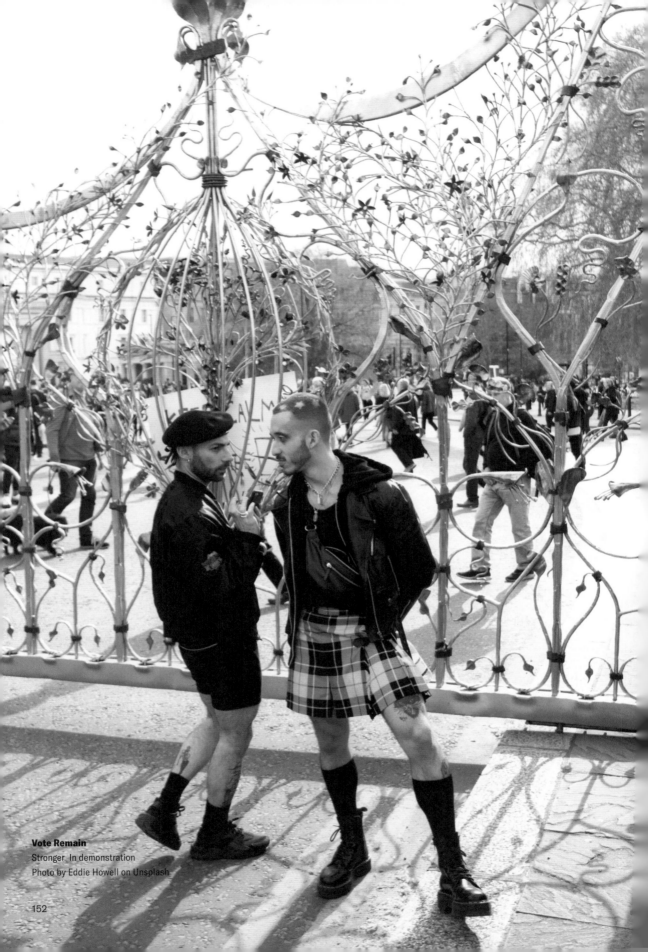

Vote Remain
Stronger_In demonstration
Photo by Eddie Howell on Unsplash

152

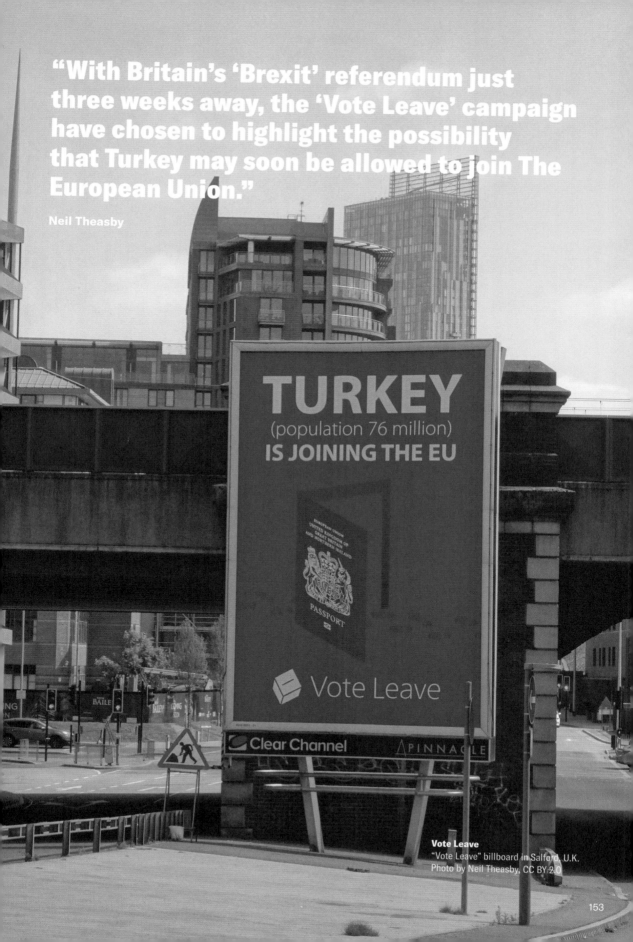

"With Britain's 'Brexit' referendum just three weeks away, the 'Vote Leave' campaign have chosen to highlight the possibility that Turkey may soon be allowed to join The European Union."

Neil Theasby

Vote Leave
"Vote Leave" billboard in Salford, U.K.
Photo by Neil Theasby, CC BY 2.0

Vote Remain
Photo by Alexandros Michailidis/Shutterstock

"I have traveled across the Pennines a couple of times recently, from Manchester to Lincolnshire, and not seen much evidence of the upcoming Referendum.

What I have seen is a handful of places where 'vote leave' is displayed. And not a single one for 'vote remain.'

The displays I have seen seem to all have been in agricultural areas. This one is typical."

Bob Harvey

Vote Leave
Photo by Bob Harvey, CC BY 2.0

No man is an island.

No country by itself.

Say you're in if you're in. This one's important. If the UK leaves Europe it'll send a strong message of but cost to haters of European values. It's not about 'same old' but about pulling through together.

Vote Remain on 23rd June

What is lost is lost forever.

Say you're in if you're in. This one's important. If the UK leaves Europe it may spell the end of the largest peace project in human history. It's not about 'same old' but about pulling through together.

Vote Remain on 23rd June

THE EFFECTS OF *LEAVING* THE E.U. FOR STUDENTS:

FUNDED OPPORTUNITES FOR YOUNG PEOPLE SUCH AS *ERASMUS* OR WORK PLACEMENTS ABROAD ARE AN EVERYDAY REALITY IN E.U. MEMBER STATES. THEY WILL DIMINISH WHEN THE UK LEAVES THE E.U.

Your opinion about the EU only counts if you're going to vote on **23rd June**

It's a question of where you feel you belong.

We are the European family.

Vote Remain on 23rd June

This vote is not about bureaucracy.

Not about things that don't work well, that are still flawed.

This vote is about our core values, about saying yes or no to democracy, human rights and solidarity.

Pick your side.

DEMOCRACY, PEACE AND HUMAN RIGHTS HAVE MANY ENEMIES.

BREXIT WILL MAKE THEM STRONGER. ONLY AS A UNITED EUROPE WE CAN STAND IN THEIR WAY.

HAVE YOUR SAY. VOTE REMAIN ON 23rd JUNE.

Vote **Remain** on **23rd** June *Don't give in to fear*

MY FATHER'S POLISH, MY MUM'S FROM SPAIN, I STUDIED IN BERLIN, NOW LIVE IN THE UK.

IT'S NEVER BEEN A HASSLE TO DO SO.

AND I DONT WANT IT TO BE.

COUNT ME *IN*.

MY FATHER'S ENGLISH, MY MUM'S FRENCH, I STUDIED IN VIENNA, NOW LIVE IN DENMARK.

IT'S NEVER BEEN A HASSLE TO DO SO.

AND I DONT WANT IT TO BE.

COUNT ME *IN*.

Say you're in if you're in.

It's a question of where you feel you belong.
We are the European family.
Vote Remain on 23rd June.

For 60 years the E.U. has been the foundation of peace between European neighbours.

Say you're in if you're in. This one's important. If the UK leaves Europe it'll send a strong message to haters of European values. It's not about 'same old' but about pulling through together.

Vote Remain on 23rd June

After centuries of bloodshed.

If people like Vladimir Putin, Nigel Farage, George Galloway, Marine LePen, and ISIS want Britain to leave the EU,

Say you're in if you're in. This one's important. If the UK leaves Europe it'll send a strong message to haters of European values. It's not about 'same old' but about pulling through together.

Vote Remain on 23rd June

where does that put you?

People ask what has the EU ever done for me?

The EU protects your rights against monopolies and challenges big business.

Marine Le Pen of the French Front National knows the significance of Brexit.
She equalled it to the Fall of the Berlin Wall, the beginning of the end of the E.U.

The collapse of European unity is a goal that she shares with one of her party's paymasters Vladimir Putin and many other European far-right movements.

The decade of what is unique to leave the E.U. Vote Remain on 23rd June

A ONCE IN A GENERATION DECISION. BE SURE NOT TO MISS YOUR VOTE.

VOTE REMAIN ON 23rd JUNE

DON'T LET ANGRY NATIONALISTS TAKE AWAY YOUR VOICE IN A STRONG EUROPE. THE EU DEFENDS YOUR VALUES IN THE FACE OF PUTIN, ISIS AND OTHER ENEMIES OF PEACE.

A POLISH FRIEND TOLD ME THE OTHER DAY:

I NOW HAVE AN E.U. FLAG AT HOME. WHEN WE DEMONSTRATE AGAINST OUR NEW AUTHORITARIAN GOVERNMENT, WE DO SO UNDER THIS FLAG.

I SUDDENLY REALISED, THE E.U. IS THE LAST DEFENCE AGAINST ANTI-WOMEN'S RIGHTS, ANTI-GAY RIGHTS, RACIST 'STRONGMEN' POPULISTS IN EASTERN EUROPE.
DO YOU WANT TO LEAVE THEM ALONE? NOW?

Vote Remain on **23rd June**

pro-EU/anti-Brexit campaign, 2016

© Wolfgang Tillmans

"We send the EU £350 million a week, let's fund our NHS instead."

Vote Leave
The slogan emblazoned on the side of the Leave campaign's battle bus in the run-up to the 2016 Brexit referendum.

Vote Leave
Vote Leave team in front of their campaign battle bus. Worcester, May 2016.
Photo by Jakub Junek/Shutterstock

Top left

March for Science Sacramento.
Photo by Andrei Gabriel Stanescu/
Dreamstime

Center left

March for Science Boston.
Photo by Paul Light/Dreamstime

Top right

March for Science Washington, D.C.
Photo by Molly Adams, CC BY 2.0

Center right

March for Science Berlin.
Photo by Bernd Wannenmacher, CC-BY-4.0

March for Science Washington, D.C.
Photo by Kisha Bari

Marching for Science

Organizing the March for Science in 90 days.

In January 2017, a social media thread – about the incoming Trump administration's plans to remove any mention of climate change from the White House website – kickstarted a global conversation about science and activism. Three months later, more than a million people took to the streets in marches across all seven continents. It was the largest ever protest in support of science. We talked with National Steering Committee member Rosalyn LaPier about why the movement's message could have such significant impact.

What was the reason for create a physical march on a global scale?

A lot of people involved in the March for Science were at the annual conference of the AAAS – the American Association for the Advancement of Science – Which is the largest scientific organization in the U.S. This was in Boston, in February 2017. At that point the discussion on social media was already happening, and there was already a group organizing the March for Science, and one of our concerns was whether it had legs.

Then the Rally for Science happened in Boston at the same time as the AAAS meeting. There'd never really been a rally or anything like that, with a mainstream science academic conference before (the rally was not sponsored by the conference). Originally people thought, oh well, hopefully a couple dozen people will show up. And then thousands of people showed up.

People on the organizing committee realized: this is something that can actually happen.

Can you tell us about the working process between the various groups?

Once there was a National Steering Committee in place, there was a call out for people to volunteer for specific tasks – fundraising, social media etc. We met almost every day in the evenings, because almost everybody had a job. We worked on various messaging and document sharing platforms. A lot of times the three co-organizers would talk throughout the day and make decisions that they would share with the Committee later that night. The process was very fluid.

The logo and the website were planned out. Somebody had already obtained the URL marchforscience.com within the first day. Social media presence was planned early on. Pretty much everyone on the committee had a PhD, very well-educated folks, people who'd worked in academia and also in activist circles, who had the skill set to throw something together very quickly.

It was an organic process where lots of different people were sort of saying, "oh, okay I'll do that, I'll get on that." There was a lot of "yeah, let's do that," instead of, "oh, here's five options and we have until tomorrow to decide." It was more like, we need to get this up and going, now, in the next 30 minutes. Everyone decided based on consensus. And then we moved to the next thing.

A lot of the decisions were made within the first couple of weeks, in terms of how the public face of the march was going to be seen. Most of this originated out of New York, partly because Carolyn Weinberg rose to the top as a lead organizer of the march, and she's based in New York.

Who were the stakeholders? Does the March for Science depend on donations, fundraisers and other influences?

From the very beginning we created partnerships with the national organizations, such as the AAAS and SACNAS (Society for Advancement of Chicanos/Hispanics and Native Americans in Science). They helped put on the march through donations.

The other thing was selling T-shirts and merchandise. I think we spent way more time discussing T-shirts than the logo. People got very engaged in this, wanting to make sure that we did it the right way. Things like, where do we buy our T-shirts from? Do we go with the cheapest T-shirt, which means we're buying it from slave labor somewhere? Or do we try to get something with a better social justice record? The kind of things that people worry about when they have a political movement, we really discussed and tried to figure out. I learned way more about T-shirts than I probably ever want to know. But that is where we got all our funding.

1

Official March for Science logo designed by Brooklyn-based artist Bryan Francis.

2

March for Science local chapter logo for Hawaii.

3

March for Science local chapter logo for Los Angeles.

4

March for Science local chapter logo for Chicago. Designed by Alex Shoup and Beth Voigt.

5

March for Science local chapter logo for San Diego.

6

March for Science local chapter logo for The Netherlands.
Logos courtesy March for Science

Below

Official posters for the March for Science. Sloane Henningsen was the creative lead to realize the March for Science branding.

1

2

3

4

5

6

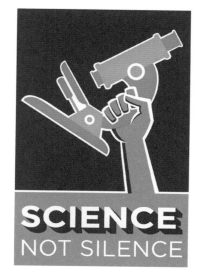

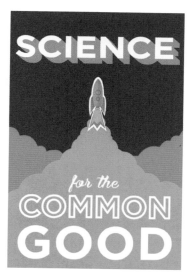

How did social media affect the grassroots organizing of the movement?

It all started with conversations on social media. I would argue that many of the orig-inal discussions happened among women, and among women of color. Later, there were some critical articles about the March for Science being organized by primarily white men, but that was not true at all. Because if you were on the National Steering Committee, or if you were on the various committees where people were actually vol-unteering and doing work, it was primarily women and people of color.

There were several social media platforms, both public and private. They literally grew overnight from a couple thousand people to hundreds of thousands.

This created the need for moderators; people who volunteered to moderate the con-versations. Multiple moderators who could read and delete things or block people. In this day and age this is something you have to have.

I think that social media helped engage a lot more non-academic people who are interested in science and who understood how science impacted their lives.

Why do you think the name has been so effective?

What is good about the name March for Science is the use of the word "for." It makes all the difference. It means that you're "for" something and not so much "about" some-thing. It is a very simple word to include. It also implies action and an activist agenda and it is a call to action. In a short sentence, it tells the story.

How did an American protest became a world protest? And how does the brand work with so many different locations internationally?

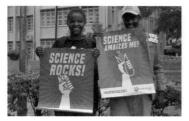

My thought is that there is a connection between chang-ing environmental laws and policies that people are interested in now. These are connecting back to science. Different communities then view the role of science in terms of people's lives, and their own lives.

In terms of the brand, once the logo was created, it was really easy for people to adapt it to their community. We wanted to create a situation where anybody could use the logo and whatever materials they wanted. It was free and available to anyone worldwide.

A person could download it in Australia, in Belgium, in the middle of Iowa, anywhere. Everybody took the logo and tweaked it a little bit with something local to identify it.

Two years on, what has been achieved?

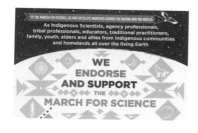

One positive thing that came out of the March for Science is that it re-energized some of the mainstream organizations.

It helped the evolution of the conversation around the purpose and role of science in American society and in people's communities. It evolved from being a March for Science by scientists to being a March for Science for the average citizen.

For example, I spearheaded what's called the Indigenous Science Statement, along with Professors Robin Kimmerer, Melissa Nelson and Kyle Whyte. We talked about how there isn't just one science (Western science), but that there are different sciences around the world – including indigenous science – that should be discussed. We wrote how science has had a positive impact but also a negative impact on indigenous communities.

Indigenous people have been the object of science. Most of our natural history museums were built on the study of Indigenous people, not only in the U.S. but worldwide. Thinking of how Indigenous people were viewed as objects of science and how that has a negative impact on Native communities was something we wanted to address.

Our statement was read in its entirely at various events worldwide and on the stage in Washington, D.C.

This was one of the really, truly positive consequences of the March for Science – having these types of difficult conversations and getting people to think about what the role of science is in their everyday lives.

Rosalyn LaPier, PhD is an award winning Indigenous writer, ethnobotanist and environmental historian. She studies Indigenous peoples' unique view of the natural world, in which natural science and religion intersect. She is an enrolled member of the Blackfeet Tribe of Montana and Métis.

Top
Indigenous Science Statement.
Opposite
March for Science Uganda.

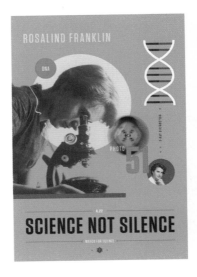

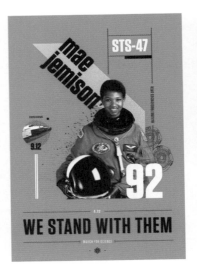

Top
"Beyond Curie" posters by Amanda
Phingbodhipakkiya available to download
on the March for Science website.
CC BY 4.0
Opposite top right
"#PoweredByScience" posters by the
FrameWorks Institute available to download
on the March for Science website.
Courtesy the FrameWorks Institute
Opposite bottom left
Posters by Megan Gannon available to
download on the March for Science website.
Courtesy the March for Science

"They got a whole bunch of stake-holders in the room and March for Science agreed to participate. To me, that process is very superficial. It's just pop-corning: what do people care about, what do you think we should be saying, and then just sort of making visuals that say that. Versus deep research and interrogation of strategy. I don't think that the conversation was offering that kind of thinking."

Beka Economopoulos, Founding Co-Director of The Natural History Museum

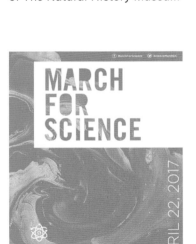

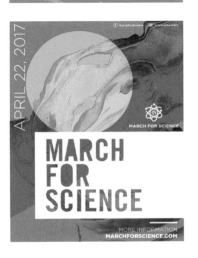

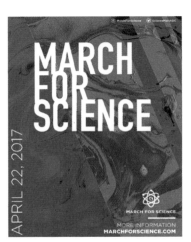

Trojan Horses and Other Insurgent Strategies

Beka Economopoulos and Jason Jones

Could you tell us about The Natural History Museum and how you came to be involved with the March for Science?

Beka Economopoulos Jason and I have been collaborating since 2003. We formed an art collective working at the intersection of art, activism and theory, working with community groups, NGO campaigns and social movements. My own background is in activism and organizing, but as a collective we operate more at a theory level of strategy and design direction. Since 2003, we've been studying how to approach design and visual language and strategy in the context of social movements. All of that research and all of that practice and experimentation informs our work.

The Natural History Museum is a project we created that works to encourage science and natural history museums to engage with climate change, environmental justice and biodiversity concerns. It's a Trojan horse strategy, to get inside the museum sector and try to transform it from within, in the form of a prototypical, traveling and pop-up museum.

Through The Natural History Museum, we were working to mobilize scientists globally to call on museums to cut ties to fossil fuel interests. Many scientists were willing to do that, but some of the pushback we were getting from science institutions was, we're neutral, we can't do what you're saying. So we started to investigate this history of neutrality, and to try to dismantle this notion of neutrality that was holding science institutions back from participating in public discourse and shaping public policy.

Then, with the election of Trump, we decided to move from scientists writing op-ed pieces or signing letters to being more visible in the streets, and to putting science activism onto a global stage.

We started with the American Geophysical Union, the AGU. That's the world's largest association of climate and earth scientists. They were going to be the first scientific convention after the election, with twenty six thousand scientists coming together in San Francisco in December 2016. We were already working with members of the AGU and we spoke with them about the election of Trump, about the cabinet nominations going to science deniers, about science getting defunded and how there is a war on science. How particular kinds of science are under attack – the science that benefits the interests of the many rather than the few; that keeps the public interest in mind rather than private gain and corporate wealth. Like climate science, that deals with water and air quality and environmental justice concerns.

We showed up at the convention and organized a rally on pretty short notice. We brought five hundred white lab coats and curated a lineup of speakers that included not just prominent scientists but also community leaders in the Bay Area, representing communities that were going to be hit hardest by these attacks on science. It

brought communities and the scientists shoulder to shoulder so that the message wasn't one of self-preservation of the scientists concerned about their jobs.

That was the first physical rally of scientists. We had no idea if it was going to work. How do you rally a movement around science? Particularly when science as a discipline is largely well defined and has also performed a lot of evil in the world. We wanted to sort of split science, and take a side on behalf of a science that serves the many and not the few, that serves the public good. We developed visuals for that and it ran in newspapers around the world.

A few months later came the inauguration of Trump. The AAAS, the American Academy for the Advancement of Science, the world's largest general scientific organization, was holding their annual convention in Boston in February 2017. This would be the first scientific convention after the inauguration. So we decided to do it again in Copley Square in Boston. Three thousand scientists and supporters showed up and *The New York Times* live-streamed it for twenty minutes, and again the story went around the world.

It was around that time, in the lead up to the AAAS convention, that the Reddit thread kicked off for the March for Science. Several of the scientists who had been involved in the AAAS in the years-long effort to get museums to drop fossil fuel sponsors got involved to help shape the March for Science. Also, random scientists who found themselves in jobs that were under threat because of the incoming administration, who maybe had no previous experience with activism. So the March for Science was an idea that came from many different places. It was it mélange, a mix of veterans of science activism and new people.

Can you explain a bit more how your role worked and what the design strategy was?

Beka We inserted ourselves as the directors of the social media team, moderating the various social media and training some of the scientists. Making sure that it wasn't problematic messaging, that it was messaging that incorporated social justice. Because again, how are you going to build a movement around science? It can't be just scientists, it has to be people and communities standing up for science. The only way you're going to do that is not by perpetuating this myth of the dispassionate, neutral, objective scientist who doesn't care about the subjects of research. Rather, championing a vision of the scientist who is doing this precisely because they do care, because they have the public interest in mind.

Jason Jones What we saw going into the March for Science is that the problems that science was facing were the result of when ideology gets mixed into science. When we were researching the history and philosophy of science, we looked for groups in a different position, such as Science for the People, a science-based collective from the 1960s made up of all kinds of scientists who were involved in the Vietnam war and other issues. They no longer existed, but we looked into them because they took a position that people will trust scientists if scientists say that you can tell people why your science is fallible.

We were coming up with language, not so much based on particular slogans they'd used, but with a similar logic of science as serving the common good. What role do you play as a scientist? Well, my role is to make the world better. It's not just to do research, to just collect things, to colonize the universe and to tell you about new things in the universe. No scientist or organiza-

tion will tell you why your inequality grows or why your water is polluted. My role in this is that I'm a producer. I work between the various people I'm sort of the glue that fits the theory between the visual production and design. I come up with the basic concepts and then work with the designers to produce things.

Beka We work with what in activism or social movements is called an affinity group, which means a constellation of collaborators who come up with ideas and approaches and contribute to the movement, and if the movement takes it on – awesome. If they don't, well then that idea wasn't a good one. It's less about sitting in meetings and agreeing upon stuff and coming to consensus, and rather about throwing stuff out into the world. If people like it and they adopt it – awesome – then you build upon it.

We had been very intentional for the several months prior to the convention, researching communication frames that were decidedly not neutral, but could open doors instead of opening a can of worms. Because a lot of scientists or science associations would push back if we directly argued that science is not neutral or that science is not apolitical. Science is always political, let's be real. Science is always going to serve some interests.

The communication frames we focused on and the visuals in this rally were about science as protecting the people and places we love, scientists pursuing truth, saving the planet. Sort of playing with the scientists as heroic figures. Very intentionally not about "our jobs are on the line," or researchers on the line, but illuminating the ways in which the cuts affect communities.

That was really the big focus of our design strategy, the visual strategy and the public relations and messaging and communication strategy. We tried to get that out, both through the social media channels and then finally through the design of some of the online visuals and memes, in particular for the front of the March for Science.

We were struggling for a particular approach to communication strategy, but we were not the official March for Science design people. There was a person who had a branding background who was in charge of all things design. They got a whole bunch of stakeholders in the room and March for Science agreed to participate. To me, that process is very superficial. It's like pop-corning: what do people care about, what do you think we should be saying, and then just sort of making visuals that say that. Versus deep research and interrogation of strategy around what sorts of intervention and public messaging can serve movement building aims, or the articulation of a counter power through visual signification. I don't think that the conversation was offering that kind of thinking.

Then there were other individuals that also threw stuff into the movement, similar to how we operate as an affinity group or collective. People were like, "hey, I made these things," and if people liked them, they put them out on the official channels. You'll notice that a lot of stuff that was put out, we didn't make it. It was complementary, but still not the communication frames we were advocating. So it was contested.

Jason Rather than imagining that we were the top of the hierarchy in control of managing the brand, we always saw ourselves as those problematic insurgents trying to shape and redirect communications. The managers of the brand were basically trying to create this very open umbrella that had no meaning, no resonance. The only reason

in our minds why the movement started to have any power whatsoever was because it represented a challenge to the way people thought about science. The brand managers were actually driving this into the ground, driving it towards a kind of status quo understanding of science that basically has no meaning. That's the question for us as insurgents: how can we create communication that is meaningful?

The reason why the March for Science took off was because people were so surprised that scientists came out of their labs in the first place to actually stand up for something specific. They were actually challenging power and not just talking about science as a matter of facts and curiosity. When you see three thousand scientists come out in their lab coats holding signs – for the first time – and saying, we want to serve the people; that is challenging to corporate interests. That's when people say, and the media says, wow, this is actually something new.

Why do you think the movement was able to spread so quickly around the world and motivate so many people who'd never heard of the March for Science to identify with movement's ideas?

Beka The specter of the rise of a right wing and potentially fascist incoming government that is proposing funding cuts on science, backed up by *Breitbart* and other entities that deny climate science and represent an anti-science force – together this really became the tipping point and created urgency in a way we hadn't seen before.

The March for Science was coming on the heels of other very visible social movements. In the U.S., we didn't have a culture of social movements and street activism in living history until

just recently. Up until to some degree the anti-or alter-globalization movement in the late '90s, but really it wasn't until Occupy and then the movement for Black Lives Matter that we started to get this culture. I think that because there was a pre-existing template and many people who had come up as young students and graduate students within the context of a culture of activism, the conditions were pre-existing for a March for Science to happen.

This idea of it spreading so quickly globally, sharing the name and branding – this maps how we as a collective understand social movements. That they are not about a consensus where everyone comes together and defines points of a platform and a logo and this and that, but rather about fidelity to a name and a language in common that holds us together in spite of disagreements and our diversity.

That was the work that we did in the context of the Occupy movement. Occupy became a name in common. Of course, it was also contested and we struggled over the meaning, it wasn't fixed. But you didn't have to petition New York to sit down in a public square and call your protest Occupy. You didn't have to ask somebody before you put up a Facebook page and called it Occupy. There were certain signifiers. You had to sit down in a public square. You had to hold a General Assembly and use twinkle fingers. Then the world would recognize you as Occupy.

Our contribution as a design collective with Occupy was to think about the visual language that could carry concepts, but also signal the presence of the movement and knit together different constituencies, different geographies, different issue focus groups, so that the whole is greater than the sum of its parts. The way that we do that isn't by determining it and spreading

it from a centralized location; we have to be very careful to employ a different model, if it's to be adopted by the movement.

It's about paying attention to the eco system of symbols, globally, that are sticking on the wall when people throw them out. We then can iterate and echo upon those symbols or that visual language. In this way, it's like the development of any kind of language. It's participatory, but it's not random.

In the case of Occupy, we were thinking about our sister collectives in Spain who were fighting gentrification and displacement, who were using yellow and black a lot. The symbols that structure and govern our use of space, they were putting these in the hands of the people demonstrating. We started to do that, engaging spatial politics in New York City around the foreclosure crisis and the 2008 housing crash and then bringing that over into Occupy. Not just as domestic politics, but also as having a relationship to the movement of Take the Square, the Indignados movement in Spain. It is ultimately a critique of neoliberal economics and policies, so that the visual language carries these concepts and reference points and relationships to other campaigns and other communities. With March for Science, we attempted to do this too, but maybe it wasn't quite as developed as the Occupy movement.

So the March for Science used similar branding strategies to Occupy?

Jason We don't actually use the language of branding or public relations. Early on in our project, we hosted all these events on art theory at the production space that we ran, including events with branding and PR professionals speaking about different strategies that can be deployed within activism. But we shifted our terminology

from that to talking about building a language in common, or organizing around a name in common. This would be to differentiate it from branding corporations, which we associated with capitalism and corporate logic, which has to do with centralization of control of symbols and language.

When we work on museums, or really any project that we've done since 2004, it has always been about appropriating existing language. Official language is recognizable and is largely controlled by a more dominant power than the interests that we represent. We intervene on that language, because we consider the language to be the visual language that governs our use in space. This yellow and black or orange and black, the diagonal stripes, stuff that you see everywhere, is determined by additional powers but it represents common interests. There's this interesting kind of flexibility that we always seek to intervene on.

It became quite successful when we used yellow and black in Occupy. We would send a flag over with yellow and black stripes on it and that's all that would be required for the police to send two police officers over for every protester who was holding one of those flags, because it represented such a challenge. Whereas if you had any other protest signifier in one of these spaces, like Union Square, the police would ignore you because there's a million protesters. Somehow Occupy as a visual language, as a name and signifier that represented a challenge, represented a threat that they were very concerned about. It had a real power behind it.

In all instances, we've been looking to intervene on an existing language and then to give it a force that is recognizable as a challenge to the existing official language. In Occupy our aim was to destabilize people's assumptions when they saw that construction of language in the streets.

How does that work, intervening in the language of natural history and science?

Jason If you think about natural history and museums, there's a visual language and a history that has certain shapes that gives these their form. From my perspective, it's essentially a craft. As a producer, to get involved in natural history you just start using the visual language associated with it. What are the signifiers and what are the materials and all of those things that inform what it is? In terms of the relationship between a corporate logic and a kind of more open approach, we chose the name The Natural History Museum as our name. It speaks to this generic name and it refers to what all these other national history museums are.

The URL naturalhistorymuseum.org was available. The reason why it was available is that every natural history museum wants to be particular and different. Our interest is in being the generic, being what they hold in common. This is very different than corporate logic. Our understanding of how to relate to design and language that we associate with natural history museums that want to be particular and unique is that we're going to associate that with the language of branding and public relations. We're going to talk about an intervention on those particular languages, designing according to an open source visual language in common, organizing around a name in common.

What it's about is destabilizing those existing official languages and encouraging them to be understood as a challenge to power. This encourages other groups to adopt that language, so that they too become a challenge to power. We always imagined that it was never us that controlled the language. It was just us that we would introduce it. We would go to a protest where there would be a black bloc roaming through the streets and in order to introduce the visual language we would do things, like drop shields on the ground that had these stripes on it. The crowd would pick them up because they are shields. But they also represent disruption and confrontational attack. At the same time, they have this productive element in that they are associated with people taking over vacant homes. We were putting homeless people into these vacant homes. It tied the movement together. We weren't necessarily in support of the black bloc, but it was a matter of finding a language to hold the movement together, recognizing that it had various people relating to that language with different understandings of what it might mean.

Beka What I think we're constantly up against as visual strategists is how deeply infused the logic of individual expression is within left activism in the United States, versus what we're trying to promote. The second you mention branding to activists they're freaked out by it. "Oh, that's Madison Avenue." [ed: Madison Avenue is a street in New York where, historically, many advertising agencies were based.] That's the purview of the persuasion industries that are inherently manipulative and in service of consumerism and capitalism. You can't have a conversation about solidarity of expression. Individual expression has no connective tissue, no glue, no cumulative aggregate power. That's why we got very intentional about the language that is used in order to introduce what are, in many ways, ideas of branding. Thinking about – again, very carefully – how a vocabulary of solidarity, visual signifiers of solidarity, could be introduced and could be adopted. By showing powerpoints to people with images of news headlines, images of different articles, social media feeds, newspapers, etc. around the world,

where you're like, holy shit, look how powerful it is! It is, in some ways, what we would call militant uniformity as a visual language. Recognizing that it was not done as branding from above but rather was very slowly and carefully introduced through really paying attention to the landscape of expression in the context of social movements, and attempting to give it some direction so that there is some coherency.

What is the role of social media in this? Has it changed grassroots organizing?

Jason All social movements have focused on the centralization of communications infrastructures. We had Noam Chomsky talking about corporate centralization, where all these media companies were buying each other; it was becoming fewer and fewer companies. In response, you had groups like the Independent Media Center, independent formations offering a decentralized model. Now we're in a different era where there's still centralization, but at the same time there's a proliferation, an overabundance of content and material, where anyone is able to produce their own independent media to the point where independent media has very little meaning.

Beka This is what theories talk about as the decline in symbolic efficiency, where it becomes harder and harder in this era of hyper-fragmentation to build shared public meaning. A lot of people are very evangelistic about the ways in which social media has benefited social movements and campaigns, and certainly it has, but it's a double-edged sword with regard to building shared public meaning in the context of what some call communicative capitalism. It's all about aeffective expression and my personal brands; how many likes and clicks and so on. All of that also contributes to private entities building wealth.

The hyper-fragmentation that we find when everyone's a media producer and we no longer have those companies we're struggling with and against; that's a challenge. But it's also an opportunity. We can grow our social media assets to the degree that we have pretty sizable distribution channels. If we're strategic about that sort of shared visual language, then there can be a trickle up where it gets distributed across social media and gets covered in mainstream media. All that said, there is a profound filter bubble. Studies have shown that the ability for social media to persuade and change people's minds is zero percent. People don't actually change their opinions as a result of the news that they encounter online. It becomes, then, a tool for us to find one another and to mobilize.

There was a *BuzzFeed* roundup of the ten funniest signs in the March for Science. Things like this lead to a greater circulation within the media ecosystem. But does it actually result in building power that has durability and can change real material conditions and policies? That's the question. If it still lives within this currency of individual expression, then we're not really having a conversation about what we call insurgency.

I think we're at a turning point in left activism where instead we're saying, look at what the Tea Party did. They were insurgents on the right. Over time that led to the rise of Trump and *Breitbart* and so on, and that the left needs to start employing these tactics as well. These strategies of insurgency are not just happening within the party structures. They're happening with institutions of civil society. For me, this means that design and branding actually can serve a strategic function and purpose in the context of splitting institutions and making these insurgencies more visible. Otherwise, they exist but they're very quiet, they're whisper campaigns. They're isolat-

ed individuals who come together in the streets and feel emboldened because there's a one-day annual march, but that doesn't really serve our purposes of building durable infrastructures and power and taking over institutions.

Change happens through continued movement building so that you have enough power and enough force in order to implement policy or affect funding decisions. With the Trump administration that is very challenging. But if there's a massive public outcry you can forestall some of the worst of it.

The question we have to ask is about how visual strategies can support and uplift insurgency strategies of those actors within institutions who are willing to collectivize and push understandings of their institutions. Not as scared wallflowers who won't speak up and advocate, but as individuals who can instead normalize a culture of science activism.

There is a big difference between a lot of individuals turning out in the streets versus the weight of dozens of science institutions, changing how they've done things historically to say every time you propose funding cuts we're going to get in your face and we're going to take over the media discourse by writing op-ed pieces and showing up as commentators, etc.

Besides Occupy and Black Lives Matter, were there other movements you learned from?

Jason From our experience with activism we've seen things changing since the globalization movement around 2000. Up until then everyone had her or his own individual sign and individual slogan, and this represented individuality and individual expression. There was no common form. This is changing.

One of the groups that we're very close with and that has a big influence on the kind of activism and social movements we're involved with is the Yes Men. They do projects that impersonate corporations. As impersonators they use different tactics, like rebuilding websites. One of their tactics is to show something that's absurd about the institution and suggest that the institution is absurd. Other times, they point to a utopian horizon. For instance, we worked with them after Obama was elected to pressure for an end to the Iraq war. We produced a few hundred thousand copies of what looked like *The New York Times* newspaper, with headlines declaring that the war is over. It had all of the advertising and all of the articles, it looked real, and we passed them out as a supplement to the newspaper. The expectation wasn't that people would believe it, but that they could begin to believe it. If they could begin to believe it, then we'd be one step closer to being able to make it possible. If they don't believe it at all, you're stuck.

The way we relate to the the Yes Men's work is to give presentations where we talked about our work as being the Yes Men without the punch line. We started The Natural History Museum as a fake natural history museum, but there's no joke. The museum sector treats us like as if we're a real museum. We still think we're imposters.

Beka For example, I joined the Association of Science Museum Directors. All I had to do is fill out an online form and send in a 50-dollar check and I became a member. This means that I can go to the annual four-day retreat with forty other science and natural history museum directors, and I've been doing this now for the last four years. Establishing relationships with all these decision makers informed our communications and messaging strategy, because I got a sense of the culture of these institutions at the upper

echelons. What language they speak, what they think is possible or not possible. What their aspirations are and what the barriers or obstacles are and how can we design communication frames that could accelerate change. That was key.

For the last four years we have been going to every science convention and museum convention or conference we can get our hands on. Setting up booths – not because we're selling our services – but with the express purpose of having dozens and dozens of conversations with people who work within the sector. Again, to understand the culture and to figure out who our allies are, how can we build power, who the people are on the inside whose interests are aligned with ours.

This really helps with our strategy, which is: you throw something out and you hope that it will stick. This becomes much easier because you've already built some trust and built relationships with the influencers who can help make something spread.

Would you say that the March for Science affected real change?

Beka There is a lot of growing pain, and there are questions about what its role is. A lot of the people who were pushing a more aspirational role for the March for Science, and coupling this with a social justice analysis and message have pulled out to some degree, because of other commitments or because of frustration around questions like, how do you turn a movement into an organization, is that even a good thing to try to do, and what is the model; is it just annual marches?

So the March for Science still exists, but I can't speak to what it's doing. Perhaps most exciting to us is how other science associations, who participated in the March for Science are shift-

ing their practice. There has been a debate playing out within science, actually over the course of many decades, about this question of neutrality and whether science activism is appropriate, about whether it legitimizes scientists or if it damages the institution of science. Science historians like Naomi Oreskes and others point historically to Einstein, or Rachel Carson, or other figures in science who were active in the public sphere on controversial topics. The legacy that they've left with regards to their science and research has never been damaged by their participation in the public sphere. Leading up to the March for Science, this debate was playing out again in scientific journals and science beat magazines and newspapers and outlets, and to some degree the March for Science put that dog to rest. This was the most exciting thing that happened in the context of the March for Science.

In January 2017, three months before the March for Science, we had our Association of Science Museum Directors retreat. There was a debate about whether to get involved or not. People voiced their concerns and fears, and a few voices in the room said, I think this is really important. It was very divided. For the first time I was outspoken about my role as a co-organizer of the March for Science and why I thought they should get involved.

Then, in May, after the March for Science, the annual museum convention took place and The Association of Science Museum Directors had a breakfast meeting. There was just one discussion item on the agenda, framed as: "many of us are beginning to rethink our positions on advocacy in light of the March for Science, let's debrief." The institutions that participated in the March for Science had a positive experience and said that they would do it again.

This really represented a turning point. It meant that in subsequent meetings we could have much more frank conversations about the role of our institutions in a time of profound environmental and social change, about the role of advocacy. It meant that scientists could participate in public discourse and even advocate, without damaging their credibility. The March for Science normalized science activism. It's a work in progress but it's definitely light years beyond where it was.

Beka Economopoulos and **Jason Jones** are founding co-directors of The Natural History Museum, an initiative that connects and empowers scientists, museums and communities to address critical environmental and social challenges. They are also co-founders of Not An Alternative, a collective that specializes in cultural strategies for social change. Their work has been widely exhibited in museums around the world.

Protesters at the front of the march holding
different signs for March for Science.
Washington, D.C., April 22, 2017.
Photo by Vlad Tchompalov on Unsplash

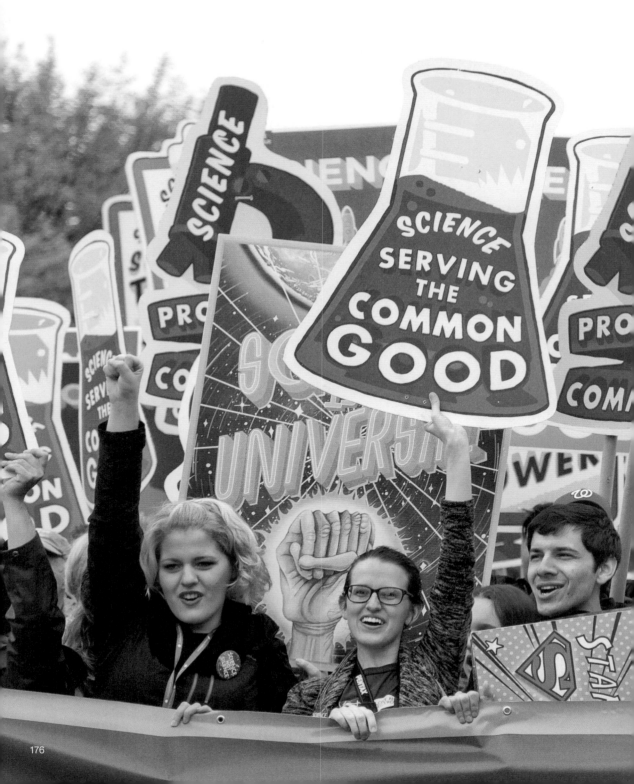

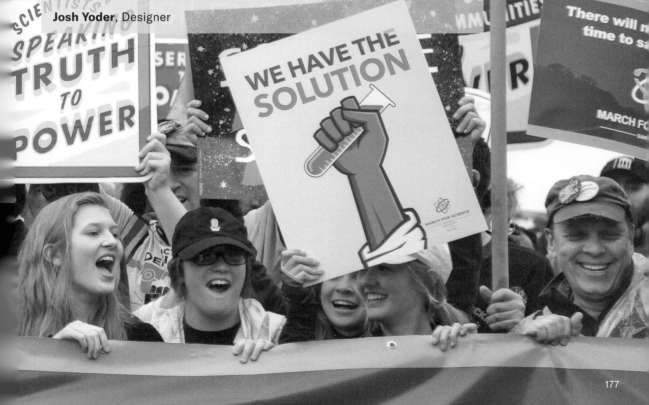

"**Find the person who is cheering the loudest, who is the most amped, who really wants to look good, and ask, 'Hey, do you want this sign?'**"

Josh Yoder, Designer

Understanding Design for Social Movements

A conversation with Josh Yoder.

You worked with The Natural History Museum project on the March for Science, providing graphics for the front of the march. Can you tell us about the work process?

We worked on a set of five different sign designs that were produced and distributed into the march. This is the way The National History Museums often approaches movements. They will get permission to develop signs, banners, visuals – branding – then show up to a demonstration and go down to the front of the march and ask if people want them. Find the person who is cheering the loudest, who is the most amped, who really wants to look good, and ask, "Hey, do you want this sign?"

It's very effective. And it's fundamentally different from the client-facing design process with traditional branding. A lot of movements aren't going to invest time in design meetings. They just want to have the choice to say yes or no, and the approval comes from the crowd choosing to use the work or not.

March for Science was really evidence of that. It was a delicate dance between getting the buy-in from the organization and making things and showing up. It's much more about understanding where we as a constituency in that movement would like the movement to go. As opposed to a purely client relationship of design where it's like, where do you as the head of the organization want this branding to be, and then clearly responding to that.

With the signage, the hand written typeface, the baby blue and similar colors, the drawings and the shapes – was the idea to convey science as fun?

I think fun would not be the operative word. It's closer to wholesome. The signs are made to be friendly and to be wholesome. This is very deliberate and it's part of the point they're making that being politicized is good. Good for society, good for science, good for the country, good for the world. It needs to be wholesome, it needs to feel just naturally friendly to you.

The term that I'm hearing and using most right now – this is particularly popularized since Alexandria Ocasio-Cortez had a quote about it – is "moral clarity." Her quote is "there's nothing radical about moral clarity" and that comes up in the visual identity meetings in movements all the time for me. Sometimes moral clarity is fun, sometimes it's serious, sometimes it's angry, but it's always human. This is a big part of social movements. They're grounded in the reality of being human.

That was very important for the science movement, because in many ways it was a re-grounding, having the public see scientists as regular people, who are altruistic and dedicated and incredibly smart, but are also just regular people.

If I say "New Deal," I think it overshadows it, but a sort of WPA[1] direction, that was the social identity that we're going for. We were looking at their

Poster showing a man with WPA shovel
attacking wolf labeled "Rumor."
Between 1939 and 1941.
Source United States Library of Congress

audience thinking, let's make our pitch towards
that audience. It's different than just following
the typeface and the exact branding specifications.

The WPA style is very interesting – they're so
commonly accepted, we look at them now and
say, oh, they're as American as apple pie. But in
their time they were very edgy political posters.
The "New Deal" was a hugely contentious era.
For example, with the national park posters,
these are scientists and conservationists step-
ping out and taking very political stances.

**The retro connotations of the basic branding
elements – the coloration, the typography,
the logo – have an almost comic strip idea.
Were you trying with this visual vernacular to
tap into a postive feeling of "American Dream"
culture, when science was seen as a very
positive part of society?**

This was a new strategy. Natural history museums
as a general base are one of the most trusted
institutions in the United States. Scientists are, to
a certain extent, a very trusted base. But as we in-
teracted with the science community, we realized

that many scientists are terrified of being seen
as political. This has led to scientists self-censor-
ing in interviews and when speaking in public.

A large portion of the scientific community was
very uncomfortable with using a march as a
tactic. For us, referencing the WPA style was a
way to embrace an America that is seen as not
political and, at the same time, make powerful
moral statements that are politically impactful.

The other thing that we did was a series of social
media graphics where the concept behind them
was to take scientists and make them look like
superheroes. Make scientists champions, make
them leaders of the people.

The strategy was: if we make them look bold and
uncompromising, as having the moral clarity of
a scientific community that is fighting for the
heart and soul of America, then those arguments
around whether science is politicized will actually
fall away. If we make them look amazing, they'll
forget they're afraid.

Once you can show the branding – and branding
is not actually a good word here, but rather
the frame you're coming from – once you can
show the visual identity, people will suddenly
have trust in it that they didn't have before you
started the process. This can fundamentally
shift the idea of what they are looking for, from
a branding standpoint.

Do you see great branding in other movements?

To me, the zeitgeist of the last ten years has been
about confronting this idea that for our social
movement to be authentic, everything has to be
handmade out of cardboard. That if you start
printing, if you start using modern technology,
if you start having aesthetics that make it look

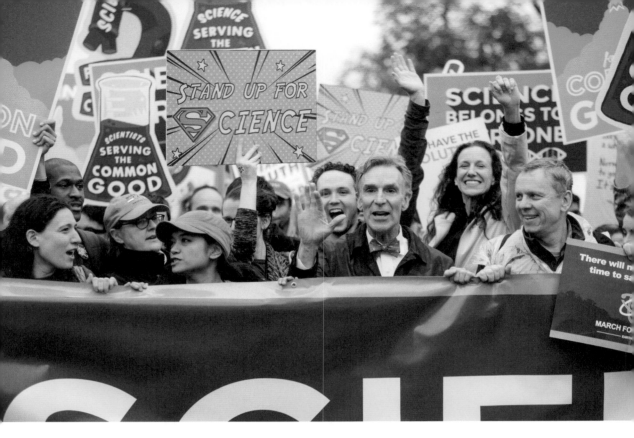

considered, that this is somehow less democratic and less in touch with regular people. There is huge power in understanding how to be authentic and how to use the modern technology associated with branding and design. But it takes a lot of skill, a lot of actual non-design skill. It takes organizing and it takes trust with the base. All of the movements that I look to as examples are movements that are finding new ways to pioneer that frontier.

How did you become aware of the power of branding in this area?

I started making signs and banners for movements as a teenager, for the anti-war movement. Bed sheets, painted by hand. I wouldn't have called it design.

I went into branding and design with the realization that we needed to reach more people, and for this you need to understand visual strategy. It's about reach. We need social movements that appeal to

really broad swaths of society, not just to people who already are interested in your issue.

I don't hear people in movements use the word branding. There's a web of other terms, "visual identity" being the big one. It's often a big argument in organizations, why you should bring on people who understand visual identity. But if you want your base to reach beyond where it is now, visual identity is one of the tools to do that.

What are the most important branding tools for protest?

Social movements are, at the end of the day, very much about narrative storytelling. That can come through the people who turn up. It can come through the stories that the speakers tell. It can come through the interaction between the people in the street and the police.

One of the most effective tools is considering how it will be seen visually, through cameras and

through people's eyes. Visual design. That requires a looser approach than branding. It requires designers to understand what's happening in the street in protests, and how people will interact. And people mostly interact visually. Considering that takes an expertise, and design as a commercial enterprise doesn't invest in that skill-set.

We need to build these skills to be able to pitch to movements. We need to build trust. And that's on the visual producers, that's not on the movements.

Part of that trust is that it takes a lot of humility. I wouldn't say it's the most important, but part of being able to do what I do, is about showing up to the art builds before marches and pushing a broom and carrying out the trash. You will not understand good visual design for social movements until you understand the minutiae of how movements come together, and that's being with the people who are there when everyone else has left, at 2.00 a.m., cleaning up the space. Doing the skills that are not relevant to your field is non-negotiable. It's about respect.

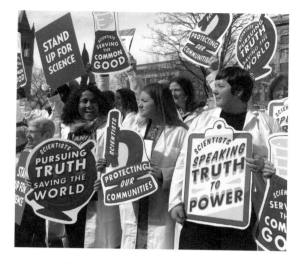

Top
The Rally for Science in Copley Square, Boston.
Placard designs by Josh Yoder.
Courtesy The Natural History Museum
Above
Posters for The Rally for Science in Boston with illustrations by Josh Yoder.
Courtesy Josh Yoder
Opposite
March for Science Washington, D.C.
Photo by Molly Adams, CC BY 2.0

Josh Yoder is a designer, illustrator and visuals producer for social justice movements. He has a BA in Design from the Tyler School of Art. He is based in N.Y.C. where he also works as a freelance illustrator.

Notes
1 The WPA or Work Projects Administration was a central feature of U.S. President F.D. Roosevelt's New Deal economic program in the 1930s and '40s. Under the WPA's Federal Art Project, unemployed artists were hired to produce artworks including posters promoting education, the arts and public health, and later war propaganda.

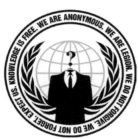

An emblem commonly associated with Anonymous. The figure without a head represents anonymity and leaderless organization. The suited figure, with a question mark where the head should be, is set against a U.N.-style globe and identical wreath.

Bottom left

Additional Anonymous digital graphics.

Below

The official United Nations logo printed as flag.

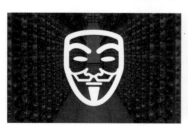

Recognizably Anonymous

How did a hacker group that rejects definition develop such a strong visual brand?

By ROB WALKER

The loosely affiliated and ever-changing band of individuals who call themselves Anonymous have been variously described as hackers, hacktivists, free-expression zealots, Internet troublemakers, and assorted combinations thereof. By all accounts the group has no clear hierarchy or leadership, or even any internal agreement about what exactly it is. And yet, as you've encountered news and speculation about Anonymous – maybe from reports about coordinated denial-of-service attacks on financial institutions that stopped doing business with WikiLeaks, or the group's association with Occupy Wall Street – you may also have noticed its memorable logo: a suited figure with a question mark where the head should be, set against a U.N.-style globe. You've also likely seen the visual symbol that's made its way onto the streets: a Guy Fawkes mask borrowed by Anonymous from the *V for Vendetta* graphic novel and movie for use in real-world protests. How did this chaotic, volunteer-driven non-organization manage to create a visual identity stronger than many commercial brands?

Anonymous traces its roots to the infamous /b/ message board on 4Chan.org. Much of the communication on the board takes place in the form of rapid-fire, freewheeling and often blatantly offensive images and remarks from legions of individuals posting anonymously, riffing on, insulting and trying to top each other. The most familiar (and misleadingly innocuous) meme to emerge from this iteration-obsessed corner of the Internet is the lolcat phenomenon. 4Chan has been around since 2003, and it's hard to pin down when and to what degree some of the people posting as Anonymous began to think of themselves as a de facto entity of the same name.

That said, some of the images and phrases now associated with the group were clearly circulating on 4Chan by 2007, when a rather sensational local Fox News report depicted Anonymous as "a hacker gang," and offered a scary assessment of wanton Internet cruelty and destruction. The segment included a disguised individual declaring: "We do not forgive, we do not forget," a phrase that's since become familiar to anybody conversant in Anonymous rhetoric, and ended with a visual of that headless-suit guy on a motivational-style poster bearing the message: "Because none of us are as cruel as all of us." This visual was doubtless grabbed from /b/, where the headless image had been posted and riffed on since about 2006. The Fox story inspired a theatrically obnoxious video response from someone purporting to speak for Anonymous: "We are the face of chaos and the harbingers of judgment," it declared. "We mock those who are in pain." This early video traffics in some of the elements – visuals, as well as what Ars Technica has called a "florid bombasticism" – of what would become the Anonymous image.

Those elements really coalesced in early 2008 when some "Anons," evidently incensed by the Church of Scientology's efforts to keep an embarrassing Tom Cruise video off the Internet, began congregating via Internet Relay Chat to organize a response. Gregg Housh, then an active participant in Anonymous activities, was part of this group. At first, he says, the effort involved recruiting people to keep re-uploading the video faster than the Church could take it down. But one participant who had some experience with the media argued that Anonymous needed "a solid identity to present to the press."

Six or eight people, Housh reckons, hashed out a press release. It read like the script to a movie trailer, so somebody proposed turning it into a video, combing Archive.org to dig up images of rolling clouds and ominous background music available under a Creative Commons license. They kept fiddling with the ending of the script using Anonymous-associated phrases already in circulation. Another contributor proposed a conclusion: "We are Anonymous. We are legion. We do not forgive, we do not forget." Pause. "Expect us."

"Everyone in the channel *erupts*," Housh recalls. "Like 'Oh my god. You've done it. *You have done it*! We win this game.'" The script was fed into AT&T text-to-speech software, and became the video's creepy voice-over. Next the group created a Web site. For a logo, they considered imagery that had been floating around 4Chan and elsewhere, including the headless suit-man. Someone – Housh says the person wishes to remain anonymous – suggested imposing that image over a U.N.-style globe logo. Then a question mark was added where the figure's head should be. In what seems like a missed opportunity, the Anonymous logo did not appear anywhere in the video. "We weren't branding experts or anything," Housh explains.

Continued on page 188

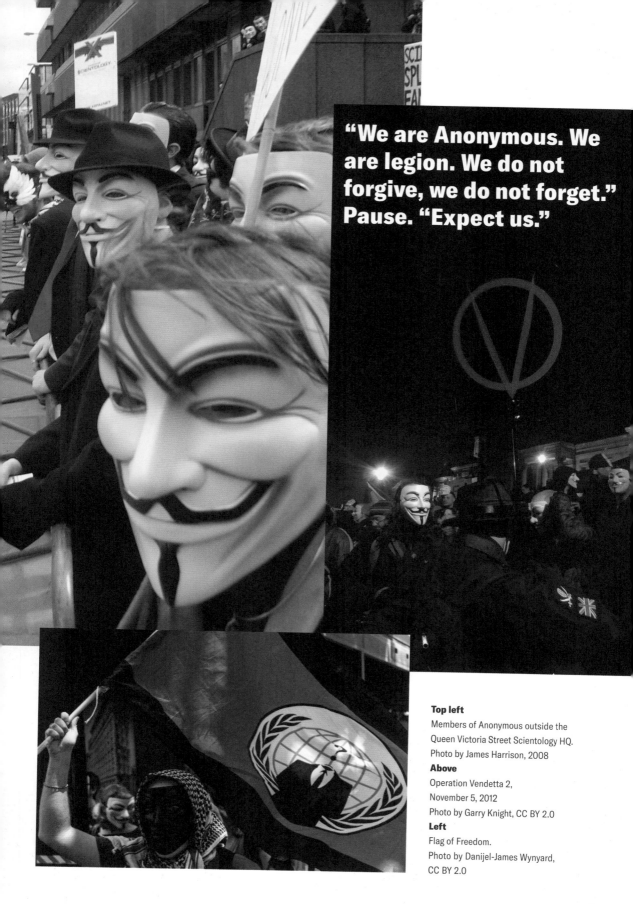

"We are Anonymous. We are legion. We do not forgive, we do not forget." Pause. "Expect us."

Top left
Members of Anonymous outside the Queen Victoria Street Scientology HQ.
Photo by James Harrison, 2008
Above
Operation Vendetta 2,
November 5, 2012
Photo by Garry Knight, CC BY 2.0
Left
Flag of Freedom.
Photo by Danijel-James Wynyard,
CC BY 2.0

I don't know why I thought of Guy Fawkes, because it was during the summer. I thought that would be great if he looked like Guy Fawkes, kind of theatrical. I just suggested it to Alan, and he said, 'that sounds like a good idea.' It gave us everything, the costume and everything. During the summer, I couldn't get any of these masks. These masks that you could get in every shop had a smile built into them. So I created this Guy Fawkes mask with a kind of smile. It was an ideal costume for this future anarchist persona."

David Lloyd, Strip Artist of *V for Vendetta*, written by Alan Moore

Insert photo top right
Guy (Guido) Fawkes (C) in *The Gunpowder Plot Conspirators* (detail), 1605.
Engraving by Crispijn van de Passe
Top left
Activist during a "Cube of Truth" protest, organized by Anonymous for the Voiceless in Zaragoza, Spain, 2019
Photo by Guillermo Latorre on Unsplash
Left
V for Vendetta, original blueline by Siobhan Dodds and David Lloyd.
Page 116 of the Vertigo hardback
Photo by Julian Tysoe, CC BY 2.0
Background
Man wearing V mask.
Paris, 2015
Photo by Novltstock/Dreamstime

Guy Fawkes Mask
17th century rebel Guy Fawkes as anti-hero in *V for Vendetta*

A group of dissident Catholics planned to blow up the House of Lords in 1605. The failed Gunpowder Plot was intended to kill King James I, a Protestant. In charge of guarding 36 barrels of gunpowder, Guy Fawkes was caught and sentenced to death. Shortly after, bonfires and burning effigies of Guy Fawkes would become a tradition held on November 5th.

The 1982 comic series *V for Vendetta* charted a vigilante anti-hero who wore a stylized mask of Fawkes while fighting a fascist British regime. Writer Alan Moore and comic strip artist David Lloyd turned Fawkes into a symbol of a righteous resistance against oppression. The comic was adapted into a movie in 2005, with the mask of "V" rendered true to the book. Since 2008 it has become known as the Anonymous mask, worn by an international protest group originated by hacker-anarchists.

With over 100,000 sales a year, the V mask's popularity reflects a generation somewhat removed from the political process, but who nevertheless consider themselves political through other channels. Ironically, the copyright from the mask's sales directly benefit the movie's producer, Warner Bros., a subsidiary of WarnerMedia. Wearing a Guy Fawkes mask gives protesters anonymity and carries in itself a political symbol. If we understand this phenomenon as the purchasing of an idea, anonymity and political dissatisfaction are becoming blurred, if not alike.

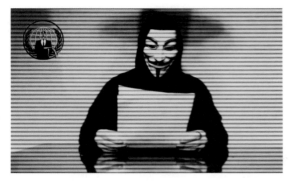
Anonymous video *Message to the American People*, 2011

Fair enough, but the video really is a fine bit of propaganda – with 4.6 million YouTube views – mixing the snotty but intimidating "hacker gang" vibe with rhetoric that not only transcended the nihilistic, but sounded rather righteous. Excited by their surprisingly large audience, participants in Anonymous' anti-Scientology efforts decided to organize in-person protests – a challenge, since they were already being accused of various illegal activities.

The need to remain anonymous at live protests led the group to adopt its now-familiar mask depicting a highly stylized visage of Guy Fawkes, an early-17th-Century British figure who was executed following a foiled plot to assassinate King James I. Though Brits have long used effigies of Fawkes in their Guy Fawkes Night celebrations, this particular, cartoonish representation comes from the 1980s comic book series, *V for Vendetta*: a vigilante character wore such a mask while overthrowing a totalitarian British government in an imagined dystopian future. In 2006, the series became a film. Also in 2006, the mask began to appear in a popular 4Chan meme called Epic Fail Guy. According to Housh, the suggestion to use the Fawkes mask as protest gear was almost immediate. But some Anons weren't convinced that the Fawkes mask was right, so they made a short list of alternatives: a Batman mask, classic masquerade masks, a few others. "Then we called comics and costume shops, all over the world," Housh says, checking availability and price, and the *V* mask won out: "It's available, it's cheap, and it's in every city." (The actual Fawkes had "nothing to do with it, for us," Housh says.)

Thousands of people in various cities subsequently participated in a day of anti-Scientology street demonstrations, plenty of them wearing the mask. "Videos and images and photographs circulated almost immediately," says Gabriella Coleman, the incoming Wolfe Chair in Scientific and Technological Literacy at McGill University and author of the forthcoming *Coding Freedom: The Ethics and Aesthetics of Hacking*. "It was just so powerful." And it cemented Anonymous as, paradoxically, a recognizable phenomenon.

Why has this particular set of signifiers stuck? For starters, the visuals simply look cool – headless-suit-guy and the Fawkes mask are both stark, simple and vaguely ominous in a way that's compelling. The suit-man juxtaposed against the U.N. map is also a cleverly subversive and ironic appropriation and exploitation of paranoia about Big Brother-style faceless power. Particularly when paired with Anonymous' over-the-top rhetoric, it suggests that the most powerful entity on earth isn't a corporation or a totalitarian regime: it's something so amorphous that the person next to you on the subway

could be part of it. And the Fawkes mask, with its hard-to-read expression and mild air of menace, extends that idea into the public sphere. At a time when privacy seems under threat, it's a tool for mixing free expression with personal secrecy – which might be one of the few propositions that participants in the Anonymous phenomenon agree upon.

Today the headless-man/U.N. globe logo appears on the widely followed @AnonOps Twitter. @YourAnonNews uses the Fawkes mask, as does @GroupAnon. And of course the mask has been worn by street protesters who supported WikiLeaks, and by many participants in Occupy Wall Street actions. In a new chapter of the movement, the mask is a symbol for the Anonymous for the Voiceless, in their peaceful "Cube of Truth" street activist demonstration for animal rights and the promotion of a vegan lifestyle.

These examples reveal that the iconography of Anonymous is highly accessible: if there is a Grand Conspiracy, you don't have to fear it – in fact, you can join it! But both Housh and Coleman underscore a vital point about the visual identity of an entity with no real structure: all of these examples borrow from the same set of images and tropes – but almost always tweak them in some way. "With Anonymous," Housh says, "you can only make suggestions." People will pick up and riff on the stuff they like – and ignore whatever they don't.

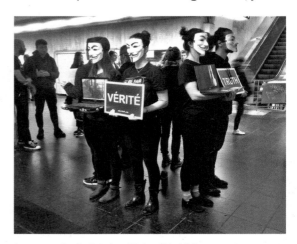

Anonymous for the Voiceless "Cube of Truth" demonstration at McGill station, Montreal, 2018, CC BY-SA 4.0

"It's very meme-like," observes Coleman, who has studied its distinctly nonhierarchical decision-making process. Coleman has argued that Anonymous' visual branding has enhanced the group's power – and may even have been essential in binding together people who resist being bound to anything, or anyone. It's impossible to say whether any given person wearing a Fawkes mask to an Occupy event is "part of" Anonymous, which after all has no official membership structure. Possibly some wearers aren't even familiar with Anonymous. But even that ambiguity seems to play to the strength of this visual identity. Participants in Anonymous who Coleman has interviewed don't seem put off by seeing their symbols go mainstream. Instead, she describes their attitude as a kind of proprietary pride with an irony of its own: "That's me."

"The Guy Fawkes mask has now become a common brand and a convenient placard to use in protest against tyranny – and I'm happy with people using it, it seems quite unique, an icon of popular culture being used this way."

David Lloyd, Strip Artist of *V for Vendetta*

A CORPORATION SHOULD NOT OWN A RELIGION AND ITS FOLLOWERS

Ask Me Why I'm Wearing A MASK

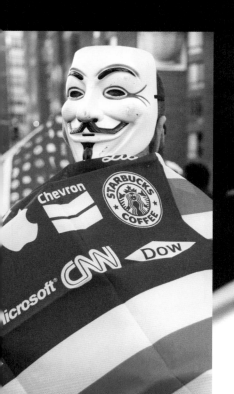

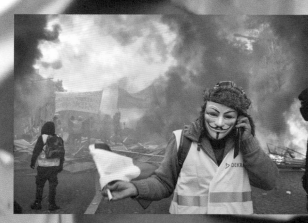

Anonymous with Guy Fawkes masks at the
Scientology Center in Los Angeles, February 10, 2008.
Photo by Vincent Diamante, CC BY 2.0

A protester wears a Guy Fawkes mask
during the Million Mask March in
Washington, D.C., November 5, 2015.
Photo by Alejandro Alvarez, CC BY-SA 4.0

French Yellow Vest protester wearing Guy Fawkes
mask at a demonstration in Paris, November 2018.
Photo by Andrew Baumert/Dreamstime

THE PRIVATE BANKER
POLITICIANS,
GLOBAL ÉLITE,

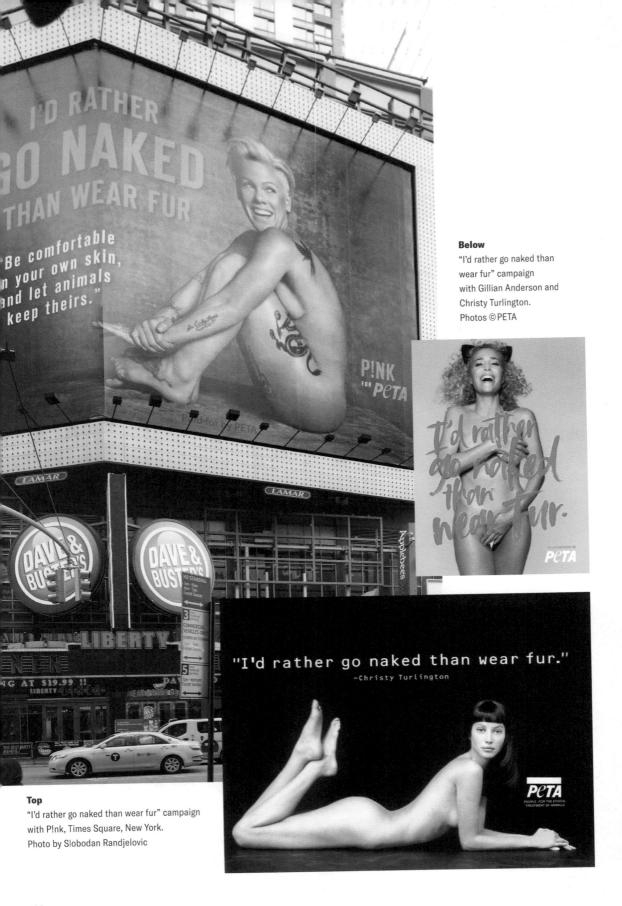

Below
"I'd rather go naked than wear fur" campaign with Gillian Anderson and Christy Turlington. Photos ©PETA

Top
"I'd rather go naked than wear fur" campaign with P!nk, Times Square, New York. Photo by Slobodan Randjelovic

"I'd rather go naked than wear fur."
–Christy Turlington

PETA

Activists for Animals

PETA's ever evolving branding helps to keep their message alive.

PETA has become notorious for its controversial protest campaigns to promote animal rights. As an activist non-profit, it has developed a brand from being on the fringes, by getting headlines meant to grab your attention. We had a conversation with Dan Mathews, the creative force behind many of the memorable People for the Ethical Treatment of Animals (PETA) campaigns. As Senior Vice President of PETA, the world's largest animal rights organization, he has mobilized a string of celebrities to speak out for the cause.

Branding tools have traditionally been seen as instruments of corporate interest. However, branding is increasingly used in the nonprofit sector. In the case of PETA, the visual language of the campaigns comes close to commercial advertising but has a different goal. Can you tell us about the purpose, the meaning and the effect of your campaigns?

Sure. Well, we strive to make our campaigns look just as alluring, attractive and compelling as a campaign for a product. The only difference is that we're urging people not to buy a product. We're trying to show the hidden story behind some of these products. Oftentimes, it's something that the public generally doesn't want to see – especially when it involves cruelty to animals. We have a lot of campaigns that spotlight the cruelty. That is what really changes people. But if you only do that, you lose a lot of people that don't want to see the graphic images. So that's why we've come up with campaigns like "I'd rather go naked than wear fur." Everybody wants to see naked people, whether they admit it or not. We started that campaign back in the early '90s. It started as something we did in the streets. And then it became an ad series using model Christy Turlington, actress Pamela Anderson and singer Pink. It's become

more of our hallmark. It's our most recognizable campaign around the world. As a result of the massive public response to it, we now try to use humor and sexuality in a lot of our campaigns.

It's a little trickier nowadays. Sexuality has so many taboos, but people are still interested in that topic. Living in a very aspirational society, we try to use an aspirational quality in our campaigns too. People are bombarded with messages all the time about using a skin cream to get good-looking skin. Get Botox to have a younger looking face. Get this sweater to make yourself look more modern and stylish. Eat vegan and you can look like this. Age much more slowly if you eat vegan. If you wear these clothes,

International "Lettuce Dress" campaign, U.S. with Cloris Leachman
Photo ©PETA

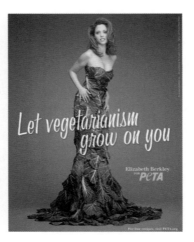

International "Lettuce Dress" campaign, U.S. with Elizabeth Berkley
Photo ©PETA

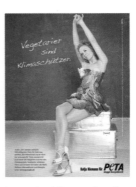

International "Lettuce Dress" campaign, Germany with Katja Riemann
Photo by Nela König/PETA, Deutschland

International "Lettuce Dress" campaign, Vietnam with Ho Quynh Huong
Photo ©PETA, Asia

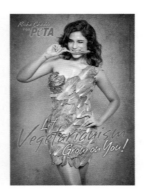

International "Lettuce Dress" campaign, Vietnam with Richa Chadha
Photo ©PETA, India

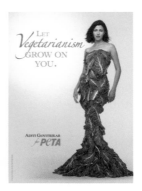

International "Lettuce Dress" campaign, India with Aditi Govitrikar
Photo ©PETA, India

you're going to look like an old frump. Only people out of touch wear fur. We use all the same aspirations for urging people to shun certain products and wear other things. We try to get them to ignore ads saying these things are status symbols and luxury items or supposed to be more helpful.

Can you explain the creative process of a new slogan or campaign?

We do not do market research. Generally, we are like a do-it-yourself punk rock charity. We have a team with really dedicated, very clever people. We all bounce ideas of each other in meetings. Some people will offer in-house input, and we'll do it the next week. If it works, great! If it doesn't work, oh well. Sometimes things work that we didn't expect to work. Sometimes things fail that we expected to work. It's just all trial and error. The luxury of having been involved for the past 34 years is that I can look back at things that didn't work and learn from them.

The purpose and meaning of the campaigns are based on various themes, but most of the campaigns have a shock value. Are the campaigns differently received in different countries and specifically created for individual and cultures?

We have almost identical campaigns for each country. But the personalities will be different. If we do a PETA campaign in the U.S. then we will use Hollywood personalities. If we do it in India, it's Bollywood personalities. In China, Chinese soap stars. In Germany, it's a German soccer player. In the U.K., it's a British TV presenter. In Australia, we have Australians lead the campaign. We have, I think, 7 million members now. We filter our campaigns through a national lens, so that it doesn't seem like we're some American pressure group (trying to tell them what to do). It has an organic feel to it. Even though it's the same campaign internationally.

How does PETA support particular campaigns? Are there fundraisers for an individual cause to create a specific campaign? Who are your stakeholders, the clients, donors, volunteers or government institutions?

Some members support us because we're the only organization targeting experiments done to animals. Animal experimental campaigns don't get a whole lot of exposure because it's not sexy.

It's difficult bringing humor into them. There's a lot of backstage government lobbying, working at the international regulatory level. But we had huge successes in getting China to approve the first two nonanimal tests, which will save countless animals from experiments. There are some people who back that. Other people back our campaigns because they are against fur or leather. Other people support us because we are changing the face of the horse racing industry – especially with the recent deaths of

so many from drugs and from whipping. Other people support everything we do. Probably half of our members are vegetarian or vegan. The other half aren't, but they know the changes we're making in those fields are important. Even if they don't happen to be vegan themselves.

Were donations ever canceled because of highly charged campaigns?

We have had some people quit over certain campaigns but not that many. We actually do campaigns despite the fact that it might upset our members because we know that they will reach the most people. We are a provocateur organization and love to get people to think about things, even if that means we have a bad reputation sometimes.

In Montreal once, a veggie campaign was done with Pamela Anderson. It was like a butcher's diagram where lines were drawn on her body. Her rump, shoulder, etc. All the same things you would see on a butcher's diagram, but on her naked body. It was going to run on the subway transit system in Montreal, but they turned it down saying that it was sexist. We had a news conference, making the point that they were getting confused between what was sexy and sexist. Why shouldn't a woman have the right to use her body as a protest?

What does a campaign mean for PETA? How do you transport the message? Through the means of protest, events, broadcast, print, social media, etc.?

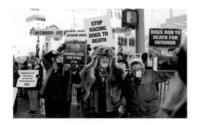 They have different goals. For instance, we have a campaign now against the sponsors of Iditarod, the annual dog race in Alaska with sled dogs. People find that this is an amazing story to see these dogs race every year. What you don't hear is that several of these dogs die every year, and there's a lot of cruelty behind it. We started a campaign protesting the sponsors. Jack Daniels, for instance, stopped sponsoring the race. The goal of that campaign is to go from sponsor to sponsor, urging them to stop. When there's no more sponsors left that will fund these events, the events will have to stop.

A different type of campaign, which is very successful of ours, happens during truck crashes. Many of these trucks are transporting animals to slaughterhouses. There have been incidents where birds or cattle have died during the crashes. On American highways, you'll see often a roadside memorial when someone died in an auto crash – there will be a memorial for the person. We have started petitions with the Department of Transportation to erect memorials for animals that were killed by the meat trade on their way to the slaughterhouses. But they always refuse us.

Right

Pamela Anderson in the "All Animals
Have the Same Parts" campaign, featuring
a familiar butcher diagram drawn on her
body. Among other celebrities featured,
Tracy Bingham and Violett Beane.
All photos © PETA

Bottom

Different logo from PETA.

1

PETA wordmark and bunny logo in a circle.

2

PETA wordmark in the bunny logo.

3

PETA wordmark.

4

peta2 logo.

5

Cruelty-Free and Vegan trust mark.

6

Beauty without bunnies trust mark.

Opposite page

Iditarod, Alaska.
Photo © PETA

Next spread left

Dan Mathews as a priest at a
fur fashion show in Milan.
Photo © PETA

Next spread right

"Vegans make better lovers"
street theater in Toronto.
Photo © PETA

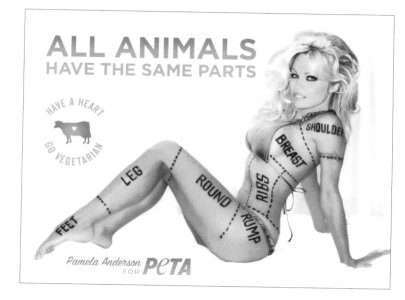

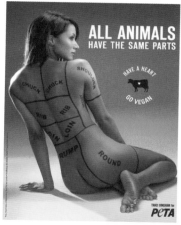

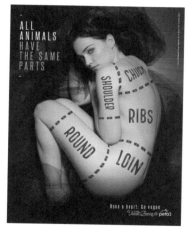

1

2

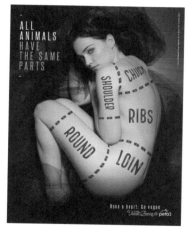

3

5

4

6

We generate so much news that it has an impact. A lot of what we do is to create a broader sensitivity to animals. The goal was not to actually set up a memorial. But we do make artwork and submit it to them. We then tell the press, where it comes out in every paper as if we had set up a memorial.

What and where were the strongest and most effective campaigns PETA ever did? Do you have a favorite campaign?

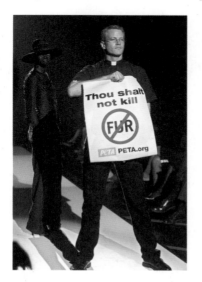

During fur campaigns, especially in the '90s, fashion houses had no interest in meeting with us. They wouldn't answer our calls, letters or emails. They wanted nothing to do with us. We got in the habit of sneaking our way into their fashion shows. They would spend hundreds of thousands of dollars to show a collection, and then we would take over the runway with signs protesting fur. They had so much heavy security after the first few years that we had to be more creative.

My personal favorite was disguising myself as a priest and getting into a fur fashion show in Milan. Italy being such a Catholic country – I used to live there – I talked my way in, pretending to be the designer's parish priest. As soon as the show started, I took over the runway with a sign that said "Thou shalt not kill," together with the anti-fur symbol. It stopped their show cold, and the press went crazy. It was all over the news.

I found that to be a really great success. We did those so many times that the designers finally started to meet with us. They didn't want us to show up on their magic day. And now we're meeting designers every trip. We haven't done that in a while. So that tells me there's some successful components.

Some of the campaigns are very graphic. Is there a strong backlash to these kinds of campaigns? Do people understand or misunderstand your position?

Sometimes the complaints we get about the graphic messages are from our own members who are so tormented by the cruelty involved that they don't want to see it again. Other times, like last night when I was on the local New York City news channel NY1, I brought a trap showing how they caught animals. And I gave them footage, to show the animal struggling in these traps. They showed me setting up the trap, but they refused to show the video because it was too upsetting. So now we're having to buy ads with the animals in traps and trying to circumvent the rules that don't allow graphic messages, which really sucks. It's the hardest thing that we've faced. Fortunately, with

social media we can put these things up and spread it around. We do have ways to try to get the graphic message across.

Do you have a favorite example of the use of branding in a protest campaign?

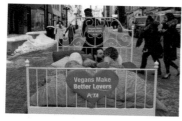

I think my favorite thing is when it's not a group of people, but an individual or maybe two to three people putting on a street theater. I think when it looks like a protest, you immediately lose a lot of people. But if it looks like a "happening," everybody wonders what's going on. An example I can give happened on Valentine's Day. There was a bed put up in a public square. A hot couple gets in the bed, and there's a sign over the bed that says *Vegans make better lovers*. It looks like a public art installation, so people will stop. Then they would really freak out, but eventually, they get it. They would stay there for 20 minutes to see these people making out while we would have people giving out leaflets about the benefits to the heart and circulation overall, your whole body. I enjoyed how the people became engaged with the message and not with angry chanting faces.

PETA created different logo trust marks. With these logos, the branding topic is entering new territory by giving third-party organizations the option to be part of a bigger idea. It is less about protest but a proactive action for companies to show the public that they are serious to comply with their worldview? How is the industry embracing the logos?

The industry is embracing the logos slowly but steadily. Herbal Essence Shampoos is the most recent example of a company that uses our logo. In the early '80s and even in the '90s, companies did not want any part of us and our logos or hearing about our protest. But then, as the culture changed, they realized that many people actually are looking for products that are not being tested on animals. They started using a lot of their own logos. But then people started wondering about animal ingredients and if they would be tested in China. Our logo is the most thorough because it makes sure of all those things. So now they're starting to use it more because of the complications that have arisen over the years.

With peta2, a younger audience is confronted with animal rights. Is it very different to speak to youth about the topic? What are the differences compared to a campaign for adults?

The audience is constantly changing, but our biggest target right now is youth. When people are young, teenagers especially, they're still developing their lifelong consumer habits. Once you've decided that steak is your favorite thing, by the time you're in your

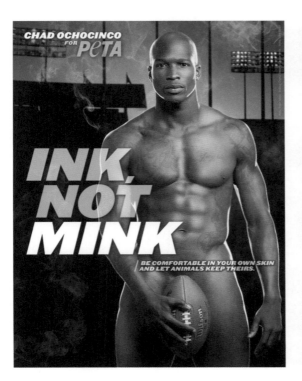

CHAD OCHOCINCO FOR PETA

INK, NOT MINK

BE COMFORTABLE IN YOUR OWN SKIN
AND LET ANIMALS KEEP THEIRS.

PETA

© 2010 People for the Ethical Treatment of Animals, Inc.

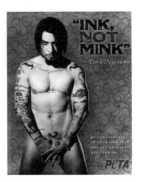

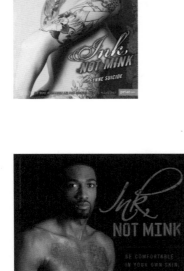

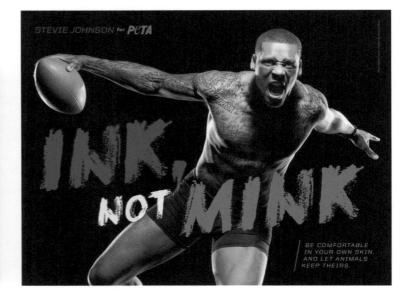

200

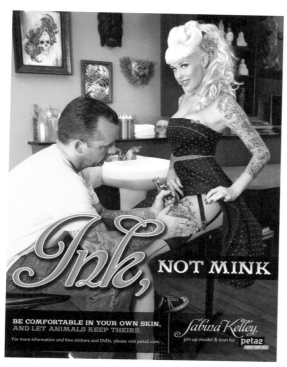

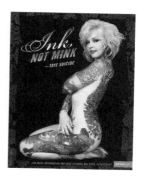

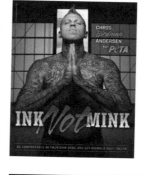

Spread

"Ink, Not Mink" campaign with tattoed models from suicidegirls.com and tattoed celebrities from the sports and entertainment industries. Clockwise starting top left: Chad Ochocinco (Chad Johnson), James Suicide, Sabina Kelley, Vanessa Suicide, Chris Andersen, Taye Suicide, Danny Cipriani, Tim Howard, Dave Navarro, Stevie Johnson, Gilbert Arenas and Fynne Suicide. All photos © PETA

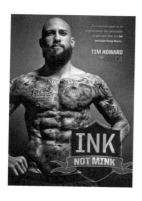

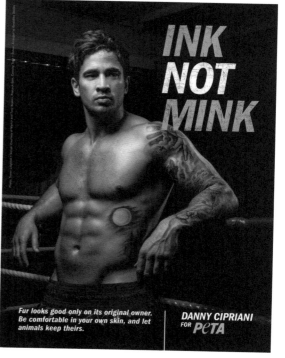

Right

"Ink, Not Mink" video campaign with Tim Howard.
Video © PETA

twenties, it's hard to dial that back. Or your love of a leather jacket. When kids are first forming allegiances with products, they are still developing them. So that's what we try to get them to change. Up until recently, sex was a great thing. Now with the "Me Too" campaign, people are more puritanical about that. The line between sexy and sexist is blurry now. We are coming up with different ways to get the message across.

What is the branding difference between PETA today and the organization in the early days?

The organization was founded on serious investigations: undercover investigations into laboratories, slaughterhouse and circuses. When I joined in 1995, I was from the MTV generation. I was 20 years old and younger than the others. Most were more from the '70s culture generation. I knew that even if we got a great story on the main news about the cruelty in a laboratory, a whole lot of people that we wanted to reach weren't seeing it. They're not watching the news; they're watching MTV. Then, over the next few years, streaming services and the Internet created more competition for people's attention. We now strive to make campaigns that seem like they belong more on entertainment outlets than on the news. The news cycles are now so sensational. A lot of people tune it out. They don't want to know the last thing Trump tweeted. They don't want to hear the latest with Brexit. But they do want to know if Beyoncé has a new album. We shifted our campaigns to be geared toward more entertainment news and not political, not hard news. We want to make sure that we don't miss people. That's how we change. We shift all the time.

Tell us how you have personally used or experienced branding in protest.

I'm from the punk school, so I don't consciously think of it as branding – it's more about conveying attitude, self-confidence and fearlessness in fighting for causes in an unapologetic way. I think a lot of people are inspired by activists who challenge them to think about issues, and we're targeting them with our tactics.

In your opinion, what role does design and branding play in protest?

I think sometimes it shouldn't look like it was branded. It has a bigger chance of resonating. Like an individual is doing it. When we have a really organized thing, I sometimes may want to make it look homemade rather than professional. It all depends on the situation.

Branding can help when targeting companies that abuse animals because a parody logo or slogan like "McCruelty" makes people pay attention. But it's still great when individuals spontaneously create their own protests, signs and slogans because it shows that animal rights are a grassroots cause that's important to so many people.

Why has design become so important?

So much activism is online now, and you've got to tailor your argument to the size of a cell phone screen, with a very small area for photos and text. You have to convey your message in five words maximum, so both image and text design are more important now than ever.

How did you become aware of the power of branding in this area?

I hated the sloppy hippie approach and slapped-together look of '60s and '70s protesting. It looked like it was meant to appeal to the protesters' own niche crowd rather than to the mainstream. It seemed very weak and didn't give me confidence that the people protesting would win because they didn't look like they had discipline or could be taken seriously.

What have you learned from your own involvement in branding protest?

Humor is really important. If you can get someone through the door with a laugh, they're much more open to the message – like with PETA's anti-SeaWorld video with Jason Biggs or our campaigns with comics.

Do you think that branding is (or can be) used against protesters? How?

It's used effectively when it distracts people from the issue at hand. In the social media era, people have such short attention spans, so it's easier than ever to confuse them. Misinformation campaigns for many different causes have been very successful since the advent of Facebook.

Which do you think are the most important branding tools for protest?

Ones that convey a sense of strength, confidence, and simplicity.

Are there any branding tools or techniques that don't apply to protest?

No, I think there's such a variety of ways people can protest now. One important point is that while corporate branding is about trying to get people to *buy* their products, protest branding is about trying to get people to *opt out* of buying products that harm animals and make kinder choices, and that's easier than ever today. When PETA was founded in 1980, we could only encourage people *not* to buy a fast-food burger; now, we can encourage them to grab a Beyond Meat meal at Del Taco or Carl's Jr. instead. Because smart companies are meeting the demand for animal-friendly clothing, food and entertainment, we're able to combat cruel corporations by highlighting choices.

Acknowledgements

More than three years of research and many discussion with designers, activists and friends made this book possible. With their support and a tremendous amount of research, time and work, we came to this result.

To get to this point, we needed the skills of Margreet Nanning to find the right publisher, interested in the subject. Without her support and enthausiasm, this book would never have happened.

We would like to thank Liam Galvin for consulting on photography and his efforts to get us the best possible image resources. Special thanks to Getty Images for their generous support in this matter.

We would like to express our admiration for his activism and thank artist Kacey Wong for his essay and many hours of discussion, and writer Terrie Ng for his writing, especially with the recent protests in Hong Kong in mind. Terrie Ng is a PhD student in contemporary history, specializing in protest movements in Hong Kong.

During a short stay in San Francisco, we stumbled upon Design Action Collective, the designers who created the visuals for Black Lives Matter. With only one email and an immediate response, we were able to set up a next-day meeting with Sabiha Basrai, receiving first-hand insight into the process.

We would like to mention the rights to use of the Extinction symbol in our Extinction Rebellion interview.
"Created by ESP in 2011" – extinctionsymbol.info

In this complex project, many have provided advice and assistance during the past three years. We gratefully acknowledge:

Most of all, these colleagues for their inspiration and contribution to making this book: Shehab Awad, Laura Brown, Lia Gangitano, Liam Galvin, Steven Heller, John Loughlin, Joe Mejía, Didi Mosbacher, Margreet Nanning, Sarah Payton, Mark Randall, Rudy Reed, Eberhard Schrempf, Karl Stocker, Jane Szita, Inge Wallage.

For our interviews, we like to thank the following people for their participation and insight on the topic and their supply of examples and artwork. We are grateful to have talked to Thomas Coombes and Simon Pates (Amnesty International, London), Marina Willer (Amnesty International/ Pentagram, London), Sabiha Basrai and Josh Warren-White (Design Action Collective, San Fransisco), Clare Farrell, Miles Glyn, Clive Russell and Charlie Waterhouse (Extention Rebellion, London), Elaine Hill, Ana Hristova and Martin Lloyd, (Greenpeace, Amsterdam and Bangkok), Joachim Roncin (Je suis Charlie, Paris), Egor Eremeev (Kultrab, Moscow), Rosalyn LaPier (March for Science/Rosalyn LaPier, Hawaii), Beka Economopoulos and Jason Jones (March for Science/The Natural History Museum, Washington), Josh Yoder (March for Science/Josh Yoder, New York), Beth Voigt (March for Science/Beth Voigt, Chicago), Dan Mathews (PETA, Virginia), Jayna Zweiman (Pussyhat Project, Los Angeles), Terrie Ng (Umbrella Movement, New York), Kacey Wong (Umbrella Movement/Kacey Wong, Hong Kong), Amy Hayes Stellhorn (Women's March/Big Monocle, Utah), Wolfgang Strack (Women's March/Strack Design, Oakland).

For their assistance to supplying examples and material on the different movements, Kate Blewett (Pentagram), Sophia Charchuk (PETA).

For photography, Maribel Dato, Carlos Andrade (Getty Images), Kevin Grieve (Extinction Rebellion), Kelly Kline (Je suis Charlie), Wolfgang Tillmans (Project Europe/Between Bridges), Denis Sinyakov (Pussy Riot).

We would like to thank the owners of works reproduced in this book for kindly granting permission and for providing photographs.

The essays and interviews were compiled with great attention to detail to show the different protest movements. With this in mind, we'd like to thank Rudy Reed in New York for his tireless work and support in pushing us in the right direction. Thank you, Bart, Mick and Phum in Amsterdam, for your support, love and patience.

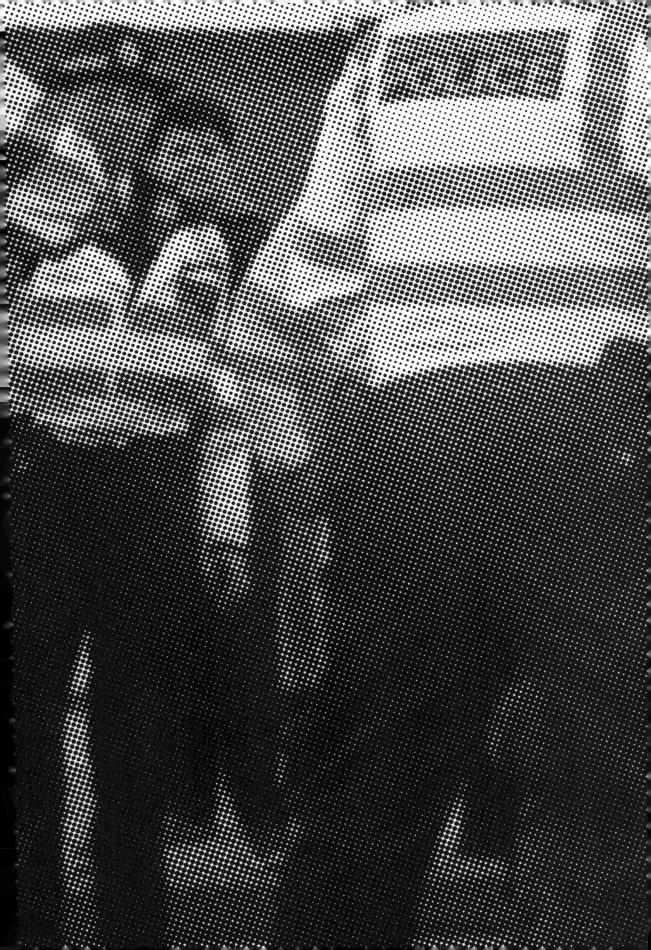

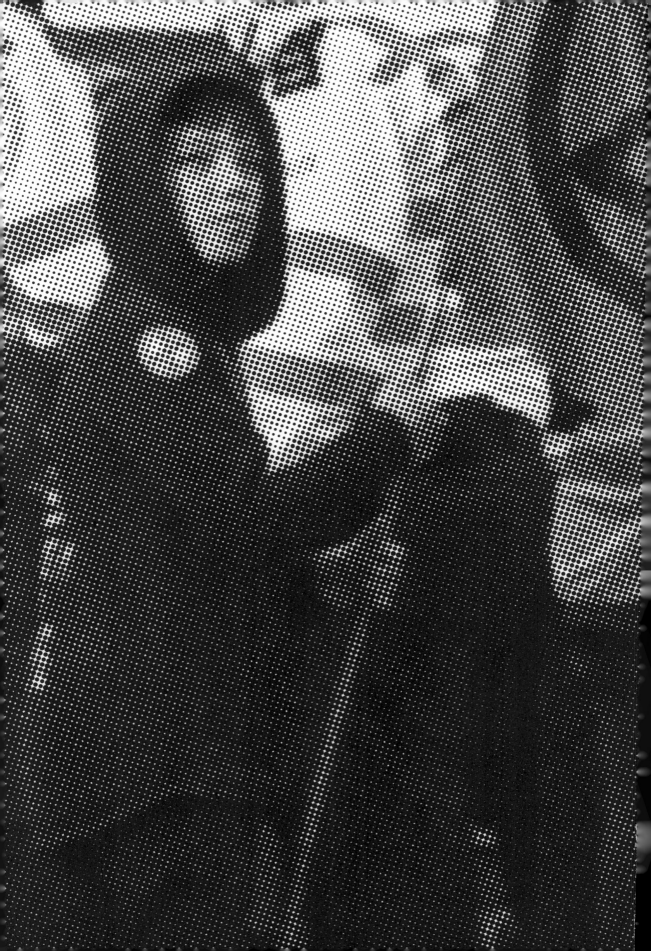